PRIESTLEY PLAYS FOUR

T0347802

J.B. Priestley

PLAYS FOUR

The Thirty-First of June

Jenny Villiers

Introduction by Tom Priestley

OBERON BOOKS
LONDON

WWW.OBERONBOOKS.COM

Published in this collection in 2013 by Oberon Books Ltd
521 Caledonian Road, London N7 9RH
Tel: +44 (0) 20 7607 3637 / Fax: +44 (0) 20 7607 3629
e-mail: info@oberonbooks.com
www.oberonbooks.com

Jenny Villiers copyright © J.B. Priestley 1946

The Thirty-First of June copyright © J.B. Priestley 1957

Introduction copyright © Tom Priestley 2013

J.B. Priestley is hereby identified as author of these plays in
accordance with section 77 of the Copyright, Designs and Patents
Act 1988. The author has asserted his moral rights.

A catalogue record for this book is available from the British Library.

PB ISBN: 978-1-84943-217-7
E ISBN: 978-1-84943-732-5

Visit www.oberonbooks.com to read more about all our books
and to buy them. You will also find features, author interviews and
news of any author events, and you can sign up for e-newsletters
so that you're always first to hear about our new releases.

Contents

Introduction 7

The Thirty-First of June 9

Jenny Villiers 109

Introduction

BY TOM PRIESTLEY

These two little-known plays illustrate beautifully my father's love of experimenting and trying his hand at new types of drama, indeed new types of writing.

Both are totally different and yet both have key elements in common. *The Thirty-First of June* is a jolly, frolic of a play painted in broad strokes of vivid colour, with over-the-top characters who lurch between two time zones, contemporary and medieval, with characters from one stumbling into the other until triumphantly at the end both combine, and there is no longer 'now' or 'then'.

This theme, quite differently handled, occurs too in *Jenny Villiers*. There, people from what seems to be the past inform and instruct characters in the present; but what is past and what is present? The two overlap becoming a whole, a uniform blend of time. The malaise of the contemporary dissolves into a continuum in which negativity disappears as a tired scum on the surface of experience, leaving the rich vigour of life blazing below, crossing the generations. What was good then is still good now, whereas what was bad was ephemeral and short-lived.

Once the classical unities dissolve, scenes can easily shift from place to place, and it is only a short step to scenes in different times, and ultimately scenes combining times. These now are commonplace with the newer media of film and television, but in the days of JBP they were revolutionary. In these two plays he uses the time shifts to suit his subjects; comic in one, tragic in the other, but the tragedy leads to redemption, death to renewed life.

But there is a further connection between the two plays. Beyond a first appearance on the stage, 1946 Theatre Royal Bristol *Jenny Villiers* and 1957 Old Theatre London School of Economics *The Thirty-First of June*, neither flourished in the theatre so my father rewrote them as novels, published in 1947 and 1961 respectively. However in the case of *Jenny Villiers*, the novel was based on the original version of the play, as performed in Bristol, but he rewrote the play to produce the version printed here. But even that was not performed, because JBP refused permission for repertory productions while negotiations failed for possible

film versions. However it was serialised on *Woman's Hour* in 1949, and broadcast in *Saturday Night Theatre* in 1954, following a TV production in 1948.

The Thirty-First of June in turn was broadcast on *Afternoon Theatre* in 1983 and read as a *Book at Bedtime* in 2005. There was interest abroad especially in Russia. But it is still waiting to be performed. Interestingly both plays would benefit from the new technology in the Theatre, to present the effortless blending of time zones without obvious trickery, and of course they would work splendidly on film or television.

THE THIRTY-FIRST OF JUNE

Characters

(Leading characters in CAPS)

PERADORE CHARACTERS

PRINCESS MELICENT

KING MELIOT
her father

MALAGRAM
An old enchanter

Malgrim
another enchanter, nephew of above

Ninette
Lady-in-waiting to the Princess

Alison

Master Jarvie
Doctor at King Meliot's Court

Lamison
A musician

Grumet
A dwarf

First Soldier

Second Soldier

Herald

Some extras for end of Scene 4, Act 2.

LONDON CHARACTERS

SAM PENTY
An artist employed by the advertising agency

CAPTAIN PLUNKET
An adventurer

DIMMOCK ('D.D.')
Director of an advertising agency

BARMAID
At The Black Horse

Anne Dutton-Swift
An assistant to Dimmock

Philip Spencer-Smith
An assistant to Dimmock

Peggy
Dimmock's secretary

Dr Jarvis
Modern equivalent of Master Jarvie

Man
Regular customer at The Black Horse

Mrs Shiny
Important Housewife

Ted Gizzard
Trade Union Official

SCENES

(NOTE: This play can be done fairly simply, according to
the ingenuity of the director and the designer, against black
drapes, using screens to suggest walls and with the essential
minimum number of furnishings and props. Or comparatively
simple sets can be used – none of them a box set – and the
order of the scenes has been arranged to make the changes
easy. LARGE means that the essential parts of the set are
well upstage; MEDIUM that they are roughly about centre;
SMALL that they are downstage, leaving plenty of room for
changes behind them. ENTRANCE does not mean that a
practicable door is necessary, only that access to the stage
must be there. Right and Left are actors' R. and L..)

ACT ONE

Scene One: The Castle. MEDIUM. Walls suggested by
tapestry hangings. No doors or windows. Entrances R.
and L.. A very fat stone pillar a little downstage L.C.
for enchanters to make their magical appearances and
disappearances. A few stools to sit on. Rich warm lighting,
not too bright.

Scene Two: Dimmock's office. LARGE. Light and bright.
Desk at back. Suggested window back L.. Further down
L. a trick cupboard, with easy swinging doors for quick
entrances and exits, with two doors behind, showing
files and book backs, that are closed after exits to suggest
cupboard is solidly full. One entrance R. – if possible a
practicable door. A light chair behind desk, and possibly
two in front of it. Powerful noise effect of electric drill just
behind suggested window. Lighting should be clear, bright,
hard.

Scene Three: Castle, as before.

Scene Four: Private Bar of The Black Horse. MEDIUM or
SMALL. Counter and bar at back. Entrance R.. On wall
down L. a hinged advertising mirror – or similar device –
for magical exits. Warm and rather subdued lighting.

Scene Five: Dimmock's office, as before.

Scene Six: Castle, as before.

Scene Seven: Television Studio. SMALL. A backing with four chairs. Very hard bright light. One entrance R. or L..

Scene Eight: Dungeon in the Castle. SMALL. Entrance from back, preferably with suggestion of steps coming down. Only tiny acting area given any light.

ACT TWO

Scene One: Private Bar, as before.

Scene Two: Castle, as before, but some change in lighting.

Scene Three: Dungeon, as before exactly.

Scene Four: Pavilion at Tournament. MEDIUM. Suggesting a kind of marquee. Hangings for walls could be those of castle reversed. Entrance R. and at L. main entrance to Pavilion, with flaps that can be fastened. A bench or two or three stools. Lighting rather subdued with brilliant sunlight outside L. entrance, together with various noise effects there.

Scene Five: Interior tent. SMALL. Tiny and set well downstage. One entrance either L. or R. Bench. Subdued lighting as in Scene 4.

Scene Six: Dragon's Lair. LARGE. A glade, so some suggestions of foliage at back and R. and L. a bush or rock coming some way downstage centre. In front is smaller rock for sitting on. Entrance upstage R. At L., not visible from entrance R., is enormous dragon's head, with puffs of smoke coming out of its nostrils. Eyes are closed, but if possible they should be capable of being opened. Head is constructed so that it is easy for actor playing Dimmock to speak through it. Strong clear sunlight.

Scene Seven: Enchanters Dining Room. SMALL. Table just big enough to seat four, and four stools. One Entrance either R. or L.. Strong focussed light on table, not spilling.

Outside this a murky atmosphere. Table arranged for various trick effects.

Scene Eight: Wedding Banquet. LARGE. This should suggest the Castle on one side and Dimmock's office on the other, being a mixture of two worlds. Apparently a semi-circular table runs from downstage R. to upstage centre to downstage L.. (This can be suggested by a number of small tables with cloths over them. In R. half everything is medieval, the table crowded with immense prop. dishes and flagons etc. In L. half everything is modern and very meagre. Full company, either in medieval or modern costume, is seated behind table, with all chief characters upstage centre. Rich warm light. If seating is difficult, the people downstage at each side can be standing.

Act One

OVERTURE

A short overture is played in front of curtain or on two rostrums at each end of orchestral pit – with a medieval musician – or musicians – at one, and a modern musician – or musicians – at the other. The music must be written so that the saxophone and/or trombone of the moderns does not drown the lighter playing of the medieval musicians. The latter must include an apparent lute-player (this could be recorded if necessary) who when others have finished and gone off, begins playing again and, after curtain rises, walks into set and sits down, still playing. (NOTE: all succeeding scenes can be introduced like this, the medieval with medieval musician, the modern with modern musician, but in later scenes they do not go into the set and the action but merely until the scene is lit and action ready to start.)

SCENE ONE

Room in Castle of King Meliot of Peradore. A lute-player, whose name is LAMISON, continues playing, NINETTE and ALISON enter L.. They are dressed in bright medieval costumes. NINETTE is a sultry dangerous redhead. ALISON is a pretty-ish mousy girl, a familiar English type at all periods.

NINETTE: *(Crossly to LAMISON.)* Oh – do stop playing that boring old tune. Don't you know anything else?

ALISON: *(Reproachfully.)* You promised to learn *The Black Knight Hath My Heart*.

LAMISON mutters something inaudible, and stops playing, though remains sitting.

NINETTE: If Melicent brings that magic mirror with her, I'll ask to look into it.

ALISON: Oh – Ninette – dare you?

NINETTE: Yes. And anyhow, the magic mirror isn't hers, and it'll have to go back to that enchanter very soon – perhaps this morning.

ALISON: *(Sighing.)* Tapestry again, I suppose. And I'll have a headache. Why doesn't anything happen now, here in Peradore. My cousin Elaine's having a marvellous time in Camelot. Several fascinating enchanters, two giants and a dragon in the neighbourhood and three or four castles under spells, and Knights of the Round Table all over the place, rescuing everybody – lovely parties every night.

NINETTE: *(Fiercely.)* It's no use sighing and mooning. We must *make* things happen.

ALISON: *(Wistfully.)* You can't if you're a virtuous-damsel character like me.

NINETTE: Well, I'm *wicked* – thank goodness! Let me have the ghost of a chance and I'll make things happen.

Enter L. PRINCESS MELICENT, an exquisite girl. She is busy rubbing with a small piece of silk the magic mirror, which is about eighteen inches square, made of shining metal with a dark frame.

MELICENT: I'm *furious.* I've stared and stared but I can't see him this morning. And I'm sure he's still thinking about me. I *feel* he is. The magic can't be working.

NINETTE: Perhaps if I had a try –

MELICENT: Master Malgrim, the enchanter, only lent it to me.

NINETTE: Only just a quick peep to see if it's still working –

She almost takes it from MELICENT, stares into it, then gives a cry of annoyance and marches straight over to LAMISON and slaps his face.

You low impudent brute! And not even a *good* lute-player.

MELICENT: *(With dignity.)* You may go, Lamison. No music this morning.

He bows and goes off R..

16

NINETTE: *(Returning the mirror.)* It worked for me –

MELICENT: Yes, but Lamison was so near. Not like *him*, my one, who's far far away. It's *maddening* not being able to see him again. What day is it?

ALISON: Lunaday – the thirty-first of June. Lovely day too. Can't we go out?

MELICENT: No, our royal parent wishes to speak to me. It'll have to be tapestry.

NINETTE: Oh – not yet. You never told us what this knight was wearing.

MELICENT: *(Confidential, delighted.)* Well, he seemed to be wearing a kind of coat made of yellow wool over a white shirt. And I don't think he's a knight. Nor a squire. Some kind of artist, I think. *(Still more confidential.)* And this is a secret. His name's Sam.

NINETTE & ALISON: *(Together.)* Sam?

MELICENT: Sam. Isn't that sweet? Another thing I didn't tell you about him – he can blow smoke out of his mouth.

ALISON: *(Astounded.)* Like a dragon?

MELICENT: No, not a bit like a dragon. Not blowing *angrily* – but *nicely* –

NINETTE: Perhaps he's an enchanter –

MELICENT: No, he isn't. Just because your aunt was supposed to be a sorceress, Ninette, you've got sorcerers, wizards and enchanters on the brain –

Enter HERALD at R..

HERALD: *(Like a professional toastmaster.)* Noble Princess Melicent – ladies – I beg to announce His Royal Majesty, King Meliot of Peradore – High Lord of Bergamore, Marralore and Parlot – Overlord of Lancington, Low Moss and Three Bridges!

MELICENT: I think you overdo those places. Who cares about Low Moss and Three Bridges!

There is a loud flourish of trumpets outside door R.. The girls cover their ears and pull disgusted faces. The KING enters. He is a worried-looking middle-aged man with a fussy manner and staccato speech. He is wearing a light crown and untidy but gorgeous robes. The girls curtsy.

KING: Morning, Melicent! Morning, girls! Not started work yet? Tapestry production has gone down seventy-five per cent since we lost our dear Queen. Well now, we've just received a summons to attend a conference at Camelot –

The girls are at once eager and excited.

MELICENT: When do we go?

KING: You don't. Men only – not even queens invited. Defence problems. In any case Camelot these days isn't the place for young unmarried daughters. Queen Guenevere – charming woman of course – but – well –

MELICENT: Don't be absurd, father. We all know about her and Sir Lancelot –

KING: *(Suddenly angry, shouting.)* You don't. Nobody does. All damned nonsense!

MELICENT: Well, then, if it's nonsense, why can't –

KING: *(Cutting in, angrily.)* Don't try to argue, girl. You've no reason, no logic. Quiet now! We want to think. Why are we here? Oh yes – we want to take our dwarf, Grumet, to Camelot – what have you done with him?

MELICENT: Oh – father, darling – you can't take Grumet to Camelot again. He can't talk – and he's only got three boring tricks –

KING: Quite enough. And the one with the venison pasty was a remarkable success last time. Sir Pelleas offered us a master armourer for him. No, we must have Grumet! Where is he?

MELICENT: *(Hesitantly.)* I've sent him – to find somebody –

KING: Find somebody? Who? Where? Why?

MELICENT: Well, you remember Master Malgrim, the enchanter –

KING: Yes. New fella. Came with a letter from King Mark, wanting our patronage. Didn't take to him much? What about him?

MELICENT: He lent me a magic mirror. It shows you anybody who's thinking about you –

KING: Nonsense! You girls'll believe anything. Where is it?

MELICENT: *(Handing it to him.)* Here.

KING: *(Staring into it.)* Just as we thought. Our own face.

NINETTE: You have to stare hard, sire.

KING: *(Still looking.)* We *are* staring hard. Oh – but who's this? Looks like Sir Kay – who runs the palace at Camelot. Yes, and he's thinking about us.

MELICENT: All of us?

KING: No – kingly us – me. And – by George – he's deciding to put us into the same cold draughty apartment on the North side of the palace. But this time we won't have it. Here – take the thing *(Giving her the mirror.)* And what's it got to do with our dwarf? Didn't you say you sent him to find somebody?

MELICENT: *(Dreamily.)* Yesterday I looked in the mirror, and saw a man called Sam who was thinking about me. He was sweet.

KING: Sam? Never heard of him. But do you mean to say you sent our dwarf with a message to this rascal?

MELICENT: I asked Master Malgrim, the enchanter, to lend his magic aid so that Grumet the dwarf could find Sam. Because Sam's not in this realm, nor in any other known to us. Sam's not in what you'd call *real life* at all –

KING: *(Relieved, delighted.)* Oh – why didn't you say so? Been stuffing yourself with mythology, legends, fairy tales – eh? Very suitable – so long as you don't overdo it. Well – well – send the dwarf along –

MELICENT: But I can't, father. I told you, he's gone to find Sam.

KING: *(Angrily.)* You can't send a real dwarf to find somebody who isn't real –

MELICENT: I didn't say Sam wasn't real – of course he is –

KING: *(Shouting angrily.)* If she isn't in real life, then he isn't real. He's imaginary. All right then – send an imaginary dwarf to find him. But what the devil's the point of sending a real dwarf? No reason, no logic, no sense! You must be suffering from summer greensickness, girl. *(He goes to the door, shouting.)* Master Jarvie! Master Jarvie!

The physician enters and bows. He is a very solemn middle-aged man, dressed in the style of a medieval doctor. The KING talks as soon as he appears, in a rapid confidential manner.

Princess Melicent – not us. She says she sent Grumet the dwarf to find some fellow who doesn't exist in real life. Obviously got a touch of something.

MELICENT: *(Impatiently.)* Father, I'm perfectly well.

KING: Nonsense!

DR JARVIE: *(Approaching solemnly.)* Your Highness may feel perfectly well. But to be perfectly well – that is something very different. Permit me, your Highness.

KING: Keep still, child. For your own good.

The DOCTOR feels pulse, feels her forehead, pulls an eyelid down, and so forth, talking gravely as he proceeds.

DR JARVIE: *(With immense gravity.)* Um – um! The excellent balance of the four primary humours somewhat disturbed. The hot humours are not being sufficiently preserved in the blood by the thick, black and sour humours purged

from the spleen. Or as Galen tells us – the vital spirits formed in the heart are not being adequately checked by the natural spirits formed in the liver. Therefore, too quick release of the animal spirits formed in the brain – thus encouraging airy notions and phantasy –

KING: There you have it. Airy notions and phantasy. The very thing that's wrong. What physic do you recommend, good doctor?

DR JARVIE: *(With immense gravity.)* A pearl dissolved in vinegar mixed with powdered dragon's tooth, taken night and morning. Mummy paste and mandrake root in hot wine as a noon and evening posset. No venison nor pig puddings to be eaten. No scarlet to be worn. A bat's wing and a dried toad fastened beneath her shift until the new moon. And perhaps the thumb of a hanged man –

MELICENT: *(In horror.)* Never – never – never!

DR JARVIE: *(Condescendingly.)* Well, we may omit the thumb. But take the physic –

KING: We'll see she does. You may go Master Jarvie, and take our thanks with you.

(DR JARVIE bows and departs.) Melicent, you stay close here.

MELICENT: *(Dismayed.)* Oh – father – must I?

KING: You must. Lady Ninette – Mistress Alison – see to it – or we shall be severe with you. Grumet the dwarf, I'll be bound, is lying drunk somewhere in this castle. But if he should return here, send him to us at once.

MELICENT: But Master Malgrim swore he could send Grumet out of real life – to where Sam is –

KING: *(Briskly rather than angrily.)* Master Malgrim's a charlatan – Grumet's a dumb little tosspot – you're a sick brain-fevered day-dreaming damsel – and your Sam's a myth, a legend, a fairytale character, a romantic nothing. Now you know our commands, all of you – then obey 'em. And

21

get out your needles and threads. *We're* busy. *You* should
be busy. But – *(As he goes.)* Busy, busy, busy. *(As he opens
the door, calling.)* No trumpets! No trumpets! Made enough
noise this morning.

The three girls look at each other in dismay.

MELICENT: Oh – now *nothing's* going to happen.

ALISON: *(Sadly.)* Except tapestry.

NINETTE: Let's *make* something happen.

ALISON: What's the matter, Melicent darling?

MELICENT: *(Almost ready for tears.)* I'm falling in love with
Sam. And I don't know where he is – when he is – who he
is – and now I don't believe Grumet can ever find him.

*She runs out sobbing as the lights fade and we begin to hear the
saxophone and trombone start playing.*

SCENE TWO

*A room in the advertising agency of WALLABY, DIMMOCK, PALY and
TOOKS. Very modern type of office with a window and one door. Light
walls with large graphs etc. on them. Periodically from outside window is
the sound of a pneumatic drill. Through one door comes occasional sound
of a recorded singing commercial. Desk with phones, intercom etc., a few
light modern chairs, cupboard on left opposite door. Bright morning light.*

*DIMMOCK is discovered looking at sample layout with ANNE DUTTON
–SWIFT and PHILIP SPENCER-SMITH. DIMMOCK ("D.D.") is a
fat, worried middle-aged type with an American manner and a flat
Manchester accent. ANNE and PHILIP are very keen upper-class career
types, probably in their early thirties.*

DIMMOCK: *(After staring a moment or two.)* It doesn't do
anything to me. It won't do anything to the client. And it's
dead wrong for the Chunky Chat Public. Out!

PHILIP: Couldn't agree with you more, D.D.

ANNE: Public-wise it never looked good to me. Client-wise I'm
not sure, D.D.

DIMMOCK: I am. It's out. Dead wrong for Chunky Chat. What's next?

ANNE: Damosel Stockings. I'm madly keen about this. Could be a big account. They want to spread themselves in the glossies visual-wise. Romantic atmosphere. Sam Penty's working on it.

DIMMOCK: *(Into intercom.)* Peggy, ask Mr Penty to bring in what he's done for *Damosel* Stockings – sharp!

ANNE: What I feel – D.D. – is –

But the pneumatic drill starts. DIMMOCK takes the opportunity of swallowing two pills. ANNE goes on talking inaudibly. When drill stops.

Don't you agree?

DIMMOCK: Can't say. Never heard what you said with that dam' thing goin' again. *(To intercom.)* Peggy, send another letter of complaint about that drill.

Good morning, Sam

This is SAM who has just entered. He is quite different from these three, in every possible way. He need not be good-looking – but he has a slow easy charm of his own. He is carelessly dressed, is smoking a bent cherrywood pipe, and carries a portfolio.

SAM: Morning. Nice day.

DIMMOCK: I haven't noticed yet. Too much on my mind.

SAM: Ah! What's chiefly on my mind is that today is the thirty-first of June.

DIMMOCK: *(Astonished.)* Thirty-first of June?

ANNE: *(Laughing.)* Don't be an idiot, Sam. There isn't such a thing.

SAM: *(Unruffled.)* So everyone's been telling me. But I woke up feeling it was the thirty-first of June, and I can't get it out of my head.

DIMMOCK: Sam, why do you keep on working for us? I've often wondered.

SAM: *(Thoughtfully but easily.)* Because I'm a bad painter. Not your idea of a bad painter, but my idea of one. So I work for Wallaby, Dimmock, Paly and Tooks – and eat. By the way, who the hell's Tooks? Or did you, Wallaby and Paly invent him?

DIMMOCK: Tooks is our financial man.

PHIL: First-class fellow!

ANNE: Smart as paint.

DIMMOCK: That's right. And – between these four walls – a stinker. No, I oughtn't to have said that.

SAM: *(Now busy with his portfolio.)* It's the thirty-first of June. Well here we are – *(He takes out a picture in bright colours of MELICENT and puts it on a chair between desk and door.)* This is what I've done for *Damosel Stockings*. And I sat up until two this morning getting it right. Now just take it in before you start talking. *(As DIMMOCK and ANNE start staring at the picture, SAM takes PHIL to one side downstage, to speak to him confidentially.)* Phil, who's this dwarf in red-and-yellow doublet and hose who's wandering about here?

PHIL: *(Bewildered.)* Dwarf? I haven't seen a dwarf.

SAM: He's around.

PHIL: Somebody in the Art Department must be using him as a model.

SAM: He never speaks. Just looks in the door – grins – beckons – then vanishes.

PHIL: Sam, you're seeing things.

SAM: I hope so. But why a dwarf in red-and-yellow tights?

DIMMOCK: *(Slowly, pronouncing judgement.)* It's got something.

ANNE: Just what I was thinking, D.D.

DIMMOCK: *(Dubiously.)* On the other hand –

ANNE: Quite. The *Damosel* crowd are tough.

DIMMOCK: What do you think, Phil?

PHIL: *(Answering at once.)* Feel what you do, D.D. Yes and No.

DIMMOCK: Let's stop looking for a minute, then take it by surprise.

ANNE: Who was your model, Sam?

SAM: Didn't have one. Not in this world anyhow. It's a story, but I don't have to tell it.

DIMMOCK: Why not? Let's have a drink. The usual? *(Into intercom.)* Peggy, let's have four large gin and tonics.

The singing commercial is now heard again but it is soon drowned by the pneumatic drill on the other side.

DIMMOCK: *(When it has stopped.)* Nobody can say I'm not keen and sharp. I worry over the firm and the accounts sixteen hours a day. But now and again I wonder if we aren't all barmy. *(PEGGY, a pretty girl – probably ALISON – enters with four glasses of gin and tonic.)* Thanks, Peggy. Hand 'em round.

SAM: *(As he takes his.)* Thanks, Peggy. Have any of you girls seen a red-and-yellow dwarf about?

PEGGY: *(Seriously.)* No, Mr Penty. Have you lost one?

SAM: No. But I keep seeing one.

PEGGY goes out.

DIMMOCK: Seeing one *what*, Sam? *(He laughs.)* For a moment I thought you said a red-and-yellow dwarf.

SAM: I did. Well, here's to Wallaby, Dimmock, and Paly and possibly Tooks! *(As the others drink, he continues.)* Yesterday, when you gave me this *Damosel* job, I sat at my work table, thinking it over. Damosel – knights in armour – castles – King Arthur and the Round Table – dragons – quests – princesses in towers. You know. And then I saw a girl in a medieval costume – through a kind of illuminated little

frame – and she smiled at me. She stayed long enough for me to do a rough sketch. Then, twice later, when I was painting and wasn't sure about her colouring, she appeared again, very sensibly and charmingly, just when I needed her most.

ANNE: *(Teasingly.)* I see you're devoted to this girl, Sam.

SAM: Certainly. Above all others. This is the girl for me.

DIMMOCK: And all imagination!

SAM: I dare say, but what *is* imagination? Nobody tells us – at least nobody who *has* any imagination. And then, after sitting up half the night trying to re-capture the look of her, I woke up this morning feeling it was the thirty-first of June –

DIMMOCK: *(Cutting in, sharply.)* Sam, you know I'm your friend as well as one of your employers. Now will you do a little thing for me, as a favour?

SAM: Certainly.

DIMMOCK: Good enough. *(Into intercom.)* Is Dr Jarvis still with Mr Paly? He is? Then ask him to come and see me. *(To PHIL and ANNE.)* You two had better go before he comes. This is between Sam and me and the doctor. But – look, Anne – before you go – I've got some sample Damosel stockings somewhere – *(He rummages in his desk and then produces several pairs of very fine nylon stockings and gives them to her as he talks.)* Just drape a few of 'em over Sam's picture – so we can make sure it all hangs together – and one thing isn't cancelling out another – and so forth –

ANNE: *(As she begins to deal with the stockings.)* Damosel will buy this – if we decide on it – but I'll have to talk to them hard. Especially Maggie Rogers – she's got a vogue fixation. There!

PHIL: *(As they prepare to go.)* Anne duckie, I'm not mad about our Mum's Chum layout – Minnie and Jeff have fallen down on it – tell me what *you* think?

They go out, having finished their drinks. SAM and DIMMOCK look at each other.

SAM: But why a doctor?

DIMMOCK: A quick check-up – can't do any harm, can it? He's a first-class man. Consultant to the Healthovite Company, among other things. *(Enter DR JARVIS. He is exactly as he was in Scene One except that he is now in dark modern clothes.)* Hello, Dr Jarvis! This is Sam Penty, one of our best artists. And he's not getting his proper sleep – he's seeing things – girls and dwarfs – thinks today's the thirty-first of June –

DR JARVIS: *(Going nearer to him.)* Mr Penty, in my experience very few people indeed *are* perfectly well, although they may imagine they are. And you're probably an imaginative type –

DIMMOCK: He is, he is, doctor.

DR JARVIS: Now, Mr Penty, just relax. Allow me!

DIMMOCK: All for your own good, Sam.

DR JARVIS does exactly what he did before to MELICENT and speaks in exactly the same way.

DR JARVIS: An eidetic type – probably hyperthyroid – with an unstable metabolism involving both iodine and calcium deficits. May have been some recent effect of the adrenal cortex on the calcium metabolism antagonistic to the functioning of the parathyroid glands. Some possible kidney trouble – sleeplessness – overstimulation of the eidetic image-creating function – chiefly due to the parathyroid deficiency and a heightening of the thyroid function – so a definite thyroid-parathyroid imbalance – resulting in an apparent objectivisation of the imagery of the eidetic imagination – phantasy states – hallucinations –

DIMMOCK: That's it, doctor. Phantasy states and hallucinations. Just what Sam's suffering from. Now can't you give him something that'll put him right?

DR JARVIS: *(Exactly as in Scene One.)* I'll tell my chemist to send round some calcium and Vitamin D tablets to be taken three times a day. I'll have him make up a mixture with Hexamine, quinnic acid, and theobromine in it – to be taken twice a day. A bromide mixture, night and morning. Avoid an excess of alcohol and too many carbohydrates.

DIMMOCK: There you are, Sam! First-class, doctor! You went straight to the root of the trouble. Very grateful!

DR JARVIS: Glad to be of service. Good-morning, gentlemen. *(He goes out briskly.)*

DIMMOCK: He'll put things right. I'll bet in a day or two you're not seeing things.

SAM: I like seeing things.

DIMMOCK: But you know what can happen to people who see things other people don't see?

SAM: Yes – they're in the National Gallery.

DIMMOCK: I mean chaps who begin to think it's the thirty-first of June – you had me guessing there, for a minute, Sam – and chaps who start asking about red and yellow dwarfs in tights.

GRUMET the dwarf, who is dressed in red and yellow doublet and hose now enters quietly, not by the door but through the cupboard. DIMMOCK continues, without seeing him.

Even while your own commonsense tells you we don't have red and yellow dwarfs here – wouldn't know what to do with one if we had one – that it stands to reason that it's nothing but your imagination –

SAM: *(Checking him.)* Pst! *(He indicates GRUMET, who is now capering, grinning and pointing at SAM.)*

DIMMOCK: *(Thunderstruck.)* Hell's Bells!

(Shouting to GRUMET.) Here – you!

GRUMET, with a last mischievous flourish at SAM, grabs the picture and stockings, runs with them and dives clean through the cupboard and vanishes.

SAM: *(Angrily.)* He's taken my Damosel portrait! Hoy-hoy!

DIMMOCK: *(Moving, shouting.)* Stop him – stop him!

They fling wide the cupboard doors but now it appears solidly filled with large books, files etc. with of course no trace of GRUMET. DIMMOCK looks at SAM with dismay.

DIMMOCK: He couldn't have gone through there.

SAM: He could. He did. And I think he came in through this cupboard.

DIMMOCK: Stop it, Sam. You've got me going now.

Enter PHILIP and ANNE.

SAM: I'm now quitting these premises and don't propose to return today, which I'm still convinced is the thirty-first of June.

DIMMOCK: What – you're going home, Sam?

SAM: *(Firmly.)* I am going to my local – The Black Horse in Peacock Place – which should be opening about the time I arrive there. *(Moves towards door, then turns.)* And if I were you three, I'd pack up all pretence of work. *It's the wrong day. (Goes out.)*

ANNE: D.D. – you oughtn't to have let him go before we decided about the Damosel thing. Where's his picture? *(Looking round urgently.)* Look – D.D. – he must have taken it.

DIMMOCK: No, he didn't.

ANNE: *(Urgently.)* But – D.D. – it's not here. *Somebody* must have taken it.

PHIL: *(Grinning.)* Perhaps a red-and-yellow dwarf.

DIMMOCK: *(Into intercom.)* Peggy, bring me two aspirins and a glass of water.

ANNE: *(Severely.)* Stop clowning, Phil – this is business now. D.D. – *did* somebody take it?

DIMMOCK: *(Heavily and slowly.)* Yes. A red-and-yellow dwarf. He dived into the cupboard with it –

ANNE: *(Smiling reproachfully.)* Now – D.D. –

DIMMOCK: *(In a sudden fury, very loud.)* I tell you – a red and yellow dwarf came and ran away with it –

The pneumatic drill starts and DIMMOCK, trying vainly to shout above it, in his rage flings papers in the air and batters the top of his desk. Rapid fade out of both sound and sight. We hear the sound of the lute. Light picks up the lute-player, then we fade in the room in the Castle, as in Scene One.

SCENE THREE

Castle, as Scene One. LAMISON playing to MELICENT and NINETTE, who look very bored. LAMISON finishes his performance, gets up and bows.

MELICENT: Thank you, Lamison. Very nice – but we're just not in the mood. So you may go.

NINETTE: And try to learn *The Black Knight Hath My Heart*.

LAMISON goes out R., obviously saying rude things about NINETTE under his breath.

MELICENT: *(Peevishly.)* Who wants a black knight anyhow? Or any other colour, for that matter? I think knights are so *boring*. All that idiotic clattering and clashing and banging! All that buckling and unbuckling!

NINETTE: I ruined my nails helping to unbuckle Sir Maris, that day at the Astolat Tournament. And then he talked about nothing but heraldry for hours and hours until I could have screamed. What I'd like is an enchanter –

MELICENT: It's what we all want, Ninette dear.

NINETTE: No, I mean a professional, a properly qualified magician –

MELICENT: They're always so *old*.

NINETTE: A really clever one, if you insisted, could make himself appear any age you fancied.

MELICENT: Yes, but I'd still feel really he was old – and a bit smelly –

NINETTE: All you're thinking about is your Sam –

MELICENT: I know. And I keep telling myself not to. Yesterday was wonderful – but today – what is there?

NINETTE: We ought to *make* things happen.

MALGRIM: *(Appearing suddenly from behind pillar.)* With my assistance, I hope, ladies. At your service, most noble princess.

MELICENT: Master Malgrim – you're not supposed to make sudden appearances like that. It's not allowed. Ninette – this is Master Malgrim, the new sorcerer who came from King Mark. Lady Ninette. *(He bows and she smiles.)*

NINETTE: Master Malgrim, how did you do it?

He is a distinguished-looking, rather Mephistophelean oldish man with a grey moustache and imperial, magnificently gowned in the sorcerer style. His presence, voice, gestures are all in the grand manner.

MALGRIM: *(With affable condescension.)* I was invisible of course. A quick simple method most of us use now. Only very old-fashioned magicians and enchanters, these days, prefer to transform themselves. For example, my uncle, who insisted upon coming along, decided to enter the castle and make his way up here as a brown rat. Not here yet, I suppose? No? That proves my point – a risky, clumsy, slow method.

MELICENT: I hope he's not coming in here as a brown rat –

MALGRIM: He's apt to be mischievous – and too fond of showing off. His name's Marlagram, by the way. One of the old Merlin school.

NINETTE: *(Admiringly.)* I think you're marvellous, Master Malgrim.

MALGRIM: Professionally I have to be marvellous, of course. But if you meant it personally, I'm flattered and delighted. But now, Princess Melicent, I must ask for the return of my mirror. You have it here, I think? Allow me. *(He takes it.)* Please don't look so disappointed. Its power soon begins to fail if one person uses it frequently. You must have noticed that.

MELICENT: *(Delighted.)* Then perhaps Sam *has* been thinking about me today. And the wretched mirror just wouldn't let me see him. But where's Grumet the dwarf? And did he find Sam? Tell me – quick – Master Malgrim –

MALGRIM: *(Shrugging.)* You go too fast, noble princess. Remember – I was refused an appointment as Court Magician and Official Enchanter to the Kingdom of Peradore. Meanwhile, thanks to my powerful and extremely skilful aid, Grumet the dwarf has now returned, carrying strange beautiful gifts –

MELICENT: *(Excited.)* From Sam? Oh – heavenly! Where *is* Grumet?

MALGRIM: *(With smooth irony.)* Ah – where indeed? No doubt one of your official Court enchanters –

MELICENT: *(Cutting in, crossly.)* You know very well we haven't any now.

NINETTE: You see, Melicent dear, you just can't afford to be high-and-mighty with him. He's *much* too clever. *(She smiles invitingly at MALGRIM, who smiles and bows.)*

MELICENT: What do I have to do then, Master Malgrim?

MALGRIM: Years ago, when your father was a young knight, Merlin gave him a gold brooch. If I could steal it, I would. But no gift of Merlin's can be stolen. You or your father, of your own free will, must hand it over to me. Give me your promise that this shall be done, and I will help you to your heart's desire. But first, before you can even see the dwarf and the gifts he brings, I must have your solemn promise.

As she hesitates, MARLAGRAM's voice is clearly heard.

MARLAGRAM: *(Not visible yet.)* Don't do it! Don't do it! No solemn promises!

MARLAGRAM comes out of the pillar. The girls scream with fright and MALGRIM looks furious. MARLAGRAM is like his nephew, but very much older-looking, with a much longer beard, and smaller, bent and shabbier. He is, however, very spry, full of diabolical sort of energy, and darts about, cackling and muttering, a very lively old magician indeed. His cackling 'he-he-he!' is unmistakeable.

MALGRIM: *(With cold disgust.)* My uncle – Master Marlagram –

MARLAGRAM: Don't trouble to tell me who they are, nephew. I know, I know, I know – he-he-he! *(He points, then goes nearer to each as he speaks.)* Princess Melicent – and a nice, ripe, tasty piece o' damselry too – and if I were only a hundred again you'd get no Sam through me – I'd attend to you myself – he-he-he!

MELICENT: *(Not unpleasantly.)* I think you're a disgusting old man.

MARLAGRAM: *(Cheerfully.)* You're quite right – I am. But I'm also very very very very clever – as you'll soon find out. He-he-he! *(Pointing at NINETTE.)* Lady Ninette – here's a wicked wench – oh a mischievous piece o' saucy goods, you are – oh what a hanky-panky, hocus-pocus, lawdy-bawdy future you have, girl!

NINETTE: *(Coolly.)* I can take it.

MARLAGRAM: *(Capering about.)* And it's all on its way – lawdy-bawdy, hocus-pocus, hanky-panky – he-he-he!

MALGRIM: *(Coldly.)* Showing off. It never stops. So tasteless and tedious. Brings discredit to our whole profession. *(To his uncle, triumphantly.)* I told you I'd be here first. Beat you by at least ten minutes.

MARLAGRAM: Fiddle-de-dee-sticks, boy! I'd a bit o' rogueish business to attend to down below. *(To MELICENT.)* See what he's up to, my dear? Trying to make you believe his

old uncle's out-of-date. But I know a lot o' tricks he's never learnt yet. I was serving my time with Merlin before this fellow was born. You're waiting for Grumet the dwarf, aren't you?

MELICENT: *(Eagerly.)* Yes. Where is he?

MALGRIM: He'll be here as soon as I have your promise –

MARLAGRAM: Don't believe him, don't believe him, my dear. He can't produce the dwarf. I've seen to that.

MALGRIM: *(Angrily.)* Uncle, this is intolerable. I warned you not to interfere –

MARLAGRAM: He-he-he!

MALGRIM: *(Angrily.)* You ask for a trial of strength, you foolish old man –

MARLAGRAM: He-he-he! Yes, a sporting contest – one round only – winner takes the princess to Sam – he-he-he!

MALGRIM: *(Drawing himself up, impressively.)* So be it. Now – *I command you* –

Stage rapidly darkens. The girls give little cries of alarm and shrink from the two magicians, who are glaring at each other.

MARLAGRAM: Go on, boy. Command away! He-he-he!

MALGRIM: *(Terribly, in some magic language.) Vartha gracka – Marlagram – oh terrarma vava marvagrista Demogorgon!* –

There is a growl of thunder and a flash of lightning.

MARLAGRAM: *(Magnificently now, in the same style.)* Vartha gracka – Malgrim – oh terramarveena groodumagisterra Beelzebub.

There is a terrific crack of thunder and then a flash of lightning that is a thunderflash actually on the stage. The girls scream. As the smoke clears and the lights come up, it is seen that MALGRIM has vanished. [He goes behind the pillar.] The girls come out of their terrified huddle, staring at MARLAGRAM, who is grinning and chuckling. Lightning as before.

MARLAGRAM: All over. No need to be frightened, my dears. He's gone – and serve him right. Too conceited – and no proper respect for his elders.

MELICENT: *(Recovering, but still rather dazed.)* But – what's happened – I don't understand, Master Marlagram –

MARLAGRAM: Very simple, my dear. I'm looking after you now. And I make no conditions – don't ask for any solemn promises – notice that. You trust me, I'll trust you. The good old-fashioned style. If it's this Sam you want, then I'll take you to him wherever he is. But first you want to see the dwarf, don't you. Of course you do. *(He calls.)* Grumet – Grumet – Grumet – come, boy – come, boy – come, boy!

There is a sound like a whistling wind, and then GRUMET is there, carrying the portrait and the stockings, grinning away.

MELICENT: *(Excited and delighted.)* Oh – Grumet – did you see him? What have you brought? *(As he hands over the portrait first.)* Is this the picture of me that Sam painted? Oh – look – look! Isn't it wonderful?

NINETTE: *(As they look, coldly.)* The nose isn't right.

MELICENT: *(Indignantly.)* Of course it is – you're only jealous. The nose is *perfect*. It's a marvellous portrait of me. *(GRUMET now offers her the stockings, grinning.)* What are these? Stockings? *(Displaying them with tremendous excitement.)* Look at them – look – look –

NINETTE: *(Excitedly.)* They're so – so – *sheer*. It must be an enchantment.

MELICENT: *(Excitedly.)* I must try them on.

NINETTE: What about me?

MELICENT: No, Ninette – not while you're feeling so jealous.

MARLAGRAM: Stop! You wish to see this Sam –

MELICENT: Of course – you said you'd take me to him –

MARLAGRAM: Then get ready. We start in an hour. No sooner, no later. I've an hour's work to do before we can find this Sam. He isn't round the corner, y'know – at least not what *you'd* call round the corner – neither in space nor in time. So I need an hour to work it out. Then we'll go – he-he-he! Grumet, stay here, boy. Now, I'm off –

The whistling wind sound as before. He runs out as fast as he can go. The wind sound fades out.

MELICENT: I'm sorry, Ninette, but you'll have to stay here – you've never been really sympathetic about Sam – so I feel I ought to leave you out of this.

She goes out L. hurrying. NINETTE looks disgustingly at GRUMET, who is squatting.

NINETTE: If only you could talk, you stupid little thing. Is it really hard to find this Sam person? *(The dwarf emphatically nods a 'Yes'.)* Can't be done without magic, I suppose? *(The dwarf shakes a vigorous 'No'.)* Not that I want him of course – I think the whole thing's ridiculous – but I refuse to be treated like this without doing *something*. I'm not going to be left out of everything as if I didn't count at all. If only Master Malgrim hadn't been so easily defeated –

MALGRIM: *(Stepping out of the pillar, coolly.)* No, Lady Ninette, I must correct you there. Actually it was a near thing. The truth is, my uncle – who, after all, is a cunning old hand – had prepared himself for that little contest – and I hadn't. Now it's my move.

NINETTE: *(Eagerly.)* No – ours? Can't *I* do something?

MALGRIM: *(Confidentially.)* You can. As soon as the princess leaves with my uncle, be prepared to receive Sam –

NINETTE: Sam? But they're going to find him –

MALGRIM: Yes, but they won't find him. Because I shall find him first. And bring him here while they're still looking for him there.

NINETTE: *(With enthusiasm.)* Master Malgrim, I adore you.

MALGRIM: Lady Ninette – again I'm flattered, delighted. *(Commandingly.)* Grumet, come here. *(Dwarf does. MALGRIM stares at him intently.)* I must read your mind, manikin.

We hear, a long way off but coming nearer, the sound of saxophone and trombone. MALGRIM lifts an arm commandingly. We hear the noise of the whistling wind.

Lady Ninette, remember what you must do. Dwarf, we go together.

As light goes, MALGRIM rushes GRUMET into the pillar, the wind noise rises. Saxophone and trombone are much louder. Light comes on the two players, who are like a pair of street musicians.

SCENE FOUR

Private bar of The Black Horse. Music can be heard playing outside, then going away. BARMAID behind bar, and a very dreary middle-aged man standing at bar. They begin talking as music fades out.

BARMAID: *(Colourlessly.)* No, he came in 'ere Tuesday, Mr Sanderson did.

MAN: *(Drearily.)* He told me Wednesday.

BARMAID: Might 'ave bin Wednesday – but I'd 'ave said Tuesday.

MAN: He could 'ave made a mistake when he said it was Wednesday.

BARMAID: That's ri'. *(A pause.)* But I might be wrong when I say it was Tuesday, mightn't I?

MAN: That's ri'.

SAM enters, dressed as before.

SAM: *(Who seems very lively after these two.)* Good-morning! Good-morning!

BARMAID: *(Lifelessly.)* 'Mornin'. Turned out nice again.

SAM: It has. Double gin and a glass of mild, please. *(As she turns to serve him, he looks at the MAN.)* In fact, I don't remember a nicer thirty-first of June, do you?

MAN: No, I don't. *(Then, feeling uneasy, he takes out a pocketbook, clearly to consult the calendar, looking suspiciously from it to SAM, who is now receiving and paying for his drinks.)*

SAM: *(To BARMAID.)* Thank you! And how are – er – things?

BARMAID: Quiet. *(To MAN.)* But I'd say it was Tuesday Mr Sanderson came in 'ere.

MAN: I don't say it wasn't, but Wednesday he told me.

BARMAID: That's ri'. But that could 'ave bin 'is mistake, couldn't it?

MAN: It could. But you could be wrong when you say it was Tuesday, couldn't you?

BARMAID: That's ri'! Could 'ave bin Wednesday like you say.

MAN: *(Gloomily.)* If it wasn't Tuesday. Well, I must be getting along. *Oh – reservoir!*

BARMAID: *(Gloomily.)* Ta-ta for now!

SAM: *(Cheerfully.)* Goodbye!

MAN goes out. SAM swallows the gin and then tastes the beer.

BARMAID: *(Very slowly and sadly.)* Been quiet all week.

SAM: *(Humourously.)* What about when Mr Sanderson was in here?

BARMAID: You mean Tuesday?

SAM: Yes, yes –

BARMAID: *(Thoughtfully.)* Or Wednesday.

SAM: Yes, yes, yes.

BARMAID: Do you know Mr Sanderson?

SAM: No, I don't.

BARMAID: Neither do I. Don't know 'oo the 'ell 'e is – an' don't care neither.

Enter CAPTAIN PLUNKET. He is a jaunty type of middle-aged man, with the complexion and style of a very hard drinker. He has a loud voice and is rather tight.

CAPT. P.: *(Shouting.)* 'Morning, 'morning. Two double Scotches, dear – like lightning. *(Turns to SAM as BARMAID begins to get drinks.)* What will you have, sir?

SAM: Nothing just now, thanks. *(Indicating his glass.)* Got one.

CAPT. P.: Ever done a deal in flat-bottomed boats?

SAM: No.

CAPT. P.: Then don't. It's hell. I've been plastered since the end of April – mostly in Cornwall. Hate the bloody place. You've heard of me – Cap'n Plunket?

SAM: No, I don't think so.

CAPT. P.: 'Course you have. Remember that film I introduced – all about the fish that climbs a tree. Same man. Pat Plunket – the Old Skipper. Turn up anywhere, everywhere. 'Here's good old Skip Plunket,' they all say. Thank you dear. Keep the change.

He has thrown a ten shilling note on the bar counter, and now he downs one of the doubles at a gulp.

SAM: Who *are* all these people who all say 'Good old Skip. Plunket'?

CAPT. P.: *(Triumphantly.)* There you are, dear. What did I say? He knew me all right. Everybody does. What's the date?

SAM: Thirty-first of June.

CAPT. P.: And about time too. Ought to be in Genoa now. I've got eighty cases of damaged custard powder there. Bought 'em off a fella in Barcelona. He was plastered. So was I. What the hell can you do with damaged custard powder?

SAM: *(Thoughtfully.)* Turn it into damaged custard, I suppose. You'd need an advertising campaign – for the new flavour. Try Mr Dimmock of Wallaby, Dimmock, Paly and Tooks. Ignore Tooks.

CAPT. P.: Thanks for the tip, old boy. How'd you feel about a half-share in a disused Portuguese light-house?

SAM: It would have to be the top half – and very cheap.

CAPT. P.: Drop me a line week after next. Care of the Albanian Sports Club, Old Compton Street. Know it?

SAM: No.

CAPT. P.: Filthy hole. What did you say your name was?

SAM: I didn't. But it's Penty – Sam Penty.

CAPT. P.: Of course. Knew your brother in Nairobi.

SAM: I haven't got a brother.

CAPT. P.: It was somebody else then. But it just shows you what a damned small world we live in. *(To BARMAID.)* Where's the telephone, dear? *(Swallows drink.)*

BARMAID: In the passage, back of the Saloon. You'll have to go out, then in again.

CAPT. P.: Anybody know the number of the Panamanian Legation? No? Never mind. *(Goes to door, then turns.)* What do you think about this deal? I've a third share in an electric band arriving from Venezuela next Thursday. Now a fella I met in Polperro night before last – he was a bit plastered – offered me in exchange a thirty percent holding in a pilchard canning company. You're a keen fella. What do *you* feel?

SAM: I must give it some thought, Captain Plunket. By the way, what would *you* feel if you kept seeing a dwarf in red and yellow doublet and hose?

CAPT. P.: *(Not surprised.)* Oh – he's looking for you, is he?

SAM: *(Staggered.)* Do you mean he's *here*?

CAPT. P.: Outside a minute ago, old boy. Shan't be long. Don't go.

He goes out. SAM looks at the BARMAID, who looks vacantly at nothing.

SAM: *(After a moment or two.)* Quiet, isn't it?

BARMAID: That's ri'.

After a moment GRUMET looks in, sees SAM and recognises him, grinning broadly. SAM now sees him, gives a start and an exclamation. GRUMET disappears.

SAM: *(Excitedly.)* Did *you* see a dwarf in red and yellow?

BARMAID: No. Saw the door blow open, that's all.

SAM: *(With a sigh.)* A double gin and a pint of mild, please?

BARMAID: *(As she gets drinks.)* You think I'm stupid, don't you?

SAM: *(Taken by surprise.)* Well – not exactly – no. But – er –

BARMAID: Of course you do. Well, let me tell *you* something. If I didn't make myself stupid on this job, in a week I'd be round the bloody bend. That'll be four and ten.

As he pays and takes drinks MALGRIM enters. He is exactly as before except he is in modern clothes, of a cut and style that suggests an elderly performer. In fact, he looks like an older conjurer in the grand style.

MALGRIM: *(Smiling.)* Good morning, Sam!

SAM: *(Surprised.)* Oh – hello! – Let's see – did we meet you at one of Natasha's parties – theatrical types – Not an illusionist, are you?

MALGRIM: How clever of you, Sam. That is exactly what I am. Malgrim is the name. *(To the BARMAID.)* I will have that bottle there – the green one –

BARMAID: The creem de men-thy? But not the whole bottle?

MALGRIM: If you please. And the tankard. *(Pointing.)* You want money of course – *(He produces a vast wad of notes and throws it down.)*

BARMAID: 'Ere, steady on!

MALGRIM: Don't keep them long, that's all. They'll be dead
leaves soon. *(He now begins emptying the crème-de-menthe
bottle into the tankard, to the astonishment of the other two.)* But
they won't change while it's still the thirty-first.

SAM: The thirty-first, eh? Did you see a dwarf out there?

MALGRIM: I did. Grumet's his name. He's in my employment
for the time being.

SAM: *(Indignantly.)* He ran away with my painting.

MALGRIM: Ah – yes – the portrait of Princess Melicent. Well,
she's seen it – she's delighted with it – and is longing to
make your acquaintance, Sam. That's why I'm here. *(Raises
the tankard.)* My respects and good wishes, Sam. *(To the
astonishment of the other two, he drains it slowly.)*

BARMAID: *(Alarmed.)* Stop him – 'e'll be unconscious in a
minute. A whole bottle of creem-de-menthy!

MALGRIM: *(Smiling as he puts down tankard.)* Very refreshing.
Now Sam – I want to keep our talk free from any
professional pedantry, if I can – but how familiar are you
with the problems of higher space?

SAM: Not at all. Who's Princess Melicent?

MALGRIM: Suppose we assume a universe of six dimensions.
The first three are length, breadth and thickness. The next
three might be called – first, the sphere of attention and
material action; second, the sphere of memory; third, the
sphere of imagination.

SAM: What do you mean when you say you're here because
this princess wants to make my acquaintance?

MALGRIM: Whatever is imagined must exist somewhere in the
universe. Now you probably think Princess Melicent is an
imaginary figure –

SAM: I do and I don't.

MALGRIM: Quite right. Because of course she is and she isn't. And while she knows that she herself is in real life, she feels that you must be outside it – as of course I do.

SAM: *(Rather indignantly.)* You mean you don't call this real life?

MALGRIM: Of course not. A horrible confused botch of dreams, nightmares, phantasies, and mixed partial enchantments. But of course it exists, just as you exist in it – and you too of course, my dear – *(To BARMAID.)*

BARMAID: Much obliged. I was getting worried.

SAM: Where does my painting come in?

MALGRIM: It doesn't yet. I'm now explaining how it's possible to move – once you know the trick – from our world to yours, yours to ours. I leave real life for imaginary life and meet you. When you go back with me, as you will do shortly, then *you* leave real life for imaginary life, to meet the princess. Which is real, which is imaginary, depends on the position of the observer. It could truthfully be said that both are real, both are imaginary.

SAM: What about the dwarf – which is he?

MALGRIM: Not quite either at the moment – I've sent him home.

Enter CAPTAIN PLUNKET, as before.

BARMAID: *He's* back. That's all we needed.

CAPT. P.: Two double Scotches, dear. What about you two?

SAM: No thanks. Got one. Captain Plunket – Mr Malgrim – the illusionist –

CAPT. P.: Of course. Couldn't place you for a moment. Seen you at the Savage Club. Remember you at the old Holborn Empire, too. Wonderful act. *(To BARMAID as she produces drinks, tossing ten shilling note again.)* Thank you, dear. Keep the change. *(Drinks.)*

SAM: You sent the dwarf home? Where's that?

MALGRIM: The Kingdom of Peradore.

CAPT. P.: Don't know it – but knew a fellow called Peradore. He'd six fingers on each hand. Never kept his hands still, though. Fellas nearly went barmy trying to count his fingers.

SAM: *(To MALGRIM.)* Peradore? Sounds to me like something out of Arthurian legends. So how can anybody *go* there?

MALGRIM: *(Smoothly.)* In the third sphere are parallel times, diverging and converging times, and times spirally intertwined.

CAPT. P.: It just shows you. And talking of times, I can put you on to a fella who has four gross of Swiss watches in the spare tank of his motor yacht. Daren't land 'em. He's hot as a stove. *(Drains his other glass.)* Let's have a spot of lunch. Troc or somewhere. On me.

MALGRIM: *(Gravely.)* Sam and I must go to Peradore.

CAPT. P.: Been closed for years, old boy, if it's the place I think you mean. Anyhow, you wouldn't try and ditch Good Old Skip Plunket, would you?

MALGRIM: Yes.

CAPT. P.: *(Linking himself with SAM.)* Can't be done, old boy. Sam and I are up to our necks in a custard powder deal and a Portuguese lighthouse. If you want to try the old Peradore, I'm game, though ten to one we'll end up in the Troc, but where Sam goes – I go.

MALGRIM: *(Sharply.)* Then take the consequences.

CAPT. P.: Old Skip Plunket is always ready –

MALGRIM: *(Commandingly.)* Silence!

He waves his hand and the stage darkens. A lute is heard faintly. He waves a hand at the panelled wall, which opens. MALGRIM stands at the opening, waving them in.

Gentlemen – welcome to Peradore!

We hear the rushing wind sound as all three move in, the light fades here, the panelling is closed, and light comes up in the private bar. The BARMAID, who has fainted across bar counter, now slowly recovers. ANNE DUTTON-SWIFT and PHILIP SPENCER-SMITH, both keen and brisk, enter.

ANNE: *(Brightly.)* Good-morning!

PHILIP: *(Brightly.)* Good-morning!

BARMAID: *(Faintly, with an effort.)* 'Morning. Turned-out – nice – again –

ANNE: *(Smiling, brightly.)* We're looking for a friend of ours –

PHILIP: *(Same.)* He said he was coming along here –

ANNE: Mr Sam Penty.

PHILIP: Have you seen him this morning?

BARMAID: *(With an effort.)* Yes. 'E's bin in.

PHILIP: *(Brightly.)* Oh – jolly good!

ANNE: *(Brightly.)* But what's happened to him?

BARMAID: *(Faintly, with an effort.)* Come closer. Just 'ad a nasty turn.

PHILIP: *(Brightly, closer.)* Oh – rotten luck!

ANNE: *(Closer.)* Don't force yourself.

BARMAID: *(As before.)* I'll 'ave to. 'Im an' two other crackpots went off together – something about a princess – in a Portuguese lighthouse – with six fingers for Swiss watches –

PHILIP: Sorry, but you're not making this awfully clear –

ANNE: But don't worry – just tell us *where* they went –

BARMAID: *(Pointing feebly at panelling.)* Through the wall.

She collapses as light fades and we hear the sound of the electric drill again.

SCENE FIVE

Room in advertising agency again. As before. Pneumatic drill is still heard. DIMMOCK is discovered trying to talk at telephone. He has a glass of milk and some sandwiches at his elbow. He looks very worried.

DIMMOCK: *(Into telephone, shouting above drill.)* ...They showed me a lay-out this morning – but I said it wasn't good enough – dead wrong for your products – not properly aimed at the Chunky Chat public – I say – *(Here the drill stops abruptly, so he goes on shouting.)* Not properly aimed at your Chunky Chat public... I'm sorry – there's a damned drill keeps starting up here... Well, we'll try to have something to show you by the end of the week – 'Bye.

Puts down telephone. Drinks a little milk and begins nibbling sandwich, all in an abstracted worried way. After a moment or two, a large brown rat pops out of the cupboard, far enough to be seen but keeping close. Then, as DIMMOCK sees it and rises in horror, we hear the sound of MARLAGRAM's 'he-he-he' laugh. Furious, DIMMOCK hurls a notebook or pad at it and misses. We hear the 'he-he-he' again, and rat goes back into the cupboard.

DIMMOCK: *(Into intercom, controlling his fury.)* Peggy, come in. *(He stands up again, tries to eat more sandwich but finds it distasteful, perhaps tries another. PEGGY enters.)* Peggy, we've got rats here.

PEGGY: I've tried to tell you that, Mr Dimmock. I could name two of them – downright disloyal to the firm –

DIMMOCK: No, I mean real rats. I've just seen one. Came out of that cupboard. A big fat brown rat – cheeky as hell. He stood there – laughing at me. What do you think of that?

PEGGY: *(Earnestly.)* I think you ought to go home, Mr Dimmock.

DIMMOCK: Go home? What are you talking about?

PEGGY: *(Pleading.)* Mr Dimmock, your health comes first. Business isn't everything. Wouldn't you like me to send for the car and then ring up Mrs Dimmock?

DIMMOCK: *(Angrily.)* No, I wouldn't. Just because I saw a rat!

PEGGY: Not just the rat. You said you saw a dwarf –

DIMMOCK: Well, I *did* see a dwarf. Now, you get on with your
work, Peggy, and let me get on with mine. *(As she goes.)*
And tell 'em next time I don't want sandwiches that taste
like sawdust.

PEGGY: *(Turning at door, reproachfully.)* Oh – Mr Dimmock – it's
not the sandwiches – it's *you* –

*When she goes, he opens the cupboard cautiously. It is solidly filled
with big books, files etc. as before. He stares at it thoughtfully, closes
doors, then walks slowly away, and, turned away from the cupboard,
tries his sandwiches and milk again. Out of the cupboard comes
MELICENT, looking very beautiful, expectant, gay, in a costume we
have not seen before. DIMMOCK turns and sees her and is astonished.*

DIMMOCK: Now what's this?

MELICENT: *(Smiling sweetly.)* It's me. Who are you?

DIMMOCK: Seeing this is my room, I ought to be asking
you that. However, as you're new – I'll tell you. I'm Mr
Dimmock, one of the directors here. And though you look
very nice, my dear, you must understand we can't have
models in costume roaming about just as they like.

MELICENT: I'm looking for Sam.

DIMMOCK: Oh – the *Damosel Stockings* job. Well, Sam *was*
here, then he went off. But I sent Anne Dutton-Swift and
Philip Spencer-Smith to bring him back, so he oughtn't to
be long. As soon as he comes, you'd better pose for him
again.

MELICENT: I think I love Sam.

DIMMOCK: You're not the first, so take it easy. What's your
name, dear?

MELICENT: I am Princess Melicent –

DIMMOCK: Doesn't surprise me. We'd the granddaughter of
a Russian Grandduchess working for us, last year. *And* an

Italian *contessa.* Make good models too – you aristocratic
girls – it's the training, I suppose.

*But the drill starts up for a few moments. She is terrified and puts
her hands to her ears.*

DIMMOCK: *(When it stops.)* I ought to have warned you, dear.
It's only that pneumatic drill –

MELICENT: *(Reproachfully.)* Why do you have such terrible
things? We don't have them in real life –

DIMMOCK: In what?

MELICENT: In real life. Have you seen Master Marlagram the
enchanter?

DIMMOCK: Never heard of him. Believe it or not, what I *have*
seen is a large brown rat that went *he-he-he* or I'm barmy.

MELICENT: *(Relieved.)* That's Master Marlagram. He said he'd
transform himself before he saw you.

DIMMOCK: *(In despair.)* We're off again. Hold it, dear.
(Into intercom.) Peggy, I want you in here – sharp. *(To
MELICENT.)* When my secretary comes in, just tell her what
you've just told me. She thinks I ought to go home and lie
down.

MELICENT: *(Sympathetically.)* Because you have a sickness,
poor man? *(She goes to him, looking at him closely.)* You have
a kind face – but it is sad. I think you may have a sickness.

*She puts a hand on DIMMOCK's forehead. He accepts the attention
with a kind of fatuous approval. PEGGY enters and does not like
this business.*

PEGGY: *(Acidly.)* Oh – I'll come back later. I didn't know you
were busy.

DIMMOCK: *(Bluffly.)* No – no – that's all right. Peggy – this is –
er – Princess Melicent – who's been sitting for Sam. Now,
Princess, you just tell Peggy what you told me – about
Master Who's-it –

MELICENT: *(Staring at PEGGY.)* Alison! How did *you* come here?

PEGGY: How did *you* know my other name's Alison? Oh – you must be the girl my cousin Audrey mentioned to me. But you oughtn't have come in here. Oh – I suppose you haven't a compact –

MELICENT: *(Bewildered.)* A compact?

PEGGY: *(Producing one.)* You know. Like this. *(She opens the compact and brings out powder puff and lipstick.)*

MELICENT: *(In ecstasy.)* Oh – how wonderful! Better than anything in real life. I must have one of these before Sam gets back –

PEGGY: I'll show you where we girls go –

Takes her out briskly, leaving DIMMOCK bewildered. He takes a flask out of desk and pours some of the spirit it contains into his glass of milk. He is sipping this when ANNE and PHILIP march in.

DIMMOCK: Did you get Sam?

PHILIP: No. We went to The Black Horse and found a mad barmaid there –

ANNE: *(Giggling.)* She said Sam had gone through the wall –

PHILIP: *(Laughing.)* To find a princess in a Portuguese lighthouse –

ANNE: It's true, D.D., we're not making it up –

DIMMOCK: Well, his model's here – all dressed up – very good-looking girl too. Says she's a princess – *(Telephone rings. DIMMOCK answers it.)* Dimmock speaking… Spencer-Smith? Hang on a minute – *(As he holds receiver for PHILIP.)* Television people for you – flapping again –

PHILIP: Spencer-Smith here. Yes?… She's *what?* …Well, I warned you to have some other girl lined up –

MELICENT enters now. PHILIP sees her.

I know, I know – but now you're asking me at the last minute... All right, I'll bring somebody.

(Puts down receiver, looks at DIMMOCK.) Look – D.D. – I'm in a jam. Can I take this model of Sam's? *(He turns to MELICENT.)* Lovely little job on the telly, dear – um?

MELICENT: What are you saying?

PHILIP: No time to stop and explain, dear. Do it on the way.

MELICENT: Will I see Sam?

PHILIP: Don't think so – but he might see and hear *you* –

He takes her off with him. But MELICENT turns at door to address DIMMOCK.

MELICENT: If Master Marlagram the enchanter comes back, tell him what has happened to me. And don't think you can't talk to him because he looks like a brown rat. *(She goes. ANNE is staring at DIMMOCK.)*

ANNE: D.D.? *What* did that girl say?

DIMMOCK: *(In a kind of controlled fury.)* Can't you understand a perfectly simple request, Anne. She said I must talk to Master Marlagram the enchanter even if he looks like a brown rat. *(Shouting.)* And don't start arguing about it. Just leave it.

ANNE: All right. But where did that girl come from?

DIMMOCK: Out of the cupboard. *(As ANNE is about to say something, he shouts.)* I said 'Leave it, leave it!' *(He now notices something on his desk. It is a large calendar.)* Now who did that? *(He turns it round and we see it shows, in large clear lettering, JUNE 31ST. Now PEGGY enters.)*

PEGGY: Mrs Dimmock's coming to take you home. And Dr Jarvis is on his way to see you.

DIMMOCK: *(In despair.)* Oh – Christmas crackers! *(The telephone rings. He picks it up.)* Yes, Dimmock here. *Mummy's Joy Products?* I'm sick of hearing about that muck of yours. Goodbye. *(He slams the receiver.)*

ANNE: *(Alarmed.)* D.D. – have a heart – it's one of our best
accounts!

PEGGY: He's not himself, Miss Dutton-Swift.

DIMMOCK: *(About to explode.)* Oh – Jiminy Jorkins! – there
must be some way out of all this. *(He glares round in despair.
Telephone rings again.)* You take it, Peggy.

ANNE: *(As PEGGY takes telephone.)* But honestly D.D. – we'll
have to explain to *Mummy's Joy Products* –

PEGGY: *(Cutting in, primly.)* It's Master Marlagram, an
enchanter – and he says 'Try the cupboard'.

DIMMOCK: *(Desperately.)* All right. I will.

He dives clean through the cupboard.

PEGGY: *(Wildly.)* After him – after him! We can't let him go –
like that – come on –

*She hurries down and dives through the cupboard. ANNE follows her
just as DR JARVIS enters hurriedly.*

DR JARVIS: *(Importantly, as he enters.)* Now – then – Mr
Dimmock – what's this I hear? –

*He stares at the vanishing ANNE, hesitates a moment, then goes to
cupboard and opens it. It is full of books and files, as before. As he
stares at it and bends to listen, the pneumatic drill comes in at full
blast.*

SCENE SIX

*Room in the castle, as before. LAMISON is playing his lute – and singing
too possibly – and SAM, dressed exactly as before, is listening to him. SAM
has a leather tankard in his hand and takes an occasional pull from
it. LAMISON concludes his song or piece on the lute, with a little bow.*

SAM: Thanks very much. Let's have another one, shall we?
(LAMISON smiles and bows.) Now – wait a minute. I heard a
thing the other night on the air – you'll probably know it.
Oh – yes – *The Black Knight Hath My Heart* –

LAMISON: *(Who is angry.)* Bah!

He stalks out angrily. If SAM is to be a pipe-smoker, he should fill and light a pipe here. Otherwise, he should roam around the room. NINETTE enters in a new costume now and looking very fine indeed. SAM, if sitting now, rises and smiles at her, and she smiles winningly at him.

NINETTE: How doth my fair lord after so much hath befallen him?

SAM: *(Doing his best.)* Fair gentlewoman – er – I am come to no harm but – er – am yet amazed –

NINETTE: *(Smiling.)* Fair sir, sithen ye seek adventure, to win prowess, oft times must ye stand amazed.

SAM: *(Struggling with it.)* Noble damsel – er – ye say sooth. Er – what name – er – ?

NINETTE: Men calleth me Lady Ninette – and among my kindred are many great lords and noble ladies – *(She curtsies, smilingly.)*

SAM: Fair Lady Ninette – men call me Sam – and the name of my family is Penty – and my kindred – to speak truth – are no great shakes –

NINETTE: And you are no great shakes at that kind of dialogue, are you, Sam?

SAM: *(Relieved.)* Oh – we needn't keep it up? Good! By the way, Lady Ninette, as you were kind enough to ask me how I was feeling, I must confess I'm feeling very hungry.

NINETTE: *(Smiling.)* I am sure you would be. *(She goes to door she entered by and opens it. GRUMET and perhaps a page or attendant enter with food and more drink all in the Medieval style. She continues talking as they put it down.)* I am hungry myself, Sam, for I waited for you, knowing you were coming. Wasn't that nice of me?

SAM: It was, Lady Ninette. I was about to say so.

NINETTE: I'm afraid I hadn't time to order anything very special.

SAM: *(Regarding the food with satisfaction.)* No, please don't apologise. This is a splendid lunch –

NINETTE: *(Haughtily to GRUMET and the other.)* We'll wait upon ourselves. Go!

As they go, NINETTE and SAM settle down to eat and drink. There can be a good deal of little by-play here, which need not be indicated, though it must be remembered there are no forks, no plates only thick slices of bread, just sharp knives to cut with and fingers used. They are eating and drinking throughout dialogue that follows.

SAM: *(Hesitantly.)* By the way – what – er – age are we in here?

NINETTE: *(Puzzled.)* What age?

SAM: Yes – age. Period. What king is reigning?

NINETTE: Arthur is still High King –

SAM: Oh – Arthurian age. Legendary really. Then I suppose everything is still in full swing – knights, enchanters, dragons, giants –

NINETTE: *(Rather surprised at this.)* Naturally. The usual Arthurian way of life. Who rules your mythical kingdom, Sam?

SAM: Nominally – a queen, Elizabeth the Second. Actually, the executive committees of the Conservative and Labour parties, the Trades Union Congress and the federation of British Industries –

NINETTE interrupts him by laughing heartily.

NINETTE: *(As she recovers.)* I'm sorry, Sam – but you must admit, now that you're in real life, it all seems so absurd. Really, people will believe in anything. Now let's be serious. I'm very anxious to know how Master Malgrim brought you here. I haven't seen him since he asked me to be ready to receive you, Sam.

SAM: We were through almost in a flash. I felt a bit dizzy of course – private bar of The Black Horse to a castle in Peradore in one move – and then I found that Malgrim had disappeared and with him a rather rum bloke, Captain Plunket, who'd insisted upon coming along. No idea where they are. You're the first person I've had any talk with here, Lady Ninette.

NINETTE: *(Smiling seductively at him.)* But rather a nice person, don't you think, Sam?

SAM: Delicious! *(He hesitates.)* But – er – something was said about a princess.

NINETTE: *(Disappointed in him.)* Oh!

SAM: Said the wrong thing, have I?

NINETTE: *(Reproachfully.)* You're not a snob, are you, Sam?

SAM: *(Apologetically.)* Not in the least. But I understand from Malgrim that the girl I painted was a Princess Melicent, and – well, you know how it is, Lady Ninette – that's the one I'm looking for.

NINETTE: *(Looking very grand.)* Is she fairer in your sight than I am?

SAM: *(Hastily.)* No, not at all. As a matter of fact I've never seen her as clearly as I'm seeing you – and you're certainly a devastatingly seductive piece – I beg your pardon –

NINETTE: Not at all. I like it. More wine, Sam. *(She fills his tankard.)*

SAM: *(Who is drinking incautiously.)* Thank you, Ninette. You're both adorable girls, I see that – different types, that's all – but it's Princess Melicent I'm trying to find.

NINETTE: She's a ninny.

SAM: Perhaps I need a ninny. *(He drinks heartily, then grins at her.)*

NINETTE: Now I'm intelligent and rather wicked. *(Pauses, perhaps drinks.)* Do you know the Macbeths?

SAM: I know *of* them of course.

NINETTE: I've a cousin in Scotland who knows them very well. A few years ago, the Macbeths were nothing – just Army people. Look at them now, ruling Scotland. All *her* doing – *she* has the brains – the determination –

SAM: *(Grimly.)* You wait!

NINETTE: Well of course you couldn't *give* me Scotland. But here too it's the clever and rather wicked women who have all the fun. Look at Morgan le fay, Guenevere, Nimue, Etarre, the Queen of Orkney. It's only clever women and enchanters who can *plot*.

SAM: In our world we don't need wicked plots any more – we can do ourselves in with Science and Progress. But tell me about the enchanter situation here – I'm not very clear about it –

NINETTE: Oh – it's rather fascinating really. There are two enchanters – Malgrim, the one I'm working with – and his old uncle, Marlagram. Now Marlagram outwitted Malgrim, and took Melicent to find you.

SAM: Oh – I say!

NINETTE: But then Malgrim, who's terribly clever, outwitted his uncle by bringing you here before poor Melicent could find you. And now you're here – but she's there –

SAM: *(Indignantly.)* And we're still separated – but now we're both in the wrong worlds. I call that a bit much –

HERALD, as in Scene 1, enters R..

HERALD: His Royal Majesty – King Meliot of Peradore – High Lord of Bergamore and Parlot – Overlord of Lancington, Low Moss and Three Bridges!

Trumpet sounds off R.. KING, dressed as before, enters, followed or preceded by two soldiers, and MALGRIM, in his original costume.

KING: *(Who is in a bad mood.)* What's happening here? Who's this fella? *(Indicating Sam.)* No, tell me later. Point is – where's our dwarf?

NINETTE: He's here, sire. Brought back by Master Malgrim the enchanter –

KING: Oh – that fella! Don't trust him. Who's this fella? *(Indicating MALGRIM.)*

MALGRIM: *I* am Master Malgrim, sire.

KING: Dam' confusing this. Don't think I won't straighten it out. Now what about this fella? *(He points and glares at SAM.)* Not one of our subjects. Isn't properly dressed. One of these fellas from Lyonesse or Cameliard – eh? Hasn't had himself announced. No credentials. And being given a dam' great lunch at our expense. *(Going closer to table, he sees something and is furious.)* That goose pasty is reserved for our Royal table. What the blue blazes is it doing here? Fella turns up – no credentials – not properly dressed – and our best wine's poured into him – he's given a blowout on our goose pasty – and *who is he*?

MALGRIM: A dangerous young man, your majesty. He came seeking Princess Melicent. He's the man she saw in my magic mirror – Sam.

KING: Sam? She said he didn't exist in real life. Character in mythology, legend, folklore, we understood. No, this can't be the fella. What's your name?

SAM: Sam. And I am the fellow she meant. We're in love. At least I hope so. I know I am.

KING: *(In a fury.)* Stares us in the face – improperly dressed – full of our best pasty – and now tells us he's in love with our only daughter! By Cock and Bull – this makes our blood boil. *(Calling loudly.)* Melicent! Melicent! *(To NINETTE.)* Where is she?

NINETTE: She's looking for him – Sam.

KING: *(Angrily.)* Looking for him! Then tell her from us where she'll find him. In our deepest dungeon. Take him away, you men. *(As they take SAM away, struggling.)* Knock him senseless if he tries to escape. *(As they go out, KING looks around and then grabs the pasty.)* There's going to be a devil of a row too about this goose pasty. You've not heard the last of this, young woman. But you've *seen* the last of it. *(As he goes out R. the KING takes a large bite out of the pasty.)*

NINETTE: *(Sitting down.)* Well, that takes care of Sam – deepest dungeon. But what about Melicent?

MALGRIM: *(Also sitting.)* Oh – it's all rather neat. She's still in Sam's world – and very soon they're *putting her on the air* –

NINETTE: Putting her on the air?

MALGRIM: *(Carelessly.)* It's a form of enchantment they have there – drab stuff – my uncle and I wouldn't put our names to such a miserable effort – Well now, what about a glass of wine – while Sam goes down to the dungeon – and Melicent goes on the air – eh?

As they laugh and fill leather tankards, lights begin to fade and we hear modern music.

SCENE SEVEN

A television studio. In a row, not straight but bent inward, from R. to L. are seated MRS SHINY, PHILIP SPENCER-SMITH, MELICENT (still in Medieval costume), and TED GIZZARD. MRS SHINY (who can be played by the actress playing the BARMAID) is a foolish middle-aged woman with an affected manner. TED GIZZARD (who can be played either by the actor playing DIMMOCK or JARVIE-JARVIS) is a slow, pompous middle-aged man. Scene opens with a very hard front light coming on, to suggest TV lighting.

PHILIP: *(In usual TV compere manner.)* Good-afternoon – and welcome once again to our *Women Can Take It* programme! On my right – an old favourite on this programme – is Mrs Shiny, president of the English Housewives Guild – who might be called our Housewives' Choice. Over on my left

here – another old favourite – and a well-known figure in the Trade Union Movement – Ted Gizzard, General Secretary of the Copper Scaling and Brass Layabouts Union. And next to me – a charming newcomer to our programme – now enjoying a successful career as a model in London – Princess Melicent –

MELICENT: *(Coming in firmly.)* I only came to find Sam. Where is he?

PHILIP: *(Hurriedly.)* Yes, yes – that's very very interesting – but we'll come to it later. Now – Mrs Shiny – first question to you. A regular viewer asks us this – what new opportunities should be given to women? Mrs Shiny?

MRS SHINY: *(With fatuous self-importance.)* I speak as a housewife – because as you know, I'm president of the English Housewives Guild, the largest and most influential association of housewives in the country. And speaking *as* a housewife, I would say that every possible new opportunity ought to be offered to women, especially in their capacity as housewives.

PHILIP: Thank you very much, Mrs Shiny. Ted Gizzard?

GIZZARD: *(Slow and pompous.)* Without committing myself beyond further disputation, I think I might reply to that particular question, without prejudice of course, but venturing to speak not only for Copper Scaling and Brass Layabouts but also for the whole consolidated Trade Union Movement as it is constituted today – I would say Yes and No – Perhaps and Perhaps Not – having regard to the fact that circumstances alter cases –

PHILIP: Thank you very much, Ted Gizzard. Now, Princess Melicent, what new opportunities do *you* want?

MELICENT: *(Firmly.)* I want Sam.

PHILIP: You mean that Sam'll provide the new opportunities, Melicent?

MELICENT: *(Severely.)* Don't call me Melicent – you're not one of my friends –

MRS SHINY: Speaking as a housewife – and as the president of –

MELICENT: *(Cutting in, sharply.)* Don't interrupt –

MRS SHINY: *(Indignantly.)* Well – really – I must say –

MELICENT: Remember – you're a housewife – not a fishwife. Now – as soon as I can find Sam –

GIZZARD: *(Not so slow this time.)* Point of order, Mr Chairman! In my opinion the item on the agenda does not call for the substitution of the particular for the general, the personal for the impersonal –

MRS SHINY: Quite right. We didn't come here to talk about Sam – whoever Sam may be –

MELICENT: I saw him – not here but in real life – in a magic mirror. It was lent to me by Master Malgrim, the enchanter, though it was his uncle Master Marlagram the old enchanter, who brought me here –

MRS SHINY: *(Indignantly.)* Really – I must protest – *as* a housewife –

MARLAGRAM's characteristic he-he-he! can be distinctly heard.

MELICENT: You see – he's here – and he's laughing at you –

PHILIP: *(Desperately trying to save the situation.)* He is, is he? That's very very interesting. And what are your impressions so far of London, Princess Melicent?

MELICENT: I don't understand it. If it isn't real – and you've all made it up – why have you made it so horribly ugly and noisy – why do so many people look so anxious or angry or sad? Unless of course it's all an evil enchantment –

GIZZARD: A what? I didn't catch.

MELICENT: *An evil enchantment.*

GIZZARD: I've spent thirty years in the Trade Union Movement –

MELICENT: *(Cutting in.)* Oh – be quiet! *(Calling.)* Master Marlagram – where's Sam?

MARLAGRAM: *(Off, very distinctly.)* He-he-he! He's in the castle dungeon –

MELICENT: *(Alarmed.)* In the dungeon? Take me to him. Where can I find you?

MARLAGRAM: Private bar of The Black Horse – he-he-he! – about half-past five – he-he-he! *(His chuckle dies away.)*

PHILIP: *(Desperately echoing it.)* He-he-he! Very very interesting – and we do wish them all the best of luck. Well now – the next question comes from a regular viewer in Surbiton, who wants to know – Will there be more women than men in the near future – and if so – how? Mrs Shiny?

MRS SHINY: Speaking as a housewife – and as the representative of many thousands of responsible English housewives – who are all deeply concerned about the near future – I would say Possibly and Possibly Not – but that it's very difficult to say exactly how. Don't you agree, Mr Gizzard?

GIZZARD: I do to a limited extent, and I don't to a much less limited and larger extent. We in the Trade Union Movement –

But the light, which has begun fading – the voices fading with it – with PHILIP's question, has now gone. MELICENT, after receiving MARLAGRAM's answer to her question, has leant back in her chair, closed her eyes, and clearly lost all interest in these idiotic proceedings. As the light and voices fade, faint sad lute music can also be distantly heard.

SCENE EIGHT

Dungeon in the castle. We see SAM, who is wearing enormous chains and manacles. After a few moments two soldiers come in, one carrying a large loaf, the other a jar.

FIRST SOLDIER: *(Putting down loaf.)* Bread.

SECOND SOLDIER: *(Putting down jar.)* Water.

They laugh together.

A LOUD VOICE: *(Off, beyond door.)* Make way for Sir Skip – the new captain of the King's Guard.

The two SOLDIERS stand to attention. CAPT. PLUNKET, though not recognisable yet, comes clanking down, completely clad in armour, with closed visor, carrying an enormous sword.

CAPT. P.: *(To the SOLDIERS.)* Go wait without.

FIRST SOLDIER: Without what, Captain? *(Both SOLDIERS laugh heartily.)* Not bad – eh – Ted?

SECOND SOLDIER: *(Still laughing.)* I don't know how you think of 'em, Jack.

CAPT. P.: *(In terrible voice, raising his sword.)* Didn't I give you an order – you pig-faced, muddy-livered, bag-pudding sons of seacows. Do I have to slice off your ears, twist your noses off, chop your thumbs into mincemeat?

SOLDIERS: *(As they go hurriedly.)* Nay, nay, Captain.

They hurry out. CAPT. P. now sits down – there are things to sit on, perhaps roughly shaped out of stone – close to SAM, who is looking dejected. CAPT. P who is very hot and breathless, takes off his helmet.

CAPT. P.: Hellishly hot, this armour, old boy.

SAM: *(Astonished.)* Captain Plunket!

CAPT. P.: The old Skipper himself. I have 'em shouting 'Make way for Sir Skip!' – you must have heard it.

SAM: Yes. But *are* you the new captain of the King's Guard?

CAPT. P.: For the time being, old boy. Had to do some fast talking – and this was the best I could do.

SAM: Look what *I* talked myself into.

CAPT. P.: *(Sympathetically.)* I know, Sam old boy. After the daughter aren't you? Always tricky. Ever tell you what happened to me in Tetuan? Give you the whole story

sometime. Not much of a place this, is it? *(Indicating dungeon.)*

SAM: *(Bitterly indignant.)* Not much of a place!

CAPT. P.: I've been in worse, old boy. Twelve of us, once, in a cellar smaller than this. But don't worry, Sam. I'll have you out of this soon. I'm having supper with this King Meliot tonight – and then I can work something for you, old boy. Ten to one he'll be plastered –

SAM: And a hundred to one you'll be plastered too, Skipper.

CAPT. P.: Strictly speaking, I've been plastered ever since the Battle of Jutland. So I can take care of the king, old boy. We're very thick already.

SAM: How did you work it? Why didn't he denounce you for not being properly dressed?

CAPT. P.: Because I pinched some armour first, old boy. Then he asked me if I came from Camelot, and I said 'Yes' I did. Had I brought him a message from King Arthur to say the meeting was off? So I said 'Yes' I had. He asked me how King Arthur was looking. And I said he was looking bronzed and fit and was laughing heartily. Then I recommended myself as Captain of the King's Guard – a new idea to this King Meliot, who's not a bad bloke though on the mean side, I'd say. Dead against you for eating his favourite pasty, he tells me. Not many perks on this job yet but of course I haven't got going. By the way, old boy, d'you know a fellow called Dimmock, advertising man?

SAM: Yes, he's my boss. What about him?

CAPT. P.: He's here, old boy.

SAM: *(Astonished.)* Dimmock? How did he get here?

CAPT. P.: Something about a rat and a cupboard. Dam' lucky for him we met. Hadn't a clue. Not very adaptable man for an advertising man. Got him under cover up in my room.

Noise at back. CAPT. P. jumps and begins shouting ferociously at SAM.

Why you impudent rogue! – You'll stay here just as long as it pleases His Majesty to keep you here.

KING MELIOT: *(Just off at back.)* Sir Skip! Sir Skip!

CAPT. P.: *(Calling.)* Coming, sire! Coming, sire! *(Dropping his voice to SAM.)* Keep your pecker up, old boy. Have you out soon. *(Shouting as he goes.)* Serve you right – you rascal! Coming, sire!

He goes out. After a moment or two, with SAM looking disconsolate, MARLAGRAM's he-he-he is heard, and as SAM, startled, jumps up and looks around, MARLAGRAM comes out of the darkness, apparently from nowhere.

MARLAGRAM: He-he-he! Well here I am, my boy. Master Marlagram – *your* enchanter.

SAM: *(Indignantly.)* My enchanter! Look at me! And what have you done with Princess Melicent? Why did you let your nephew bring me here, so that she missed me?

MARLAGRAM: *(Chuckling.)* He outwitted us there, didn't he? Oh – he's a smart lad – trained him myself one time. A hard worker too. But then we all are – *he-he-he!* The trouble was, I'd an urgent call to Scotland – some old friends, the Weird Sisters –

SAM: The Macbeth affair, was it?

MARLAGRAM: *(Angrily.)* Who's been talking?

SAM: I'll tell you later. But don't simply tell me how smart your nephew is. Family pride's all very well – but if you can't help us – if you're past it – say so –

MARLAGRAM: Past it! You're talking like a fool, lad. Bar Merlin – and he's retired – I'm the best enchanter between here and Orkney.

SAM: Then you must be having an off day.

MARLAGRAM: *(Offended.)* I'm past it. I'm having an off day. Go on, lad. It only needs a few more words from you, and I'll leave you to it, to get out of this the best way you can.

SAM: Master Marlagram, I apologise. But you can imagine what I'm feeling. Melicent's gone into my world – and God knows what's happening to her – and here I am – helpless –

MARLAGRAM: Say no more, lad. And if you don't mind we'll do the rest in easy verse:

> When things get worse
> I take to verse

SAM: But have you time
> To make it rhyme?

MARLAGRAM: Things have gone wrong
> But not for long
> I'll settle 'em soon
> Making a start late this afternoon

SAM: But – surely – man
> It ought to be possible to find verses that scan.

MARLAGRAM: I don't take pains
> For men in chains –

SAM: A nasty crack –
> You'll take it back –

MARLAGRAM: No, no, my boy – I like to tease – *(Calling.)*
> A light – and your attention, please.

Now in light, to audience.

> YOU THINK I'VE MADE A POORISH START
> BUT I'LL DO ALL RIGHT IN THE SECOND PART.

Chuckles as curtain comes down.

End of Act One.

Act Two

Music as before, ending with modern instrument.

Private bar of The Black Horse, exactly as before except that light is different – late afternoon instead of morning. Same BARMAID, same MAN as before.

MAN: *(After a moment or twos rumination.)* Quiet, isn't it? *(As she does not reply, but not impatiently.)* I say it's quiet.

BARMAID: I'm not sayin' anything.

MAN: Why?

BARMAID: Ask me no questions, I'll tell you no lies.

MAN: *(Conceding this.)* That's ri'.

BARMAID: *(Bursting out.)* My brother Albert says he saw it done at Finsbury Park Empire one time –

MAN: Saw what done?

BARMAID: *(Darkly.)* Vanishing act.

MAN: *(After pause, faintly hopeful.)* Turned out nice again.

BARMAID: *(Casually.)* Can't expect anything different, thirty-first of June.

The MAN stares at her suspiciously, she returns his glance innocently. He takes out his diary and consults it anxiously, then they exchange the same looks. Enter MALGRIM dressed as he was in previous scene here.

MALGRIM: *(Brisk and authoritative.)* Twelve glasses of Benedictine and cold milk.

BARMAID: *(Staring at him, staggered.)* Benedictine and cold milk! Twelve glasses?

MALGRIM: Twelve. The bacteriological section of our medical conference is meeting here.

BARMAID: *(Still staring at him.)* 'Ere – didn't you come in this morning – drink a whole bottle of creem de menthy – and then go through the wall?

MALGRIM: I did.

The BARMAID gives a faint moan and disappears from sight.

MAN: I fancy she's a bit off-colour today.

MALGRIM: *(With authority.)* So are you, my friend. Just look up, will you?

As MAN looks up, MALGRIM makes a quick pass, and the MAN stands staring up, rigid. MALGRIM now concentrates on the wall, mutters some spell and makes signs at it. Stage darkens for a moment and rushing wind sound is heard. When it lights up again, the wall is open, as it was at end of scene in Act One, but standing in entrance is MARLAGRAM, chuckling in triumph.

MARLAGRAM: He-he-he-he! Surprised you, didn't I, my boy?

MALGRIM: Showy – but cheap as usual Uncle. You really ought to retire from serious work, y'know. All right for childrens' parties and that sort of thing –

MARLAGRAM: I'll give you childrens' parties – you conceited young pup! And don't try to ask for any help from *Aghizikke* and *Balturzasas*, or any of that group o' demons, 'cos I fixed them with a pentacle this afternoon – he-he-he-he!

MALGRIM: *(Contemptuously.)* I know you did. Too obvious, my dear Uncle. So I moved, with a cat and bat, to *Akibeec* and *Berkaiac* and their group. Want a trial of strength? *(As MARLAGRAM comes out into room, leaving passage in wall open behind him.)* No, I thought not. No decent strategy, no proper planning. You realise I'm now a move ahead of you?

MARLAGRAM: No I don't.

MALGRIM: Of course I am. If you go back to Peradore, then you leave me here to meet Princess Melicent.

MARLAGRAM: I'm not going to do that, my boy.

MALGRIM: Very well. Then you stay here, I return to Peradore, and there I'm a move ahead of you. *(Moves towards opening in wall.)* I'll have Merlin's brooch yet – you'll see.

MARLAGRAM: You can't close that wall after you, though. Like to try?

MALGRIM: *(Turning at opening.)* Why should I bother? Waste of effort. *(As he goes.)* I'm a move ahead of you.

MARLAGRAM: *(To himself.)* He is too. Smart lad – but too pleased with himself.

He moves restlessly, obviously trying to plan something. In one of these moves he can casually push the still rigid MAN out of the way as if he is a piece of furniture. A flap underneath bar counter opens, and the BARMAID, dazed, comes creeping through. She stands up straight, still dazed, stares at MARLAGRAM, then at the MAN, then at opening in wall.

BARMAID: *(Faintly.)* Oh – my godfather! *(To MARLAGRAM.)* Look – could you drink twelve glasses of Benedictine and milk?

MARLAGRAM: No. Never touch milk.

BARMAID: *(Still dazed.)* Cheery-bye then!

She totters out through the opening in the wall. MARLAGRAM gives the MAN a tap, then goes under bar counter and appears behind it.

MAN: 'Ere, what's wrong with my eyes?

MARLAGRAM: They're looking at nothing – out of nothing. You haven't been alive for years. What are you drinking?

MAN: *(Gloomily.)* Mild ale.

MARLAGRAM: You've been drowning yourself. He-he-he-he! What you need is a pint of dragon's blood. Here! *(He produces a pint glass mug filled with crimson liquid. The MAN takes it.)* Drink that – and come to life. Millions of you crawling about, just waiting for free coffins. Dip your nose into that – and tell me what day it is.

MAN: I'll take a chance. *(He drinks, then coming to life, grins broadly.)* By crikey – they were right. It's the thirty-first of June.

MARLAGRAM: That's more like it – he-he-he-he!

Enter MELICENT and PHILIP.

PHILIP: *(Talking as they enter.)* I'm not saying you're not a very nice girl, duckie – and probably just right for Sam – but the fact remains you've finished me with television for at least the next two years –

MELICENT: *(Seeing him.)* Oh – Master Marlagram – I'm so glad to see you. Hurry up and take me back to real life.

MARLAGRAM: We're off in one minute.

MAN: *(To PHILIP.)* What you want's a drop of this dragon's blood. Then you won't care if you've finished with television for ever. *(To MARLAGRAM.)* Another pint o' dragons, please!

MARLAGRAM: *(Producing it.)* There you are! Ready for off, girl? Watch it then. Here it comes.

PHILIP: *(Holding up a cigarette.)* Would you mind giving me a light for my cigarette?

MARLAGRAM: *This is it!*

He sets off a powerful green or red flare, and the roaring wind noise is heard. In the glare and smoke, MELICENT goes through the wall, which closes behind her, while MARLAGRAM simply disappears behind bar. When smoke has cleared, MAN and PHILIP are left staring at each other, both holding their pint glasses.

PHILIP: *(Dazed.)* Cheers! *(He drinks.)*

MAN: All the best! *(He drinks.)*

PHILIP: *(Trying to cope with the situation.)* Er – what – er – *(He looks round in a kind of despair, and makes a few more vague noises.)*

MAN: *(Cheerfully.)* Turned out nice again, hasn't it?

PHILIP: *(Still dazed.)* Has it?

MAN: *(Cheerfully.)* Can't expect anything different, though, can you – thirty-first of June?

He takes a long pull at his drink while PHILIP stares at him and then finally, still in a dazed fashion, drinks himself. We begin to hear the laughter that opens next scene as this one fades out.

SCENE TWO

Room in castle, as in Act One, but light is different. KING, CAPT. PLUNKET and DIMMOCK are sitting drinking, with HERALD or LAMISON in attendance as cupbearer. KING is dressed as before, CAPT. P. is in medieval costume without armour, and DIMMOCK is exactly as he was in Act One. They are in high spirits, roaring with laughter, and already rather tight.

KING: *(As laughter subsides.)* We used to know rather a good one – the one about the three chapmen who met in Camelot. Can't quite remember it all – but remind us to tell it to you next time we meet. Cupbearer!

CUPBEARER fills the tankards as talk continues.

CAPT. P.: Talking about remembering, your Majesty, I've just remembered something.

KING: So have I. *(Pointing to DIMMOCK.)* He's the second fella I've seen today not properly dressed. Other fella's in the dungeon. Wanted our daughter.

CAPT. P.: I've just remembered that Dimmock and I have a scheme.

KING: Who's Dimmock?

DIMMOCK: I'm Dimmock, sir.

KING: Then you're not properly dressed, Dimmock. What did you say you had, Sir Skip?

CAPT. P.: A scheme, your Majesty – a plan – a device – an idea. Bags of money in it.

KING: Bags of money? Where?

DIMMOCK: In this scheme, your Majesty.

KING: I doubt it. Doesn't seem to me to be anything in it. Unless of course Dimmock knows more than you do.

DIMMOCK: I *am* Dimmock.

KING: Well, how far does that take us? No, we've turned down hundreds of ideas better than that. It lacks body. Cupbearer! *(He motions him to fill up again.)* This wine has some body in it. Your scheme hasn't. That's the difference.

DIMMOCK: *(To CAPT. P.)* Your turn. I give up.

CAPT. P.: *(Impressively.)* Your Majesty – I beg leave to drink to your health and happiness and the continued prosperity of your kingdom of Peradore. *(Drinks.)*

KING: Much obliged, Sir Skip – though we must point out that our kingdom of Peradore is anything but prosperous –

CAPT. P.: But Dimmock and I are ready to bring you bags and bags and bags of money –

KING: That's better. Have you a scheme?

CAPT. P.: Yes, sir. Now – where we come from, everybody wants to go somewhere else –

KING: Why?

CAPT. P.: Just for a change and a rest from our wonderful way of life.

DIMMOCK: Everybody saves money to visit some other country.

CAPT. P.: And we think they ought to come here – to Peradore –

DIMMOCK: Conducted tours – see the castles – see the knights – see the dragons –

CAPT. P.: We'll have to have one of your enchanters working for us, of course, looking after the transport –

DIMMOCK: Then the money'd come rolling in –

KING: To me? No, of course not.

DIMMOCK: Your Majesty could have a seat on the board and a nice holding of the original stock –

KING: Boards and stocks? Don't know what you're talking about. What about those bags and bags of money?

CAPT. P.: You do what our rulers do. As soon as people have money, you take it away from them in taxes –

KING: Taxes? Nonsense! A guilder here – a groat or two there – we know about taxes –

DIMMOCK: But on our plan you take half they've got – or three-quarters –

CAPT. P.: You charge 'em for all the castles – administration and security – for having a roof over their head – for their clothes and their beds – for the roads and the paths –

KING: *(Derisively.)* And for the air they're breathing – eh?

DIMMOCK: Well, that's new – but you might get away with it – worth trying –

KING: *(In a passion.)* Worth trying! Might get away with it! Why – you impudent, greedy scoundrels – we'll have you flogged for talking such stuff to us. Cupbearer, summon the guard. *(As CUPBEARER hastens to door to bring guards, who are the two SOLDIERS we saw before.)* Fellas here have been hanged, drawn and quartered for doing less than you're asking me to do. We wouldn't treat even cannibal heathens and one-eyed pigmies in such a scurvily devouring fashion. There isn't a prince in Christendom who'd consent to listen to such evil counsel – and most of 'em would spill your foul brains on the stones. *(To the SOLDIERS.)* Take these rogues into custody – and if they speak a single word, knock 'em on the head –

FIRST SOLDIER: What, Majesty – our captain too, Sir Skip?

KING: He's no longer your captain – but a rogue and a vagabond, like the other fella. Take 'em away.

FIRST SOLDIER: Ay, ay, Majesty. But where to?

KING: *(Uncertainly.)* Well now – let us see –

MALGRIM and NINETTE, now in medieval costume again, suddenly appear.

MALGRIM: *(Smoothly.)* Your Majesty, may I make a suggestion?

KING: *(Rather startled.)* Who the devil are you? Oh yes – enchanter fella. Pushin' fella – don't overdo it. *(Notices NINETTE, who is smiling at him.)* Where have you been, Ninette? And where's our daughter?

NINETTE: *(Seductively.)* I'll explain everything, sire – as soon as we're alone. But – Master Malgrim –

MALGRIM: *(Taking the lead.)* Your Majesty, please allow me to take charge of these two prisoners. A little experiment – for the benefit of our art and science –

KING: Turn 'em into something, eh? Not a bad idea. But that doesn't mean you've now got a Court Appointment, understand? Off you go, then. *(As they all move off but NINETTE, he realises he is both tired and thirsty.)* Cupbearer? No, no, you can go. Lady Ninette can act as cupbearer.

NINETTE: *(Smiling.)* Of course, sire.

KING: *(Holding out his tankard.)* Fill then, Ninette. And help yourself too, girl. *(As she fills the two tankards.)* Never an hour's peace these days. King Arthur summons us to Camelot. Then he countermands the summons. Our daughter's half off her head – and now missing. In love with a mythological character. Fellas arriving from nowhere, not properly dressed. Appoint a fella Captain of our Guard and discover he's an impudent rogue. Enchanter keeps popping up and out without so much as a by-your-leave. Just can't cope with it. Must be getting old.

NINETTE: *(Close to him, smiling.)* Oh – no – sire – you're in the prime of life – our Majesty's rather tired and rather hot – allow me – *(She pats his brow with a hankerchief and then smooths it with her hand.)*

KING: *(Pretending not to enjoy all this.)* All very well – but where's our daughter?

NINETTE: She's been very naughty, sire. She left our world, looking for this man. Now she's on her way back – with Master Malgrim's uncle, the other enchanter – a horrible old man called Marlagram –

KING: Marlagram? Is he still around? Remember him with Merlin years and years ago. Of course he's a lot older than we are.

NINETTTE: Of course, sire. And in any case – as my aunt the sorceress used to tell us – a man is only as old as he feels –

KING: She said that, did she? I wish we'd thought of it. Brilliant original woman your aunt – always said so… always said so…

NINETTE: You need someone like Master Malgrim to relieve you of all the boring routine duties, don't you think? You can't do everything yourself, it's too much –

MELICENT, dressed as before, is now in the room, with MARLAGRAM, in his original costume, behind her. MELICENT is blazing with fury.

MELICENT: *(Angrily, as she crosses to them.)* I should think it *is* too much.

KING: *(Angrily.)* Don't talk to us like that. Where have you been? What have you been doing? And who the devil's this? *(Pointing to MARLAGRAM.)*

MARLAGRAM: *(Not at all alarmed.)* He he he he! Surely you remember me, King Meliot?

KING: Go away, Marlagram. It's bad enough having your nephew pushing himself forward all the time –

MARLAGRAM: *(Cutting in.)* A bright lad – but mischievous – a tricky plotter –

MELICENT: Is my Sam still in the dungeon?

KING: *(Angrily.)* He isn't your Sam – but he *is* in the dungeon – and there he's staying –

MELICENT: *(Alarmed.)* OH – NO – Father – please –

KING: And another thing, young woman. We've had enough of your whims and caprices. Tomorrow after the tournament we announce your marriage –

MELICENT: *(Urgently.)* Never!

KING: We don't know who the bridegroom will be yet – but you'll marry him if we have to lock you up and give you nothing but bread and water –

MELICENT: *(Stormily.)* I won't – I won't – I won't –

KING: You will. And that's our royal command – bear witness, Lady Ninette and Master Marlagram, that we have spoken.

MELICENT: *(Urgently.)* Master Marlagram, you remember the brooch that Malgrim wanted –

MARLAGRAM: Yes – he-he-he-he! – we're both after it of course –

MELICENT: It's yours if you help me now –

MARLAGRAM: *(Delighted.)* Done! And notice I never asked for it. He-he-he!

KING: What's all this nonsense about a brooch? Whatever it is, we assure you –

MARLAGRAM: *(Very impressive now, the magician.)* Stop, King Meliot!

He holds up a hand. Light changes. Distant roll of thunder. NINETTE gives a little cry of alarm and shrinks back.

KING: *(Uneasily.)* None of your old Merlin tricks, Marlagram, please. Years out of date now, my dear fellow. Steady now –

MARLAGRAM: *(Tremendously impressive.)* The moment of clear sight, given me under the Seal of Solomon, is with me now, King Meliot of Peradore. Two terrible dangers approach this castle. One is the unknown Red Knight who will challenge all, and can overcome all but one, at the tournament tomorrow. The other is a ravening fiery dragon

that is even now muttering and smouldering in the wood below. And only he who overcomes the Red Knight may slay the dragon. And it is he who must marry the Princess.

KING: *(His teeth almost chattering.)* Certainly – certainly – very reasonable in the circumstances. But are you sure about the Red Knight and the dragon? There couldn't be any mistake –

MARLAGRAM: *(Wildly.) Mistake!* What – you question the moment of clear sight – the Seal of Solomon himself?

There is on the darkening stage a terrific flash of lightning and roll of thunder. The GIRLS scream. MARLAGRAM slips out.

KING: *(Alarmed.)* No – no – no – you're quite right – very reasonable too – we give our word –

MARLAGRAM: *(Triumphantly – off.)* He-he-he-he-he-he! And that's another old Merlin trick, King Meliot – years out of date too –

KING: *(Almost in the dark, admiringly.)* Gone, has he? Well, as we've said many a time, you can't beat the old school of sorcerers when they're really in form. Cranky, expensive, a bit messy – but they do let you know exactly where you are. And where we are – we have a bloodthirsty Red Knight and a ravening fiery dragon on our hands. In our opinion – a bit much.

Scene blacks out completely.

SCENE THREE

Dungeon as in Sc.8, Act I. SAM seen as before, chained and manacled. FIRST and SECOND SOLDIERS enter as before, carrying rations. They leave door open behind them.

FIRST SOLDIER: *(Putting down bowl.)* A drop 'o broth this time – for a treat.

SECOND SOLDIER: *(Putting down loaf.)* And another loaf.

FIRST SOLDIER: Just a loafer, you are, chum. *(Both SOLDIERS laugh.)* Not bad – eh – Ted?

SECOND SOLDIER: *(Still laughing.)* You'll kill me yet – Jack.

SAM: Where's your Captain – Sir Skip?

FIRST SOLDIER: Sir Bloody Skip 'as 'ad it. First we put 'im under arrest – an' now the enchanter's gettin' to work on 'im – *and* on the other bloke –

SECOND SOLDIER: By this time they might 'ave bin turned into a couple of basset hounds –

FIRST SOLDIER: An' that's a dog's life, chum. See – Ted – they come like lightnin'.

SECOND SOLDIER: *(Laughing as they go.)* You're a bloody marvel – Jack.

They go out. SAM tastes the broth.

SAM: Terrible. *(Turns and calls up.)* I say – this broth is terrible. What do you make it out of – arrowheads?

MARLAGRAM enters, chuckling. He is carrying a large pasty and a tankard.

MARLAGRAM: He-he-he-he! Well, here I am again, my boy. And here's a real supper.

SAM: *(As he takes it.)* Thanks very much, Master Marlagram.

MARLAGRAM: King Meliot's best wine and his favourite pasty – he-he-he!

SAM: There'll be hell to pay if he finds out. There was when I had 'em for lunch. *(Begins eating and drinking.)* You brought back Princess Melicent of course?

MARLAGRAM: Yes, and we've come to a nice little arrangement. She gets what she wants. I get what I want. You couldn't have it neater.

SAM: Speak for yourself. What happens to me?

MARLAGRAM: Well, what do you want to happen to you, my boy? Most people don't get what they want just because they don't know what they want. Now do *you* know what you want?

SAM: Certainly. When a man's chained up in a dungeon, he starts from scratch.

MARLAGRAM: He starts from scratch / To make a match.

SAM: *(Still eating and drinking.)* No verse, if you don't mind. After you'd gone this afternoon I couldn't stop making up thousands of bad lines. But certainly I do want to make a match, as you say. I've never thought of myself as a marrying man, but now I want to marry Melicent, whichever world we decide to live in. Dam' good pasty this. I don't blame the King for wanting to hog it all himself.

MARLAGRAM: But why Princess Melicent, my boy? You've known plenty of young women – pretty girls, clever girls, arty-party ever-so-hearty girls – he-he-he! – why come so far as Peradore to marry one?

SAM: *(Still eating and drinking.)* I want to marry Melicent because she seems to me to offer two wonderful qualities I've never found before in the same girl – a loving kindness and a beautiful strangeness. A smiling princess – what every man wants. But God knows what she sees in me.

MELICENT: *(Entering now.)* God knows – and I know, my darling – but neither of us will ever tell you.

MARLAGRAM: He-he-he! She heard everything you said, my boy. He-he-he!

MELICENT: I wish you'd stop making that silly noise – and conjure poor Sam out of his chains and things. You can, can't you? Otherwise I'd have brought a file.

MARLAGRAM: I can – though chains and manacles are quite tricky. Quiet, now. *Eeeny-meeny-miny-mo.* There you are. *(Sound of chains falling.)*

MELICENT: How clever of you! I must remember that. *Eeny-meeny-miny-mo.*

SAM: I've known it for years, but never knew it would do anything to chains.

MELICENT: Are you having a nice supper, darling?

SAM: Yes, I am, sweetheart. But what happens now? Though don't think, Master Marlagram, that I'm not grateful for the chain work and the supper. But what's the next move?

MELICENT: *(Enthusiastically.)* That's where Master Marlagram's been so very very clever –

MARLAGRAM: Though my nephew – smart lad! – got here first, one move ahead of me –

MELICENT: You see, my father says now I must marry someone – he's very cross about everything – so Master Marlagram prophesied that there's a terrible Red Knight who's going to challenge everybody at the tournament tomorrow –

MARLAGRAM: *(With relish.)* And a monster fiery dragon's coming too – might be here already – he-he-he!

MELICENT: And my father's agreed that whoever overcomes them both receives my hand in marriage. And of course that has to be you, darling.

SAM: Bless you!

MELICENT: Hasn't Master Marlagram arranged it all cleverly and cunningly?

MARLAGRAM: You don't know the half of it – the way I took advantage of being a move behind my nephew – he-he-he!

SAM: *(Laughing too.)* Brilliant, I'll bet! What an enchanter! So I go out tomorrow – and pretend to have knocked off a terrible Red Knight and a fiery dragon. Wonderful! *(He laughs again.)* Well, so long as you give me a few tips about what to say and how to look, I can pretend all that as well as the next man. *(He laughs again.)*

MELICENT: Just a minute, darling.

SAM: Sorry – making too much noise. High spirits. *(He drinks.)*

MELICENT: You see, you won't be *pretending* –

SAM: *(Coming spluttering out of his drink.)* *What?* D'you mean there *is* a Red Knight – *and a dragon?*

MELICENT: Of course, darling.

MARLAGRAM: And all you have to do is to overcome them – swish-bish-bang-wallop! – he-he-he!

SAM: *(Staring from one to the other, aghast.)* Yes – but – have a heart!

MELICENT: *(Cheerfully.)* That's the point, darling. I *have* a heart. And it's all right talking about every man wanting a smiling princess – very sweet of you, and I'm sure it's true – but of course the one who marries her must have proved himself a hero.

SAM: *(Dubiously.)* What if he isn't a hero?

MELICENT: Why bother thinking about that? You *are* a hero. You wouldn't be here if you weren't, darling.

SAM: That's true – to some extent. But don't forget, this kind of life's quite strange to me. I've never had a single lesson in tackling Red Knights and dragons.

MELICENT: That makes you all the braver, darling.

SAM: *(Anxiously.)* Yes – but – er – would there be any chance of – er – an invisible cloak – or an unbreakable spear – or a magic sword that cuts through everything – any of the usual heroes' aids?

MELICENT: Very sensible, Sam darling! What do you think, Master Marlagram?

MARLAGRAM: 'Fraid not – he-he-he! We've left it a bit late, haven't we – and they all run into money these days.

SAM: Well, what about some sort of general enchantment – so that nobody knows exactly what's happening – ?

MARLAGRAM: Then nobody'd know you're a hero –

MELICENT: And if you're not a hero, you can't marry me, Sam dear. Let's go. We're putting you into the assistant-chief-armourer's room –

MARLAGRAM: He'll be here but standing in the corner all night. He-he-he! I've made him think he's a mace. *(Begins to move out.)*

MELICENT: So you can have a good night's sleep, darling.

SAM: *(Ready to move.)* I'd have a better one if I also thought I was a mace. What time's the tournament in the morning?

MELICENT: *(Calling back as she goes.)* Seven o'clock.

SAM: *(Moving, horrified.)* A Red Knight at seven o'clock! I can't face even a fried egg at seven o'clock.

As soon as scene fades, we hear sound of trumpets. At other side of stage, HERALD appears, in a light that suggests clear early morning sunlight. Before he speaks there is another fanfare.

HERALD: *(With great pomp.)* Hear ye – hear ye – hear ye! His Royal Majesty, King Meliot of Peradore, High Lord of Bergamore, Marralore and Parlot – Overlord of Lancington, Low Moss and Three Bridges – doth pledge his solemn word that he who overcomes the Red Knight shall be first to try an honourable venture with the fiery dragon now below in the wood – which if he should also overcome he shall be given the hand of Princess Melicent in marriage. Refreshment may be obtained in the buffet behind the main stand. Spectators in the gallery are requested not to throw the peel of oranges.

Another fanfare. We now hear a tremendous din – the shouts of the crowd, the clash of weapons, the thud of horses' hoofs, drums and trumpets. This continues off when next scene opens.

SCENE FOUR

The interior of a large medieval tent-pavilion gay with heraldic devices etc, richly decorated. Noises, coming off L., must be heard between dialogues. Several small covered stools. The pavilion is well-lit but we should feel that outside entrance L. is a blaze of sunlight. SAM is discovered, sitting half-dressed with a few pieces of armour already on, looking gloomy. His shield, helmet and weapons are bundled together, near him, on the floor. He listens to the noise outside. Now we hear an umpire's voice off L. exactly like Wimbledon.

UMPIRE: *(Off L..)* Deuce! *(More noise.)* Vantage to striker! *(More noise.)* Game! Game – Set – and Match to the Red Knight.

A large unconscious and much battered knight is carried through the pavilion by attendants from L. to R. watched by SAM with shuddering interest. As soon as they have gone, LAMISON appears R..

LAMISON: *(Staying near entrance.)* Her Highness Princess Melicent would fain have a word with thee.

SAM: *(Rising and going, gloomily.)* I would fain have a word with her too – it might be the last.

LAMISON holds flap open for him but stays when SAM goes.

LAMISON: *(Sneering.)* Go, fool! *The Black Knight Hath My Heart* – quotha! The Red Knight hath thy liver.

Enter MALGRIM and NINETTE carrying similar bundle of weapons etc we have seen on floor.

NINETTE: Thank you so much, Lamison. Just what we needed.

LAMISON goes and they come in.

MALGRIM: *(Pleased with himself.)* Now you see, my dear Ninette, we exchange good weapons, shield and helmet the Princess provided for him – *(Kicks bundle on floor.)* giving him this utility trash once authorised by the Camelot Armour and Weapons Board. Ha-ha-ha! *(As they exchange the bundles.)*

NINETTE: Marvellous, darling!

MALGRIM: *(With mock modesty.)* Oh – just one of a few amusing ideas I've had, my dear Ninette.

NINETTE: *(With enthusiasm.)* What I adore about helping you, darling, is that you never stop having these brilliant original ideas – really lovely wicked plotting all the time. Anything else?

MALGRIM: Yes. Stay behind and persuade him he needs a tankard of ale to give him courage – *(He is moving to entrance R. carrying bundle from floor.)*

NINETTE: *(Delighted.)* And then you'll send him some abominable potion –

MALGRIM: *(As he goes.)* That'll render him faint and dizzy – ha-ha-ha!

Goes. More noises off. SAM returns, looking gloomier than ever.

NINETTE: Sam – why so downcast?

SAM: Lamison said the Princess wanted to speak to me – and I couldn't even get into the Royal Box – not properly dressed.

NINETTE: Wouldn't you like me to buckle your armour for you, Sam dear?

SAM: I'd like somebody to give me a hand but not you, Ninette dear.

NINETTE: *(All innocence.)* You don't trust me?

SAM: *(Gloomily.)* I'm a chump but not that much of a chump.

NINETTE: Oh – you *are* unfair. I've a good mind not to tell you about the special Tournament ale –

SAM: *(Hopefully.)* Tournament ale?

NINETTE: Brewed specially for competitors in tournaments. But of course it's no use my offering to bring you some.

SAM: Quite right.

NINETTE: But perhaps if I ask the barmaid to bring you some –

SAM: Barmaid? There isn't a barmaid here –

NINETTE: *(As she goes.)* Of course there is.

> *She goes. Noise off again. This time we hear what seems to be a boxing referee – slowly 'Six......Seven......Eight......Nine...... Ten' and the sound of a boxing bell. Again, a bleeding unconscious knight is carried through from L. to R..*

> *SAM has now opened the bundle of weapons etc. He gives the helmet a kick and dents it, to his astonishment and disgust. He tries the sword and at once bends it. In despair he leans on the spear and it begins to crack. All this amounts to a comic routine, needing careful timing and rehearsal. There should still be noises off. As he sits down in despair, the BARMAID from The Black Horse, exactly as we saw her before, enters carrying a pewter tankard.*

BARMAID: *(In her usual toneless style.)* One tournament ale.

SAM: *(Taking it.)* Thanks. *(Recognising her.)* Oh – it's you.

BARMAID: That's ri'. Turned out nice again.

SAM: I wish it hadn't. Well, I need this. *(He empties the tankard in one long go.)* Strong stuff. Bottle or barrel?

BARMAID: Don't ask me. That chap with a beard give it me for you – tricky bloke, I'd say –

SAM: *(Aghast.)* Malgrim?

BARMAID: That's him. What's up? All right, isn't it?

SAM: *(Uneasily.)* I don't know yet. By the way, you haven't seen Captain Plunket – y'know, the chap who ordered all the double Scotches –

BARMAID: No. Is *he* here?

SAM: He *was.*

BARMAID: I saw Mr Sanderson. He's offerin' ten to one on the Red Knight. They say he's bloody murder, that Red Knight.

> *FIRST SOLDIER looks through flap at L..*

FIRST SOLDIER: You're on next, chum. Ha-ha! *(Withdraws.)*

SAM: *(Groaning.)* Help me on with this armour, will you?

BARMAID: You're not going out there, are you?

SAM: *(Groaning.)* I have to.

BARMAID: My gawd! Well, I don't know which goes where –
but I'll do my best – you'll need all this an' more.

*Through this dialogue BARMAID, with some false starts, helps SAM
to put on his armour.*

Not very thick an' 'eavy, is it? They ought to do better for
you than this, if you ask me. Proper tinny stuff, in't it? I
thought it'ud weigh tons.

SAM: It did when I first brought it here.

BARMAID: Perhaps somebody's changed it. 'Ow yer feeling?

SAM: Terrible.

BARMAID: You don't look a good colour. I wouldn't stay out
long if I was you –

SAM: I don't expect to. Haven't got a couple of aspirins, have
you?

BARMAID: Sorry, I'm right out of 'em. Why don't you have a
nice lie down instead?

SAM: I probably will.

FIRST SOLDIER looks through flap again.

FIRST SOLDIER: Which do you fancy – mounted or on foot,
chum?

SAM: *(Gloomily.)* On foot.

FIRST SOLDIER: Quite right. 'Aven't so far to fall. A minute to
go, chum, then you're on. And what a hope you've got!

Withdraws. SAM now takes up his weapons and moves about a bit.

BARMAID: I've seen all this on the pickshers – but I don't
fancy it somehow. Rather 'ave cowboys an' Indians. Or

them gangsters in night clubs. Of course this is more *spectacular* – if that's what you fancy.

SAM: *(Who is probably trying to straighten sword.)* It's not what *I* fancy –

A LOUD VOICE: *(Off, L..) SIR SAM!*

SAM: *(Miserably calling.)* Coming.

BARMAID: Well, you've got a knight'ood out of it, 'aven't you? Best of luck, dearie, an' just remember – there'll always be an England.

SAM: *(Gloomily.)* Thanks very much.

He braces himself and strides out L.. Immediately there is a mixed outburst of cheering, booing, laughter etc. BARMAID peeps out through flap L.. MELICENT comes hurrying in R.. She is extremely agitated.

MELICENT: Tell me, have they begun? I thought I wouldn't mind – but now I daren't look. You'll have to tell me. What's happening?

BARMAID: They're sort of walkin' round each other, dear. Ooo – that Red Knight's a hell of a size, isn't he? Make two of poor Sir Sam. One-sided, I call it. Oo – now they've started.

Sound from L. of weapons clashing on armour etc.

MELICENT: Master Marlagram promised me it wouldn't be a real mortal combat – that he'd work an enchantment somehow –

BARMAID: 'E'll 'ave to 'urry up, then.

MELICENT: Who's winning?

BARMAID: 'Oo d'yer think? Our chap 'asn't an earthly. Ref ought to stop it. Red Knight's beatin' 'im back – beatin' im back – oo – what a slasher!

MELICENT: Oh – horrible – horrible! I ought to find Marlagram –

BARMAID: *(Excited herself now.)* They're coming this way – they're coming this way – Sam's slipped – No – he's up again – Red Knight's at 'im again – *(Sound of clashing nearer. The women shout above it.)* they're comin' nearer an' nearer –

MELICENT: Oh – I can't bear it – I can't bear it – *(Shouting urgently as she runs out R..)* Master Marlagram – where are you? Master Marlagram!

As she runs out, BARMAID backs from entrance L.. Clashing comes nearer. SAM now comes backing in, desperately warding off enormous blows from the Red Knight, a gigantic ferocious figure in red armour, with a huge (false) helmeted head with red hair, moustache and beard Once they are well in, CAPT. PLUNKET, for it is he, sees the BARMAID.

CAPT. P.: *(To BARMAID.)* Two tournament ales.

BARMAID: *(Without surprise.)* Two tournament ales – yes, sir.

Goes out R.. Flap at L. is being opened by FIRST and SECOND SOLDIERS but by the time they look in, CAPT P. jumps towards them, waving his sword.

CAPT. P.: *(Roaring.)* Keep out – ye mis-begotten, whoreson knaves – or I'll make sausages of your lights and livers –

He fastens the flap, then turns towards SAM and takes off the false head. He is hot and breathless.

CAPT. P.: Let's sit down, old boy. But we'll have to keep on making a clatter – or they'll wonder what's happening.

They sit down on stools so placed that they can easily hit each other's armour, which they do throughout dialogue.

SAM: *(Still dazed by the surprise.)* But – Skipper – how do *you* come to be the Red Knight?

CAPT. P.: *(Coolly.)* Enchantment, old boy. That fella Malgrim did it, last night. Very thorough job too. I really felt I *was* the Red Knight – ready to knock hell out of everybody – until a few minutes ago. Then something happened – either more enchantment – or less. Back to the Old Skipper again.

SAM: But how am I going to kill you?

CAPT. P.: Oh – we can work it out – with that head and the armour. Leave it to me, old boy. But keep some clatter going. Hit yourself for a change. Like this. *(Idly bangs himself with sword.)*

SAM: Trouble is – I must have been doped or something – I feel dizzy –

CAPT. P.: Thought you weren't looking too good, old boy. Ever been doped on the Gold Coast? I was, one time. Didn't come out of it for three weeks – and for two of 'em I thought a dam' great spider was biting my toes. Witchdoctor stuff, or course. Just as good as these fellas.

BARMAID comes in R. with two tankards.

BARMAID: Turned out nice again.

CAPT. P.: Thank you, dear.

SAM: None for me.

CAPT. P.: *(Taking a tankard.)* Put the other down there, then, dear. Unless you'd like it.

BARMAID: *(Primly.)* No, ta. Never touch a drop except for a port an' lemon now an' then – or a gin an' pep if me tummy's a bit off.

CAPT. P.: Best thing for that is a *Valparaiso Manana*. Three of them and you could eat a horse. And ten to one it's what you get too. Well – down the hatch!

BARMAID: *(As CAPT. P drinks.)* 'Appy days!

CAPT. P.: Now dear, you'll have to give us a hand. Sam's groggy. Try and keep going a minute or two, Sam old boy. You help me with this damned armour, that's a good girl. *(As she helps him take it off.)* Have to keep going somehow. Steady for some Red Knight stuff – *(In huge Red Knight voice.)* Surrender – you knock-kneed manikin! Surrender!

SAM: *(Doing his best.)* Never.

CAPT. P.: *(In his ordinary voice.)* Louder. They'll never hear you old boy. *(In his Red Knight voice.)* Surrender, I say!

SAM: *(Producing a shout.)* Never! *(Groaning.)* Crikey! That's given me a headache.

CAPT. P.: *(Red Knight voice.)* Nobody'll come in here – or I'll slice his nose off – *(In his ordinary voice, to BARMAID.)* Now look, dear – just keep clattering away with this sword while I take a breather and work something out –

He gives the BARMAID his sword and she bangs away with it at a breastplate, while he, now out of his armour, drinks with a tankard in each hand.

SAM: *(Recovering a little.)* By the way, what happened to Dimmock?

CAPT. P.: No idea, old boy. Malgrim turned me into the Red Knight before he started on Dimmock. *(To BARMAID.)* Not getting tired, dear, are you?

BARMAID: A bit. But it makes a nice change. *(We hear from nowhere, MARLAGRAM's 'He-he-he!')* That's that very old conjurer. Get on your nerves, don't they?

CAPT. P.: Now Sam old boy – can you pull yourself together just for half a minute – won't take a second longer?

SAM: *(Rising shakily.)* I'll try. What do I do?

CAPT. P.: Get ready to show 'em the head. When they've seen it, you be ready to run off with it, Violet –

BARMAID: Queenie.

CAPT. P.: Of course – Queenie. Well, you run off with the head –

BARMAID: Where to?

CAPT. P.: Anywhere – ladies' cloakroom.

BARMAID: They won't want it in there.

CAPT. P.: *(Hastily.)* Don't argue, Queenie dear. Now, Sam old boy – here's your sword and the head – *(Giving them to him.)* Get ready to wave the sword and hold up the head

when I open that entrance. *(SAM goes unsteadily towards L..)* Stand clear for the Red Knight's death scene – *(He takes his sword from BARMAID and bangs hard, then shouts in Red Knight voice.)* Mercy! Have mercy! O-o-o-oh! *(In ordinary voice.)* Here we go, chaps.

Throws down sword, kicks armour, rushes with BARMAID to entrance L., unfastens the flap, and shouts.

He's done it. He's done it.

BARMAID: *(Shouting.)* Sam's won. Sam's won.

SAM waves sword and holds up the head. A great cheer from off L.. Then the two SOLDIERS, HERALDS, and all available players, come swarming in, cheering. CAPT P. supports SAM and at same time tosses the head to BARMAID, who runs across to R. as if she were playing rugger with it. As soon as she is off R., the KING, MELICENT, NINETTE, ALISON, MALGRIM, MARLAGRAM, enter from R..)

CAPT. P.: He's all right – not badly hurt. But give him air – give him air.

MELICENT: *(Embracing SAM.)* Oh – Sam darling – it was wonderful. You're not hurt, are you?

SAM: *(With effort.)* No, darling – just dizzy – that's all –

KING: Stout fella! Well, you can take it easy now – for an hour or so. The dragon's in position down in the wood but it's asleep. Better not wake it up yet. *(With a gasp, SAM slithers down to his knees, almost out.)* Must knight you properly too. *(Touches SAM on shoulder with sword, which sends SAM further down.)* Arise – Sir Sam! *(But SAM is out cold.)* We said – *Arise, Sir Sam!*

MELICENT: *(Getting down to SAM.)* Oh – father – don't be so idiotic. Help me with him – you men.

Two soldiers, assisted by MELICENT, followed by KING, carry SAM. CAPT. P. also goes with them. They all go off R.. Rest of company, remaining on stage, are now addressed by MR. SANDERSON, an obvious bookie and not in medieval dress.

MR. S.: Well, people – the favourite's lost – and I'm paying out ten to one on Sir Sam. Anybody lucky?

BARMAID: *(Offering him a betting slip.)* Yes, me, Mr. Sanderson.

MR. S.: That's right, Queenie dear – you're the lucky lady today. *(He hands her a bag of money.)* Now people, here's your chance to get your money back. I'm offering eleven to two on the dragon – eleven to two against Sir Sam – here's another chance to back your boy – the chance you missed before – eleven to two on the dragon –

As he begins doing business, scene fades.

SCENE FIVE

Small tent. SAM is resting. After a moment KING and MELICENT enter. Latter is carrying a cloak and ancient parchment MS.

KING: How are you feeling now, Sir Sam?

SAM: Better than I did, sir. Though not too bright.

KING: Dragon's still asleep but it'll be waking soon – so, if you're taking it on, you'd better get ready and go along.

MELICENT: But – father – you have to explain first. You know, you promised.

KING: So we did. Well, this is the situation, my dear fella. You're now Sir Sam – conqueror of the Red Knight – and of course no more dungeon for you. You're free. Give you a note to King Arthur, if you like.

SAM: Thank you, sir. But what about this dragon?

KING: Coming to that. Now you have the choice. You're free to go – no dragon, if you don't want to take it on. But no dragon, no daughter. Can't marry Melicent if you don't fight the dragon.

MELICENT: *(Anxiously.)* You have to choose, Sam.

SAM: I see. What – er – sort of dragon is it? Just a little one perhaps?

KING: *(Heartily.)* Not at all. First-class dragon. Only caught a glimpse of it – but seemed a magnificent brute –

SAM: *(Unhappily.)* It did, did it? You do realise, Melicent, I don't know how to fight a dragon – never even seen one before –

MELICENT: *(Gravely.)* Yes, Sam. You'd have to be very brave. And perhaps I'm not worth it.

SAM: Yes, you are. All right – I'll have a bash at the dragon –

MELICENT: Oh – Sam!

KING: Good man! It's a private contest this time, by the way – no spectators allowed –

SAM: I'm glad to hear it.

KING: That's the rule now. Last time the public were admitted, about fifty of 'em got hurt. When a big dragon, like this one, really gets desperate –

MELICENT: No – please, father!

SAM: *(Wistfully.)* In the stories I used to read – the dragon-challenger usually had some sort of magic help – an invisible cloak – or –

MELICENT: *(Producing gaudy but tattered cloak.)* Well, there's this cloak – but it's terribly moth-eaten – look – *(Spreading it out to show holes.)* And of course where the holes are you won't be invisible – though of course it might at least *confuse* the dragon –

SAM: *(Hopefully.)* Better than nothing, certainly. Some of me would be invisible –

MELICENT: *(Dubiously.)* But there's another difficulty, Sam darling. Father, you tell him –

KING: *(Cheerfully.)* Fact is, my boy, we're not certain about this cloak. Haven't had it out for years. Now it's a dragon-challengers' cloak, no doubt about that. But there's two kinds, and we can't remember which this is. There's the cloak that makes you invisible to the dragon. But there's

also the dragon-rousing cloak – specially designed and coloured to make the dragon very angry and full of fight –

SAM: *(Indignant.)* And you can't remember which this is?

MELICENT: I'm afraid not, darling. Isn't it a nuisance? Of course the holes might make him less angry –

SAM: The cloak's out. No cloak. Anything else?

MELICENT: *(Unfolding parchment.)* Well then, there are these old instructions about how to deal with the different kinds of dragons, but they're awfully difficult to follow – *(She shows it to SAM.)*

KING: Have to puzzle it out between you. Your eyes are younger than ours.

MELICENT: *(As they look at parchment.)* Now we know this is a fiery dragon –

SAM: *(Gloomily.) And* big. Turn to the larger sizes –

MELICENT: *(After more reading.)* It says here that if the beast be shovel-tailed, crouch low and to the left for its first spring. Can you remember that, darling?

SAM: Yes. But *is* this one shovel-tailed? And what happens if it isn't?

MELICENT: It says if it's a narrow-tailed dragon with a yellow cross underneath, you musn't crouch low but jump high to the right –

SAM: But – look – if it's a horny short-tail you must keep moving all the time. But how the blazes do I know if it's a horny short-tail or a yellow-cross narrow tail or a shovel-tail –

KING: Only saw it a long way off – but it looked like a shovel-tail to us. Oh – before we forget – our chief armourer has a special sword for you – two-handed of course – ordinary sword won't make any impression on a dragon. Well – now – best of luck, Sir Sam – and better count on its being a shovel-tail and crouch low and to the left for its first spring –

SAM: *(Gloomily.)* Thank you, sir. But I think I'll try the horny-short-tail technique and keep moving all the time – but leave the instruction book –

MELICENT: Oh – Sam – I'm beginning to feel frightened now –

KING: Come along, daughter. That's no way to talk to a hero –

MELICENT gives SAM a quick kiss, then goes out with KING. Left to himself SAM gloomily continues reading.

SAM: *(Reading.)* 'If the beast should have a broad fishtail with scarlet markings, then at the first pounce it be best to spring high into the air' Oh – murder! 'Yet divers of these broad fishtail dragons have a foul trick of swinging upward with their monstrous forepaws' – Oh shut up!

He folds up the parchment, disgustedly, then looks up as an enormous double-handed sword make its appearance, held out to him by the ARMOURER, a very small man. Scene fades.

SCENE SIX

Dragon's Lair Glade. Dragon's head can be seen at L.. Eyes are closed and puffs of smoke are coming regularly out of nostrils. CAPT. P. is sitting rather downstage centre, where he can see the dragon but with a slight turn can also see anybody entering from back R.. He is dressed in a queer mixture of modern and medieval costume, and is puffing away at a cheroot keeping time with the dragon's puffs. The light is the sunlight – golden misty in its distances – or a beautiful summer morning. After a few moments for the scene to establish itself, ANNE DUTTON-SWIFT and PEGGY enter back R.. They are wearing the same clothes they wore in Act One, but now look rather untidy and weary. PEGGY carries a notebook and file of letters to be answered. They see CAPT. P. and he turns their way as they come down.

ANNE: Good-morning.

CAPT. P.: *(Rising.)* Good-morning, ladies.

ANNE: Tell me, are you one of us or one of them?

CAPT. P.: Depends who you are, doesn't it?

ANNE: I'm Anne Dutton-Swift – of Wallaby, Dimmock, Paly and Tooks – the advertising agency.

PEGGY: And I'm Peggy, Mr Dimmock's secretary.

CAPT. P.: Then I'm one of you. Cap'n Plunket, ladies – the Old Skipper –

ANNE: *(Delighted.)* Why of course – I remember you now. You're the heavenly man who did the film about fish that could climb trees –

CAPT. P.: *(Delighted, shaking hands.)* I knew I'd meet somebody one day who'd seen that film – and now here you are – pretty as a picture too. Wonderful!

ANNE: *(Equally pleased with him.)* Yes – isn't it? Just gorgeous meeting you here of all places!

PEGGY: Mr Dimmock *is* here, isn't he?

CAPT. P.: He *was*. Last night we had a few flagons and stoups together – but then we ran into trouble and now he seems to have disappeared – enchantment probably –

ANNE: Is there *really* enchantment here?

CAPT. P.: Place is stiff with it. Early this morning I was a huge Red Knight – about seven foot high with ginger hair bristling all over my face. Felt like him too for a time. As for Dimmock, I'll try to find out what's happened to him – once this dragon business is settled.

PEGGY: Oh – there's dragon business, is there? Where?

CAPT. P.: Here. I was just having a quiet smoke with the dragon. Look – *(He leads them downstage where they can see the dragon.)*

ANNE: *(Alarmed.)* Oh – my goodness! And I thought they never existed!

CAPT. P.: They don't in South Kensington – but they do here – different set-up altogether. But don't worry about this dragon. He's asleep – and probably won't wake up until Sam's ready to challenge him.

PEGGY: *(Bitterly.)* Oh – Sam's in this is he? He would be. Typical artist. He ought to be hard at work now for Wallaby, Dimmock, Paly and Tooks, not challenging dragons. His holiday isn't until September.

ANNE: Captain Plunket, we've been lost ever since we arrived here. *Do* tell us where we ought to go.

CAPT. P.: *(Leading them up R. again.)* Up to the Castle, I'd say. Take the first turn to the left, then you can't miss it.

ANNE: Thank you *so* much. *(As they go, to Peggy.)* I think he's a sweet man – don't you?

PEGGY: No

They go out R.. CAPT. P. comes back, goes fairly close to the dragon and looks at it, then returns to his original place and re-lights his cheroot. After a moment or two, Sam enters slowly R.. He is lightly armoured and carries the enormous sword, also the parchment. He looks tired.

SAM: *(Wearily.)* Hello, Skip! Where's the dragon.

CAPT. P.: Here, old boy. Still sound asleep. Must have had a dam' good breakfast off somebody. How are you feeling?

SAM: Terrible. What – er –sort of dragon is it?

CAPT. P.: I won't deceive you, old boy. He's big – a socking great beast. And got everything but the kitchen stove. Look!

SAM comes further down and takes a look at the dragon.

SAM: *(Gloomily.)* He's got the kitchen stove too. *(He goes upstage again, puts down the sword and opens the parchment.)*

CAPT. P.: No time for reading, surely, old boy?

SAM: *(As he looks at it.)* It's a dragon-fighters' instruction book the King dug out for me. I dunno – the old man really is a bit slap-happy –

CAPT. P.: Only king I knew really was Um-dunga-sloo – way back off the Ivory Coast. Sold him two hundred and fifty

alarm clocks and five gramophones – only one of 'em worked.

SAM: Let's stick to the dragon. Would you say it's a Shovel-tail, a Narrow-tail with a yellow cross, a Horny Short-tail, or a Broad Fishtail with scarlet markings?

CAPT. P.: Haven't a clue, old boy. And you can please yourself, but I don't propose to go and examine his tails.

SAM: *(Gloomily.)* Neither do I.

While SAM still looks at the parchment, CAPT. P. takes a look at the dragon. The puffs are faster and larger now.

CAPT. P.: *(Returning to SAM, lowering voice.)* I think he's getting steam up.

SAM: *(In despair.)* Oh – lord!

CAPT. P.: *(Shaking hands.)* Well, all the best, old boy. Like to give you a hand but of course it's against the rules. But I won't be far. *(As he goes.)* Good luck, old boy.

He goes up and out R.. SAM now takes up his enormous sword, and tries a two-handed swing or two, not very successfully. A lot of smoke from the dragon now, great snorting and puffing noises, like an angry train. SAM comes down to take a look at it, and listens in dismay. He returns to his former position. CAPT.P. cautiously peeps in up R..

CAPT. P.: *(In loud whisper.)* Anything happened?

SAM: *(Same tone.)* Not yet. But he sounds as big as a railway train.

CAPT. P.: Have to challenge him, y'know, old boy. One of the rules.

SAM: I wish you'd shut up about the rules.

CAPT. P.: Take it easy, Sam old boy. Leave you to it now, eh?

He withdraws. SAM pulls himself together, comes down and round and faces the dragon.

SAM: *(Muttering.)* This is going to sound dam' silly. *(Loud but uneasily.)* Look here – I'm challenging you to – er – combat. We needn't make it mortal – what d'you think?

The dragon should now open one eye.

Well – what d'you think?

DIMMOCK: *(Inside dragon's head, no smoke now.)* No, Sam. Stop it.

SAM: *(Astonished.)* Stop it?

DIMMOCK: Yes, it's only me.

SAM: How do you mean it's only you?

DIMMOCK: It's *me – Dimmock.*

SAM: Dimmock? What are you doing inside a dragon?

DIMMOCK: *(Crossly.)* I'm not *inside* the dragon. I *am* the dragon. And it's like having an acid stomach ten feet long. *(Coughs.)* So hot and smoky too.

SAM: How did it happen?

DIMMOCK: That enchanter, Malgrim, did it. After he turned the Skipper into the Red Knight, he turned me into a dragon –

SAM: But I'm supposed to knock you off in order to marry Melicent -

DIMMOCK: *(Hastily.)* Now don't be foolish and hasty, Sam. You and I have always been good friends. None of the firm's artists have been better treated than you. And if you feel you ought to have a rise, I'll gladly take it up with the board –

SAM: You can't take anything up with the board, looking like that, can you? In the meantime, what am I going to do? I promised to challenge the dragon –

DIMMOCK: Yes, but not *me*. Go and find a proper dragon.

SAM: No, you're the dragon I'm supposed to overcome – nothing said about any other dragon –

DIMMOCK: Yes, Sam – but if you have me disenchanted – or whatever they call it – and I'm me again and there's no dragon, then that's the same thing. So you go and find that enchanter. Or the other one – the old one. I'll tell you what, Sam. I'm prepared to offer one of them a seat on the board. I'll put it in writing. *(Calls.)* Peggy! Peggy!

PEGGY enters R. with notebook and file of letters. SAM stares at them both in amazement.

PEGGY: *(Showing no surprise.)* Yes, Mr Dimmock?

DIMMOCK: Take a letter to Mr. Paly. *Dear Fred – I'm writing this from a place called Peradore, where I ran into a little trouble – (He breaks off.)* Just a minute Peggy.

CAPT. P. now enters R. and comes down and across.

Don't just stand there staring at us, Sam. Go and find those enchanters. It's just as important for you as it is for me. Skipper – you go with him.

CAPT. P.: Dimmock, is it? Tell me, old boy, do you *feel* like a dragon?

DIMMOCK: I did – very nasty too – but it's worn off. Now, Skipper, you go with Sam and get me disenchanted – you know what we decided about the company – so if you have to then offer both of them a seat on the board.

CAPT. P.: Can do, old boy. But in the meantime, we can't have you staying here, dictating letters. You're supposed to have been knocked off by Sam. You'll have to hide in the wood until you're disenchanted.

DIMMOCK: All right. But hurry up with it. *(As SAM and CAPT.P., carrying the sword between them, begin to go R..)* Where was I, Peggy?

PEGGY: *(Reading.) Dear Fred – I'm writing this from a place called peradore, where I ran into a little trouble –* that's all

DIMMOCK: *(Dictating.) But with a bit of luck everything now might work out for the best. I'm discussing a merger here with a very smart concern – Marlagram and Malgrim – enchanters –*

PEGGY: I don't think Mr Paly will believe in enchanters.

DIMMOCK: He mightn't now – but he will next time I talk to him. Where was I? Oh- yes – enchanters. *One or both of 'em might want to come on to the board, which means, first as we've often agreed, dropping Wallaby, but also Tooks. When I explain the set-up I have in mind, Fred, you will agree that Tooks would never fit it in – too narrow-minded and has not got the enterprise. We might try one of the enchanters looking after finance and the firm's taxation problems.*

Light and voice begin to fade together at beginning of this last speech, and scene has faded out by the time speech ends.

SCENE SEVEN

Enchanters' Dining-room. MARLAGRAM enters, sits down at table.

MARLAGRAM: *(As if addressing invisible waiter.)* Bowl of porridge.

It appears magically on the table, and at once he begins eating it. After a moment MALGRIM enters and sits opposite.

Have a bowl o' porridge, like me.

MALGRIM: Great Beelzebub – no! I don't have to eat slops yet. *(Sharply addressing invisible waiter.)* Duck and green peas. Flagon of Bordeaux. *(Nothing happens. MARLAGRAM watches with a malicious grin.)* Didn't you hear me? *Duck and green peas. Flagon of Bordeaux…*

MARLAGRAM: *(When it is obvious the magic isn't on.)* He-he-he-he! *(Addressing invisible waiter.)* Bowl of porridge.

A bowl of porridge appears in front of MALGRIM. He is furious.

MALGRIM: *(Jumping up, angrily.)* This is absolutely intolerable, Uncle. We agreed from the first that no matter what magical moves and countermoves we might have to make

against each other, neither of us would interfere with the domestic arrangements. And now look what you've done!

MARLAGRAM: Who started breaking arrangements, lad? You did. As soon as that young man Sam challenged the dragon, you should have changed the dragon back into what's-his-name. Then there'd be no dragon and Sam could have claimed his Princess.

MALGRIM: *(Sitting again.)* Why should you care? She's given you the Merlin brooch.

MARLAGRAM: Not she! You ought to know what women are, even young ones. I don't get that brooch till the King's given his consent to her marrying Sam.

MALGRIM: O-ho! No brooch yet – eh?

MARLAGRAM: He-he! No lunch yet neither.

MALGRIM: Pooh – I'm not hungry –

MARLAGRAM: And another thing, lad. Where's that girl Ninette gone to – eh! He-he-he! Well, you know that flock of geese just below the Castle? He-he-he! Now she's one of them –

MALGRIM: *(Jumping up, angrily, ready to go.)* Why – you unscrupulous old –

MARLAGRAM: *(Cutting in.)* Sit down, boy, there's over two hundred geese there – you'd be all day on it. I'll turn her back as soon as we've finished our business. Plenty of business too. Sam and that Captain Plunket are on their way here.

MALGRIM: How do you know?

MARLAGRAM: I'm an enchanter, aren't I lad? And a better one than you – an' of course if you have an enchanter son or nephew, you'll be better than him. Remember, ours is a profession of wise men. So we have regress instead of progress. That means that as we grow old we're always the best men in the profession –

MALGRIM: But at that rate – in a few hundred years –

MARLAGRAM: They'll be no better than amateurs – right. People won't believe what we could do. But they're here. *(Calling.)* Come in, come in!

Enter SAM and CAPT. P.
Sit down, sit down. What'll you take to drink?

CAPT. P.: Two large Malmsleys.

MARLAGRAM: *(Addressing invisible waiter.)* Two large Malmsleys – sharp!

CAPT. P.: *(As drinks appear on table.)* Service! Couldn't manage a cigar, could you, old boy?

MARLAGRAM: Not here. Not for hundreds and hundreds of years.

CAPT. P.: *(Ready to drink.)* Well – happy days! *(Drinks.)* Now, Sam old boy, tell them.

SAM: *(Earnestly.)* Look here – you two – you've simply got to disenchant Dimmock and make that dragon vanish – or I'm sunk. And, after all, I didn't know the dragon was Dimmock when I went to challenge him.

CAPT. P.: Quite right. I was there. Who'd have thought that was Dimmock – a thing that looked like the *Flying Scot* with scales and knobs on. I say Sam behaved like a hero – so he *is* a hero. But he won't be if that dragon hangs about dictating letters to a secretary.

MARLAGRAM: You needn't argue with me. I want to get on with company business. So I want Dimmock here and no dragon, just as much as you do. But it's all a bit tricky, Captain – *(He hesitates.)*

MALGRIM: *(In grand but smooth manner.)* Gentlemen, I'll explain what it is my uncle shrinks from admitting. He can't restore Dimmock to his ordinary shape without my help.

MARLAGRAM: If I'd time I could –

MALGRIM: Possibly. Possibly not. But you haven't time.

SAM: *(Urgently.)* That's true, we haven't. That dragon ought to have gone *now*.

MALGRIM: Now you can only have my help on my terms. First – a half share in the Merlin brooch. Secondly a seat on the board of the new company. Thirdly, Uncle, you take Ninette out of that flock of geese.

MARLAGRAM: That's easy. It's the other two I don't like, especially the one about sharing Merlin's brooch –

SAM: Master Marlagram – please –

Enter MELICENT, who can be wearing a cloak over her dress for final scene. She enters so quickly, speaking as she does, that we suspect that magic is at work.

MELICENT: Yes, Master Marlagram – you've been helping us, and we're grateful – but don't spoil it now –

MARLAGRAM: Now just a minute! How did *you* get in here?

MALGRIM: Exactly what I was about to ask. You didn't do this by yourself –

MARLGARAM: Nobody could, without permission. After all, we *are* enchanters –

MALGRIM: So who did it?

MELICENT: *(Coolly, smiling.)* Well, if you must know, a second cousin of mine has just arrived the Castle – and she's a girl who was taught by Morgan le Fay –

MARLAGRAM & MALGRIM: *(Together.)* WHAT? *(They now speak very urgently to each other.)*

MARLAGRAM: Nephew, we're having no young sorceresses on the job here –

MALGRIM: At the last conference in Avalon we were definitely allotted this territory –

MARLAGRAM: But you know what women are! Look, lad, we must clear up here – Dimmock, dragon, company business and all –

MARLGRIM: Right, Uncle – and then we'll see who's working the magic round here –

MARLAGRAM: Excuse us! *(They hurry out together. MELICENT laughs.)*

MELICENT: I thought that would set them off. Here isn't any second cousin who's been with Morgan le Fay. I walked straight in here. I think the invisible demon who looks after them is sulking about something. Wasn't I clever, Sam darling?

SAM: *(Rather dazed.)* Yes, you were, Melicent darling.

CAPT. P.: Fact is, old boy – and this is where you want to watch it – they're all sorceresses when they want to be. I think I'll try this invisible demon. *(Calling as MARLAGRAM did.)* I'll have another large Malmsey.

A glassful of wine, from the darkness above, descends on his head. Ghostly laughter from above, in which MELICENT joins as CAPT. P. makes spluttering sounds.

MELICENT: *(Solemnly now.)* Sam darling, as soon as my father's given his consent, we must decide – first – where the wedding ought to be – and then of course what I ought to wear –

SAM: You'll have to decide what you're doing to wear –

MELICENT: *(Calmly decisive.)* Don't worry, darling, I intend to –

SAM: As for the wedding, I think it ought to be mixed – I mean to say, both worlds are getting rather mixed now, so both worlds ought to be in it.

CAPT. P.: Dead right, old boy. Help the company too.

MELICENT: What company?

CAPT. P.: Just business, my dear. Leave it to us.

The enchanters come bustling back, talking as they come.

MARLAGRAM: *(Hurriedly.)* All fixed. He-he-he! Dimmock'll be here in a minute. We've left a dragon's head that the King's inspecting. He'll give his consent. We've fixed that too. He-he-he!

MALGRIM: So we'll trouble you for that brooch, Princess. I know you have it with you.

MELICENT: Well, I suppose I must. *(She puts the brooch on the table.)* And now I can tell you there isn't a girl sorceress at the Castle.

MARLGRAM: *(Chuckling.)* No, we know there isn't. But you're only a day out. There's one coming tomorrow –

MALGRIM: She's seen Sam in a magic mirror –

MELICENT: *(Horrified.)* What? *(She takes SAM's arm possessively.)* Then he won't be there. But *I* will – and if she thinks she's coming here – *(She is interrupted by the entrance of DIMMOCK, who looks hot and flustered.)*

DIMMOCK: *(Breathlessly.)* Sorry – gentlemen – but what with suddenly not being a dragon – and then being shot here out of that wood – I can tell you –

MELICENT: Let's go, Sam darling, then you can ask my father for my hand, and then we can decide about the wedding –

They go out. DIMMOCK sits at the table as he speaks.

DIMMOCK: Before we get down to business, I must tell you I could do with a drink –

MARLAGRAM: Certainly –

CAPT. P.: Hold it. I'm against this invisible demon service. Isn't there any other way.

MALGRIM: Why not? *(He clasps his hands. BARMAID suddenly appears.)*

CAPT. P.: *(Seeing her.)* That's more like it. Two large whiskies, Queenie.

BARMAID: *(Calmly.)* Two large whiskies. Turned out nice again, hasn't it?

She goes, returning at some appropriate moment with the whiskies without speaking. The four men are now very much in conference.

DIMMOCK: Who's in the Chair?

MARLAGRAM: I am. He-he-he. Senior man present.

MALGRIM: Well, Mr Chairman, you've agreed to the following conditions. One – that Messrs Marlagram and Malgrim are invited to join the board of Wallaby, Dimmock, Paly and Tooks. Two – that Wallaby and Tooks should be asked to resign and their voting stock transferred to Marlagram and Malgrim. Three – that the new concern be known as Marlagram, Malgrim, Dimmock and Paly –

DIMMOCK: *(Cutting in.)* No, Mr Chairman, I'll accept your seniority, but I'm too well-known in the advertising world to follow Mr Malgrim, for all his exceptional ability. I propose that the new agency be known as Marlagram, Dimmock, Malgrim and Paly.

MARLAGRAM: I'll accept that, so no need to vote on it – he-he-he! Now you want Captain Plunket to be general manager of the subsidiary tourist agency company, to be called Marlagram, Malgrim and Dimmock – eh?

DIMMOCK: How did you know?

MALGRIM: After all, we *are* enchanters.

CAPT. P.: And it's going to be tricky running an expense account with you fellows.

MARLAGRAM: *(Very briskly.)* We split fifty-fifty on all English and Peradore business. But I take seventy per cent of anything from Scotland and the Orkneys – I've got a good connection up there –

MALGRIM: And I want at least sixty-five per cent of all commissions from Wales and Lyonesse –

DIMMOCK: There isn't such a place –

MALGRIM: There is *now* and *here* –

DIMMOCK: But it's going to take some selling at our modern end –

MALGRIM: On the contrary, to visit a place that's vanished – what could be more attractive –

CAPT. P.: I agree with Mr Malgrim. A three days visit to Lyonesse – full board and all excursions –

MARLAGRAM: Chair, chair, gentlemen!

DIMMOCK: Now look, Mr Chairman, what I say –

MALGRIM: Mr Chairman, I only want to point out –

During these last speeches, the light has been fading, but not the voices, which if anything are louder and louder. Silence when light finally goes. Light comes up at other side of stage for TV ANNOUNCER, either man or woman.

ANNOUNCER: After the news there will be our usual *Cooking For You* – tonight it is How To Boil An Egg. Then in tonight's Hot Spot programme – by special arrangement with the Malagram, Malgrim and Dimmock Travel Agency, we shall be taking you over to the Princess of Peradore and Sam Penty combined Two-world Wedding Feast –

As light fades, great burst of brassy music.

SCENE EIGHT

The Wedding Feast. Brilliant lighting. The whole company is seated at table. In the middle are MELICENT, wearing gorgeous medieval costume, and on her L., beginning the modern half, is SAM, in a dinner jacket. On SAM's L., are the modern characters. On MELICENT's R., is first the KING, then the other medieval characters. (Where there has been doubling, the most important character should be in its own half.) There must be the sharpest possible contrast between the two halves, not only in the gorgeous medieval costumes and rather dingy modern evening dress but also in what is on the table, for in the Peradore half the table is loaded down with gigantic and opulent medieval dishes and confections

– boar's head, peacock, swan, barons of beef, a castle of sweetmeats etc and flagons, tankards, etc, etc – while in the modern half everything is very meagre indeed, in the meanest style of public dinner. If it is possible, understudies and/or supers should furnish two or three gorgeous medieval serving men or maids at one side, pouring out enormous helpings of wine and ale, and on the other side a miserable waiter and waitress gingerly filling tiny glasses with something pale.

As scene fades in, DIMMOCK, who is holding a great many typed sheets, is standing up and coming to the end of a very long speech.

DIMMOCK: ... And – er – concluding these brief remarks –
for of course I had no idea I would be – er – called upon
tonight – to help propose this Toast – finally – I wish to
assure all our friends from Peradore here tonight – that if
– er – at any time – they wish to pay us a visit – we on our
side will be only too happy to – er – show them all we can
– and to explain, as best we can, all those – er – astonishing
developments which have made – er – for progress – and
– er the triumph of our civilisation – er –

*The pneumatic drill starts up. He hurls down his notes, then sits
down. Drill stops. He gets up, drill starts again. He gives it up now.
Drill stops.*

KING: Master Marlagram will reply for Peradore.

MARLAGRAM: *(Rising.)* Your majesty – ladies and gentlemen
– he-he-he! – having listened to our friend Mr Dimmock
for the last half-hour, I will now be very short indeed. If he
and our friends in his world should ever tire of the progress
they are making, and the triumphs of their civilisation, and
are ready to make do with a little peace and quiet, good
food and drink, pure air, leisurely talk, a night's sleep and
no radio-activity to devour the marrow in their bones, we
on our side will do our humble best to entertain them.
(Applause. He sits, chuckling.)

KING: Captain Plunket will now propose the Toast.

CAPT. P.: *(Who is tight.)* Your Majesty – Princess Melicent – Sir Sam – boys and girls – shan't talk long as most of you seem to be thoroughly plastered.

BARMAID: *(Calling.)* Never! *(She hiccups.)* Pardon!

CAPT. P.: Princess an' Sam say they'll live in both our worlds. Quite ri'. Same here. Lot of talk – seem to remember – about One World. I say – Two Worlds. So does Princess – so does Sam. Fact that there's a difference of a day – that at this end of the table it's Wednesday and that end it's Tuesday – who cares? Great advantage really. Work it properly – have two Saturdays running – an' never a Monday. One time in Mauritius – thought it was Thursday for a week – grew a beard an' nearly learnt how to play a mandolin – tell you about it someday. But now it's time for the happy pair to wish us all long luck an' the best of life. Join Toast in drinking us.

They stand and drink to the bridal pair. Applause and cheers.

PRINCESS: *(Smoothly.)* As I am entirely unaccustomed to public speaking, while thanking you for the way in which you have both proposed this Toast and received it, I shall ask my husband to reply on my behalf. *(Sits to applause.)*

SAM: Thank you, thank you! Nobody realises better than I do that I don't deserve to have won the hand and heart of a beautiful smiling Princess. I've not been clever, I've not even been very brave. Just lucky. All I can say on my own behalf is that when at last the great day arrived – I knew at once, without anybody telling me, that it was the Thirty-First of June. *(To the audience, smiling.)* That's the secret, ladies and gentlemen. Never mistake for just another day – that day of all days – the glorious Thirty-First of June.

Burst of music as he sits down and the whole table breaks into apparent animated talk. Curtain.

End of Play.

JENNY VILLIERS

Note: This version of the play is substantially different from the short novel, *Jenny Villiers*, which I based on my original version of the play, produced at the Bristol Old Vic.

Note: Jenny Villiers and Ann Seward are played by the same actress, and Alfred Leathers and John Stokes by the same actor. These are deliberate doubles, but there are of course plenty of ordinary doubles as well.

JENNY VILLIERS	ANN SEWARD
ALFRED LEATHERS	JOHN STOKES
JAMES WHITEFOOT	JULIAN NAPIER
OTLEY	JOURNALIST
MAYOR	SAM MOON
DR. CAVE	SIR ROMFORD TIVERTON
AUGUSTUS PONSONBY	SPRAGG
MRS. LUDLOW	NURSE

1st and 2nd ACTRESS, LANDLORD and DOCTOR all played by understudies. They appear in Scene I as guests or members of Cheveril's company, and in the banquet scene as members of the Shakespearean Society. About five walk-ons, especially for Scene I, and possibly the banquet scene, would complete the company.

Add Cheveril, Pauline, Kettle to above lists of doubles, and you have eleven – plus four small understudy parts above – fifteen – plus five walk-ons – twenty.

Characters

PRESENT DAY

MARTIN CHEVERIL

a dramatist

ANN SEWARD

a young actress

PAULINE FRASER

leading lady in Cheveril's Company

ALFRED LEATHERS

an old actor

JAMES WHITEFOOT

leading man

OTLEY

manager of Theatre Royal

DR. CAVE

MAYOR OF BARTON SPA

other members of Cheveril's company, guests at
party, waiter and waitress.

ONE HUNDRED YEARS AGO

JENNY VILLIERS

a young actress

WALTER KETTLE

stage manager

EDMUND LUDLOW

manager of Theatre Royal Co.

FANNY LUDLOW

his wife

JULIAN NAPIER

leading juvenile

JOHN STOKES

an old actor

SAM MOON

a comedian

AUGUSTUS PONSONBY

secretary of Shakespearean Society

SPRAGG

a writer of farces

1st ACTRESS

2nd ACTRESS

NURSE (MRS. PARSONS)

JOURNALIST

LANDLORD

DOCTOR

SIR ROMFORD TIVERTON

Other members of Ludlow's company. Also, members of Shakespearean Society.

The action, which is continuous, takes place in the Green Room of the Theatre Royal, Barton Spa.

Act One

Scene: The Green Room of the Theatre Royal, Barton Spa

It is a large room, probably dating from the middle of the eighteenth century, and it has been carefully preserved. It is panelled in dark wood, and the general effect is rather sombre. Downstage Right (actors') is the door to manager's office, etc. This is the only door in sight, and there are no windows visible. The room is, so to speak, waisted at the centre, and probably there is a pillar at each side, with an arch between. This narrowing at centre forms two oblique alcoves R. and L., behind which the extra little scenes are set. In alcove R. is a large case in which are old theatrical costumes and properties, among them a crimson gauntlet glove. Alcove L. can have a similar case, or only an old theatrical portrait. Downstage L. below alcove, is a small desk with telephone, light, inkstand, etc., and a chair to go with it. This desk need not be period. But all the other furniture should not be later than about 1840 as it may be used in the ghost scenes. Between pillars and back wall are entrances, including door down to stage L. that are not seen. On the back wall are portraits and old playbills, including the portraits mentioned in the text. The back wall must not be set too far back, as the White Hart banquet scene at the end of Act I must be set behind it; and centre portion of the back wall must be easily removable for this scene. Also on the back wall is a fairly large trick mirror – for JENNY's final appearance in Act II. Small wooden chairs, same colour as panels, against back wall. Darkish stage-cloth covering the whole room.

At rise, a cocktail party, given in order that the MAYOR and prominent citizens of Barton Spa should meet Cheveril's Company, is just coming to an end. Upstage beyond pillar R. we see end of table with drinks and sandwiches on it, and WAITER and WAITRESS in attendance. As many persons as possible should be on the stage, representing Cheveil's Company and Barton citizens. The MAYOR, a middle-aged shopkeeper type, is wearing his chain, etc. OTLEY, the manager of the theatre, a bustling, friendly fellow, is running the party. Prominent among Cheveril's company are PAULINE FRASER, leading lady, a handsome actress in

her forties; JAMES WHITEFOOT, a good-looking youngish leading man; and ALFRED LEATHERS, a distinguished old actor.

The MAYOR is on his feet, prominently placed to make his speech, and the company are quieting down to hear him. He can clear his throat once or twice, but as soon as the curtain is nicely up and the scene is taken in by the audience, he begins. He can use any touch of dialect that comes naturally to the actor, but this must not be overdone.

MAYOR: Ladies and gentlemen – in behalf of the Borough Council of Barton Spa, I 'ave very great pleasure in welcoming to our ancient borough the very talented actors and actresses who 'ave come with Mr. Cheveril from London – to give us 'ere in Barton Spa – the first performance of 'is new play – *The* – er – *Glass Door.*

Some applause.

We are looking forward very much to seeing this new piece before London sees it. And I'm sure Mr. Cheveril and 'is company will find 'ere as good an audience as they can 'ope to find anywhere – very keen an' always ready for a good laugh.

'Hear hear!' and some laughter and applause.

Now we people in Barton Spa are very proud of this old Theatre Royal of ours – which dates back nearly two 'undred year – and 'as been associated with some of the greatest actors an' actresses of its time. We've spent a good deal of time and trouble – yes, *and* money – keeping this famous old theatre – including the old Green Room 'ere – in good shape, keeping every thing we could keep to remind us that this is one of the oldest theatres in the country. A lot of people think it's the best outside London. We *know* it is.

Some laughter and applause.

Well, I 'ope you ladies and gentlemen who 'ave come to entertain us will accept out best wishes for the show, and that you'll 'ave a very enjoyable stay so that you'll want to come again.

Applause, during which OTLEY whispers to the MAYOR. Then OTLEY addresses the company.

OTLEY: Ladies and gentleman, as Mr. Cheveril has been delayed, I'm going to ask Miss Pauline Fraser, leading lady of *The Glass Door* company to reply on his behalf.

Applause, and all turn and look expectantly at PAULINE, who is rather nervous but charming.

PAULINE: Mr. Mayor – Ladies and Gentlemen – first I must apologise for the absence of Mr. Cheveril, and I know how sorry he'll be that he's missed this lovely party. All of us in the company do appreciate the privilege of playing in this beautiful old theatre of yours.

'Hear, hear!' and applause from the players.

We've all often heard and read about the famous old Theatre Royal of Barton Spa – and of this old Green Room you've kept so wonderfully. It has a lovely atmosphere, even if at times it is a bit ghostly.

Some laughter.

Being here in the old place with a brand-new play – which we'll have to rehearse again tonight – so I hope nobody's had too many cocktails –

Laughter.

I say, being here makes me feel all over again what a marvellous thing the theatre is. Never as good as it was – always just about to die – but somehow always renewing its enchantment – always finding new life – perhaps just because it's so warm and human, so foolish, and yet so glorious – as people themselves are. Yes, just because it's really so close to the heart. That's why we're so glad and proud to be working for it. And why we're so glad and proud to be here. Thank you very much.

During the latter part of this speech a stage-hand enters L. and beckons importantly to OTLEY, who goes up to him, listens to what

her has to whisper, then hastily goes out L.. During the applause at end of PAULINE's speech, OTLEY re-enters L., obviously excited.

OTLEY: *(Rather excitedly.)* Ladies and Gentlemen –

There is silence, and they all look at him.

Mr. Cheveril is here –

A buzz of interest and excitement. OTLEY holds up his hand for silence, and looks serious.

He had rather a nasty little accident down on the stage – but he's recovered sufficiently now to say a few words –

Some applause, during which OTLEY brings in MARTIN CHEVERIL. He is an attractive man in his late thirties, but at the moment is looking white and shaky and rather dazed. He speaks with some effort, and now and again put a hand to his head.

PAULINE: *(Going up to him – with concern.)* Martin – what happened?

MARTIN: It's all right, Pauline. *(With an obvious effort he faces the party.)* Mr. Mayor – Ladies and Gentlemen, I was fortunate enough to overhear Miss Fraser's very charming speech. And now I feel it is hardly necessary for me to apologise for not being here earlier, because Miss Fraser replied for us all so much better than I could have done. But I must explain that as I was looking at some furniture in the wings, on my way up here, one of the counter-weights suddenly took a dislike to me and knocked me out for about half an hour –

A murmur of sympathy and concern.

(Smiles, with an effort.) I can only hope that some of your old ghosts here don't dislike authors…

Some laughter.

(Looking more serious.) I am not sure if I agree with what Miss Fraser has said about the theatre. I'm beginning to have serious doubts whether the theatre can renew its life and its old enchantments. The play we are opening here,

The Glass Door, is a serious attempt to write about the world as it is and people as they actually are, which means that it may seem to some of you a grim and unpleasant affair, and not what you wanted. If so, please accept my regret in advance. *(He concludes his speech with an obvious effort, but smiling.)* And I can assure you, Mr. Mayor, that we do appreciate this fine old theatre, and the friendly welcome you have offered us. Thank you.

There is some rather bewildered applause. Leaning a little on OTLEY, MARTIN goes across to be introduced to the MAYOR and MAYORESS, while the GUESTS begin to drift out, and the WAITER and WAITRESS begin to clear the table away. During speeches that follow, MARTIN, PAULINE, and OTLEY go off R.

Exeunt MARTIN, PAULIN and OTLEY.

Meanwhile, ALFRED LEATHERS and WHITEFOOT have come downstage.

LEATHERS: *(Confidentially.)* Well, old boy, what do we do now?

WHITEFOOT: *(Same tone.)* He looks very shaky. Probably ought to get to bed. He must have a dam' narrow escape from being knocked out altogether.

LEATHERS: I know. Saw it happen once. Still, he could make that speech.

WHITEFOOT: And we agreed that we'd have to tackle him before tonight's rehearsal. About our last chance.

LEATHERS: Yes – but you heard what he said. Good as told them they wouldn't like it, and that he didn't care.

WHITEFOOT: *(Grinning.)* Too late. The advance has almost sold us right out here.

LEATHERS: *(Impatiently.)* Yes, old boy, I know. But I'm not thinking about here. I'm thinking about when we get to town.

WHITEFOOT: Yes, yes, Alfred, we're all thinking about town. And we'll simply have to put it to him, as we agreed.

LEATHERS: Well, you heard him. What are we going to say if he's in this mood? Authors! I've had fifty years of 'em. And I know now why Shakespeare's the best of the lot.

WHITEFOOT: Why?

LEATHERS: *(Chuckling.)* He's dead.

PAULINE now enters R. She joins them with a rather conspiratorial air.

PAULINE: Martin was unconscious when that stage hand found him. They've sent for a doctor, but Martin insists on staying here. What are we going to do now?

WHITEFOOT: We'll have to put it to him. It's our only chance, thought Alfred doesn't give us much hope.

LEATHERS: Well, my dear, you heard what he said to the Mayor and Corporation. Not very tactful, to say the least of it.

PAULINE: I know. Though it must have been an awful effort to talk at all. I'm not sure – *(She hesitates.)*

WHITEFOOT: Not sure about what?

PAULINE: I'm not sure this is the best way of doing it, particularly now. I might do better by myself.

LEATHERS: I think you might, my dear. You're old friends, and the feminine touch might do it.

PAULINE: But I want him to understand that we all feel the same. But if we're obviously making no headway with him – I'll give you a hint – and then you'd better leave him to me.

WHITEFOOT: That'll be easy, because we can go down to rehearse the first act, and there's twenty minutes at least before we come to your entrance.

PAULINE: Yes. And remember – don't go back on what you said this morning. If necessary, tell him what you feel. It's our only chance.

MARTIN now enters slowly from R.. They break up and watch him.

LEATHERS: How do you feel, old boy?

MARTIN: *(Carefully.)* Not too bright, Alfred. I got a hell of a crack, and though nothing seems to be broken, I still ache a lot, and my head's still singing. So I'll sit down. *(He does so.)*

PAULINE: Perhaps you oughtn't to stay, Martin.

MARTIN: No, I'll be all right. There's a doctor coming, and probably he can give me something to keep me going tonight. Then I can take it easy tomorrow all day. If you want to start on the first act, go ahead. I'll be down later, after the doctor's been. Don't worry about me.

He sees now that the three of them are not going, but are facing him with a deputation look about them. He looks from one to the other with a quizzical smile.

MARTIN: I see. A deputation, eh?

LEATHERS: *(Rather apologetically.)* Well yes, old boy, you could call it that.

MARTIN: Go on, then. *(As they hesitate.)* It's the third act, isn't it?

WHITEFOOT: We've all been feeling it for several days. But we pretended, even to each other, that it was all right.

PAULINE: And after rehearsal this morning, we couldn't keep it up any longer. *(Vehemently.)* Martin, we all hate that third act.

LEATHERS: It's true, old boy.

MARTIN: *(Not unpleasantly, but dryly.)* Rather late to discover that, isn't it? We open on Monday.

PAULINE: Yes, but as it's you – and we've done it before – there's still time – *(She hesitates.)*

MARTIN: Time to do what?

PAULINE: *(Bursting out.)* Time to write and rehearse another ending to your play that isn't so cynical and bitter – and –

and *hopeless*. Alfred, Jimmy – you tell him. *(She swings away to hide her feelings.)*

LEATHERS: She's quite right, old boy. In my opinion – and I ought to know, after fifty years of it – they'll never take that ending. Too much for 'em altogether. And if you insist on it, then when we get to town we're in for a flop.

MARTIN: You may be right. But after all, Alfred, it'll be a fairly distinguished sort of flop, and won't do any of you much harm.

WHITEFOOT: Just a minute, Martin. That's not quite what Pauline and I feel. We feel that even if it does run, it's not going to do people any good. They've had a hard time, and they don't want to be hurt any more – and we feel the same.

PAULINE: *(Charging in again.)* And what you make them say and do isn't *true*. I just don't believe it – and it's all wrong.

MARTIN: *(Quietly.)* Now wait, Pauline. You and the others read the play. You and I discussed it.

PAULINE: *(Urgently.)* Yes, but we didn't realise how absolutely desolating and hopeless that third act becomes in production. Of course you knew it, but we didn't. There isn't a glimmer of real understanding left between your people in the end – it's as if each one is mumbling away in a glass case –

MARTIN: The play's called *The Glass Door*, you know.

PAULINE: *(Savagely.)* And it might as well be called *The Glass Coffin*.

There is an awkward pause, with MARTIN looking at them coolly, while LEATHERS and WHITEFOOT exchange glances. PAULINE, with an effort, now speaks to them quietly.

You'd better go down and start the first act. Tell Bernard I'll be ready for my entrance.

LEATHERS: All right, my dear.

LEATHERS and WHITEFOOT go out L..

MARTIN: *(Looks expectantly at PAULINE.)* Well, Pauline.

PAULINE: *(Quietly, with an undercurrent of emotion.)* It's not only that the play's that going to flop or to hurt people and then make them harder than ever, but that ending isn't true – and it isn't really *you* Martin.

MARTIN: No, that's where you are wrong. It's me all right. And I believe it's true. You don't like the end of my play. But that's how life is, Pauline. No real understanding. No genuine communication. And mumbling and mouthing behind glass doors.

PAULINE: Life's not like that.

MARTIN: Isn't it?

PAULINE: No, it isn't. And I've seen more of it that you have. It's just you, Martin.

MARTIN: All right, then, it's me. But I don't propose to give our customers any hot-water bottles and sedatives…

PAULINE: *(Cutting in, sharply.)* I'm not asking you to.

MARTIN: Let 'em shiver and stay awake – and think for once, before they start burning and blasting each other all over again –

PAULINE: *(Hotly.)* And they might as well, if that's all life is –

MARTIN: All right, let 'em. And I'm sorry, Pauline – but I don't care if this hopeless ending that you hate so much is my parting gift to that cosy painted old bawdy-house, the theatre, with all its old enchantment –

PAULINE: I meant that when I said it.

MARTIN: And I mean what I'm saying, my dear. I'll tell you a secret. In about an hour or so George Gavin will be ringing me up from town, and it's about ten to one he'll offer me joint control of three of the best theatres in the West End –

PAULINE: *(With some excitement.)* Why, that's what you've always wanted.

MARTIN: It's what I wanted once. But now – *(He shrugs.)*

PAULINE: *(Horrified.)* But you're not going to turn down his offer?

MARTIN: Yes, with many thanks. I told you I was through.

PAULINE: *(Aghast.)* Martin, I don't believe it!

MARTIN: It's true. Oh – I'll go on writing, naturally. Go back to novels. Do some film scripts. But I shan't go on writing for the theatre. Not that that matters, because I don't think the theatre, as we know it, will last much longer. The old witchcraft's just about worn out…

PAULINE: *(Scornfully.)* We've all heard that before.

MARTIN: I know. It's always been just about to die. But don't forget that the most obstinate old invalids do at last turn their faces to the wall. And I believe that's what the theatre's doing.

PAULINE: And don't you even care?

MARTIN: In a way, yes. But not much.

She regards him curiously. He looks enquiringly.

Yes?

PAULINE: I'm just wondering if you've really recovered from being knocked out by that wretched thing…

MARTIN: *(Laughing.)* Probably not. It was no joke – a hell of a bump. But I don't think my brain's cracked, if that's what you mean.

PAULINE: *(Stormily.)* Perhaps it's a pity it isn't.

MARTIN: *(Half serious, half joking.)* Hoy – steady, Pauline! I'm not a bad as all that!

PAULINE: *(Seriously.)* I mean something different. I wish you could escape from your own imprisonment. I wish you could break down the glass door you've made for yourself.

MARTIN: That's what none of us can do.

PAULINE: How do you know? You don't even know yourself yet. And – if you want to know what I think – you've had so much success so easily that now when you've nothing – and nobody – to work for, to fight for, to care about – then you're bored and getting cynical and bitter – all shut up inside yourself, imagining you know all about life –

MARTIN: *(Cutting in.)* I'm not bitter about myself. I suppose I've been lucky. It's the millions of poor devils –

PAULINE: *(Cutting in, forcefully.)* No, it isn't. That's where you deceive yourself, Martin. It's nothing to do with other people. It's you – you. You imagine you've had it all and everything seems to taste stale or sour, so the you invent elaborate theories to explain. No communication! Glass doors! And behind all your cleverness and boredom, there's somebody quite young, bewildered and disappointed – and lonely – because he can't talk to anybody, because he's shut up there alone. Why on earth don't you go and fall in love?

MARTIN: *(With a grin.)* I'm waiting for that. The famous old feminine cure!

PAULINE: It's been working for a long time.

MARTIN: Well, I haven't tried it lately, haven't felt like it.

PAULINE: *(Contemptuously.)* Oh – I don't mean –

MARTIN: No, I know.

PAULINE: I meant something that would reach that other Martin Cheveril, shut away there – alone. Hopeless, I suppose. It would need a miracle.

MARTIN: And there aren't any miracles – though perhaps I oughtn't to say that –

PAULINE: Why?

MARTIN: That stage hand said it was a miracle I wasn't killed down there – a very near thing. But that's not the kind of miracle you mean and that I seem to need, according to you. And you can't really blame me if I end a play with everybody so to speak behind glass, making frantic gestures that nobody else understands…

PAULINE: *(Rather miserably.)* No, I don't blame you. And I shan't say anything more to you, Martin. You won't change that hopeless terrible third act. You'll leave the theatre…

MARTIN: Which is dying anyhow.

PAULINE: *(With a flash of temper.)* Of course it'll die if people like you leave it. *(She turns away sharply.)*

LEATHERS looks in L..

LEATHERS: Look, old boy, sorry to butt it – but we're still getting a nasty little hold-up in that telephone scene in Act One. Bernard has an idea for a cut. Do you feel up to coming down for a minute – to tell us what you think?

MARTIN: Yes, Alfred.

LEATHERS: Still a bit shaky, though, aren't you?

MARTIN: *(As he moves up.)* Yes, but I can manage.

LEATHERS waits at the door. As MARTIN passes PAULINE, he touches her lightly.

Sorry, Pauline. Take it easy now. They'll be wanting you on the stage soon.

They go out L..

PAULINE can light a cigarette. After a moment there are sounds of voices off R. – OTLEY's and ANN's. Door R. is thrown violently open, and ANN SEWARD dashes in with OTLEY in pursuit. She is an attractive determined girl in her early twenties, not naturally impudent, but with her courage screwed up now. PAULINE stares in surprise.

ANN: *(Breathless, disappointed.)* Oh – but he's not here.

OTLEY: *(Indignantly.)* You see – all for nothing. And you ought to be ashamed of yourself, pushing yourself in like that. Where would we be if everybody started behaving like you?

ANN: *(Not too rudely.)* I don't know, and I don't care. The point is – I'm not everybody, I'm an actress – and I must see Mr. Cheveril.

OTLEY: Well, you're not going the right way about it. *(Turning to PAULINE.)* I'm sorry, Miss Fraser. I tried to stop her, but –

ANN: *(Coming forward, impressed.)* Miss Fraser? Oh – you're Pauline Fraser.

PAULINE: *(Smiling.)* Yes. Who are you?

ANN: Oh, you've never heard of me. I'm Ann Seward –

OTLEY: *(Cutting in.)* Now listen, Miss Seward…

PAULINE: *(Cutting in.)* No, it's all right, Mr. Otley. I'm free for a few minutes, and I'll talk to Miss Seward.

OTLEY: All right, Miss Fraser. I was only trying to see that Mr. Cheveril wasn't bothered by anybody.

ANN: *(Giving him a sudden charming smile.)* Of course you were. Sorry – but I just had to come in.

OTLEY: *(Grumbling a bit as he goes.)* I don't know whether you had to – but you are in…

He goes out.

The other two look at each other.

ANN: *(Confidentially.)* You see, what happened was this – I'm playing at the Rep. at Wanley – about thirty miles from here – and I heard Mr. Cheveril was trying out his new play here – and I felt I simply had to see him, particularly as I'm not either playing or rehearsing this week. I'm not really like that – you know – all pushing and barging in. If I had been, probably I wouldn't still be in weekly rep.

PAULINE: *(Smiling.)* Perhaps not, but still – you've plenty of time – you're very young.

ANN: *(Denying this.)* I'm twenty-four.

PAULINE: (*Still smiling.*) That's not very old.

ANN: It's older than it seems to anybody who isn't twenty-four. *(Looks at PAULINE with admiration.)* I think you're marvelous. When I had a week off, last Autumn, I stayed in London, going to theatres – and on Tuesday I went to see you in Martin Cheveril's play – *The Wandering Light* –

PAULINE: Good! It was a lovely play.

ANN: Yes. Then I went on Wednesday, and then I went again on the Thursday matinee – three times. You were wonderful. But – do you mind if I say this – ?

PAULINE: *(Amused.)* Probably. But risk it.

ANN: *(Eagerly.)* Well – at the end of the second act, when you get the news that he's back and waiting for you, I think you ought to have dropped everything you were holding – just as if it wasn't there anymore – and then walked straight out into the garden. You know…

She goes through a pantomime of listening, with an armful of clothes, mending, etc., then of dropping it all and moving, like a sleepwalker, straight forward. This bit of miming is very well done, and PAULINE watches it closely and with approval.

Do you mind me saying that?

PAULINE: Of course not. I wanted to do it like that – only the producer wouldn't let me. Look here – I think you really are an actress –

ANN: *(Eagerly.)* Do you? I know I am. Of course it's pretty hopeless in weekly rep. – especially in Wanley. Do you know Wanley?

PAULINE: *(Shuddering.)* Played for a week there once, years ago. And you're perfectly right.

ANN: I could be a thousand times better if I only had a chance, particularly in a Cheveril play. I love them. Please, Miss Fraser, I don't was to be a nuisance – I hated forcing my way in – but I simply had to see him. Where is he?

PAULINE: He's down on the stage just now, but he'll be back up here soon. I ought to warn you, though, that he's just had a nasty, little accident – and so mightn't want to see anybody...

ANN: I won't fuss him. I'll just explain quietly who I am and what I've done and ask him to give me a chance.

PAULINE: Well, sit down – and have a cigarette.

ANN: No, thank you, if you don't mind. I won't sit down, I feel too restless and excited – *(She looks about her, really for the first time.)* This is a lovely room, isn't it? Is this the famous Green Room everybody talks about?

PAULINE: Yes, and they've kept it more or less as it used to be.

ANN: It's a pity we don't have Green Rooms now. *(Looking around upstage.)* This is a terribly exciting place.

PAULINE: A lot of people find it rather frightening – spooky.

ANN: I'm sure its simply crammed with ghosts, just longing to show themselves and whisper in your ear.

PAULINE: Stop it!

ANN: No, but the point is – they aren't the usual kind of ghosts – murderers or old mad women – they'd just be actors and actresses, our sort of people, excited about the theatre just like us – I don't think I'd mind them at all. And I'm sure they're here, dozens of them. Miss Fraser, why don't you sit up here late at night – and watch –

PAULINE: My God, no – I'd be terrified!

ANN: *(Now glancing at the portraits at the back.)* I suppose these people must have played here, when it was grander than it is now. Edmund Kean – he *looks* a good actor somehow, doesn't he? Helen Faucit – rather sweet.

(And she moves downstage R..) Mrs. Yates – I like it when they call them 'Missis', don't you? Water-colour sketch of Miss Jenny Villiers in the part of Viola. Presented by the Barton Spa Shakespearean Society.

Jenny Villiers – nice name – I've never heard of her before, yet somehow it sounds familiar. And I'll bet she had to pester people before she could get a chance – even though she does look so sweet and sad – and wears ringlets. *(Suddenly startled.)* What was that?

PAULINE: *(Staring, startled.)* Why – it wasn't anything, was it? I mean – I didn't see anything.

ANN: *(Breathless, but quiet.)* No – but did you – feel – something?

PAULINE: *(Confused.)* No – not really – I think it was you who startled me.

ANN: *(Slowly.)* I'm sorry – but you see, just when I'd said that – y'know about Jenny Villiers – I seemed to feel a sudden little rush of air – very cold air , and them somebody – something – seemed to whisk past me. *(Sees something on the floor beside her and cries out.)* OH!

PAULINE: *(Startled again.)* What? What is it?

ANN: Only this. *(She picks up a red gauntlet glove of old-fashioned kind, and holds it out for PAULINE to see.)* It wasn't there before, you know. I'll swear it wasn't. I couldn't possibly have missed it.

PAULINE: *(Going closer as ANN moves in too.)* A gauntlet glove. Part of an old costume. They have some bits of old costumes and props here. *(She glances towards alcove R.)* It must have fallen out. *(Relieved.)* That's it. And that's what you must have felt.

ANN: *(Slowly.)* I suppose so. Only – it couldn't have fallen out – it must have jumped out – to have brushed past me like that. *(Staring at PAULINE.)* It's a bit peculiar, y'know – a glove behaving like that.

PAULINE: *(Hastily.)* No, it isn't, and for goodness' sake, child, don't start pretending anything queer has happened. I have to be around here for the next ten days – and you haven't. Just put it back.

ANN: *(As she goes to the case with the glove.)* I think *she* did it – Jenny What's-her-name.

PAULINE: *(Uneasily.)* Nonsense! Now let's be sensible. *(She goes back to door L. to open it.)* Mr. Cheveril will be back any minute, and I know he won't want to see you – I'll have to try to persuade him. You'd better wait outside.

ANN: But if I was still here, he'd have to talk to me.

PAULINE: No, he wouldn't. Don't forget people are always trying to see him – and he hates it, particularly just now. Your only chance is to do what I tell you.

ANN: *(Humbly and gratefully.)* Yes, of course. And don't think I'm not grateful.

PAULINE: *(Listening.)* I think he may be coming up now. You'd better get behind that door and wait. I'll do my best for you.

ANN: *(Moving to door R.)* I think you're a darling.

She goes out to R., not quite closing the door behind her.

PAULINE goes to case, where glove is, and stares at it a moment. Then MARTIN enters L.. He has several unopened letters in his hand. PAULINE comes down to meet him.

MARTIN: That scene's all right now. We've made a neat little cut. They'll be wanting you in a minute or two, Pauline.

PAULINE: I was just going down. Martin – there's a girl here. She's with a local reparatory company – and she's taken the day off and come here – just to see you –

MARTIN: Otley shouldn't have let her in.

PAULINE: He tried to stop her, but he couldn't. She's a determined young woman – and I shouldn't be surprised if

she's quite a good little actress. Now she is here, you'll see her – won't you?

MARTIN: *(Quietly and firmly.)* No.

PAULINE: Now don't be mean, Martin –

MARTIN: She'd no right to push herself in. And there's nothing I can do for her except to tell her that I don't care for her manners. *(As PAULINE is about to protest.)* No, I'm sorry, Pauline. But if she was a young Duse or Bernhart – I still wouldn't care. I'm just not interested anymore. I haven't to find any more promising young actresses – thank God! – and I don't see why I should be victimised in this way –

PAULINE: *(Reproachfully.)* Martin – this is all wrong. I hate it…

MAN'S VOICE: *(Off L..)* Miss Fraser, you're wanted on the stage.

PAULINE: *(Calling.)* I'm coming. *(She moves up L., then turns.)* I wish something would happen to you – I don't know what – something so big and strange that you couldn't explain it away – just *feel* it.

She hurries out.

MARTIN, with his back to door R., begins casually opening his letters. Door R. opens and ANN stands in doorway.

ANN: Mr. Cheveril, I'm the young actress. My name's Ann Seward –

MARTIN: *(Without turning.)* You had no right to come in here. Will you please go?

ANN: I've acted in lots of your plays – and loved them.

MARTIN: *(Still looking at the letters.)* Yes, but I'm busy – and I don't want to see you.

ANN: Not even just to *look* at me?

MARTIN: *(Angrily.)* No. Will you please go at once.

ANN: *(After a pause, with strange certainty.)* You'll be sorry soon that you said that.

(She takes the glove out of the case and flings it down.) Look – the glove's on the floor again. Even the ghosts are on my side. Be careful!

She goes, closing the door behind her.

MARTIN turns now, looking puzzled. After a moment he sees the glove on the floor, pick it up, and examines it, with a certain smiling but rather melancholy curiosity. He glances at the case, but does not return the glove there but brings it across to the little desk and tosses it down, to finish glancing at his letters in which he has no real interest. OTLEY looks in through door R.

OTLEY: Doctor's here Mr. Cheveril. Dr Cave. Good chap.

MARTIN: Send him in. Oh – and perhaps he'd like a drink when he's done with me.

OTLEY: *(Smiling.)* I don't think he'd object. What about you, Mr. Cheveril?

MARTIN: Just a glass of water, please.

OTLEY goes, leaving door R. open.

After a moment or two during which MARTIN shrugs his shoulders over the letters, tear them up and tosses them into a wastepaper basket, DR. CAVE enters briskly, carrying his hat and usual bag. He is a pleasant, middle-aged GP.

DR. CAVE: Well, Mr. Cheveril. I gather from Otley you had a very narrow escape. *(Comes near, and looks sharply at MARTIN, who is sitting.)*

MARTIN: Yes. I just missed the full weight of the thing, but I got enough to knock me out.

DR. CAVE: *(Drawing chair nearer.)* So I understood. Nasty experience. Well, how are you feeling now? *(He takes MARTIN's pulse, looking at watch.)*

MARTIN: Still shaky. Head aches. Knees a bit weak. Nothing seems quite real yet, if you know what I mean.

DR. CAVE: *(After finishing pulse.)* Yes…yes…very natural… *(Looks at him a moment searchingly.)* Well, now, let's see what

happened up here – *(He feels MARTIN's head gently.)* Humph! You can consider yourself lucky you didn't take the full weight of it. Must have hit you a glancing blow. Better just listen to your heart. *(He has now taken out his stethoscope and uses it.)* Humph! Some shock, of course – only natural. How were you before this happened? Bit tired? Been working hard?

MARTIN: Yes, we're just coming to the end of some pretty hard rehearsing. And I still can't get out of the habit of acting for everybody, which is a bit wearing.

DR. CAVE: Quite so. Well, the only real danger is delayed concussion, which can be very unpleasant. No use telling you to forget your play and go to bed, I suppose?

MARTIN: No. I wouldn't do myself any good if I did go.

DR. CAVE: That's what I thought. You people are all the same. Well…

OTLEY enters R. with whisky-and-soda and glass of water on tray, which he places on desk.

OTLEY: There you are, gentlemen. And I'll see you're not disturbed.

MARTIN: *(As OTLEY goes.)* Thanks. But I'd like to see you for a minute after the doctor's gone.

DR. CAVE: And that'll be very soon. I'm a busy man.

OTLEY goes out R.

(Looks at tray.) Whisky? No, no, can't let you have that just yet, you know.

MARTIN: *(Smiling.)* That's for you, not me. Mine's the water.

DR. CAVE: Quite right! Stick to it. And I'll help by drinking the whisky. *(He takes the whisky.)* Well, here's luck to the play! *(Drinks, then puts down glass and lights a cigarette.)* Humph! Better whisky than I can get, when I can get it. You theatrical people know where to find it. Good little chap, Otley, isn't he? We think he's made a good job of running

this old theatre of ours – though you mightn't think so after that nasty little accident of yours.

MARTIN: Oh – that couldn't be helped. And he is a good chap.

DR. CAVE: *(Becoming professional again.)* Well, Mr. Cheveril I'm letting you stay on here tonight because you'd only be worrying and fretting if I didn't. *(He now looks into his bag as he talks.)* But you'd better rest as long as you can tomorrow. And in the meantime, I want you to take two of these tablets now, settle down quietly in that chair for an hour or two, relax, and don't bother about anything – and then they ought to see you comfortable through your rehearsal tonight. Then try two more in the morning. Two now, two in the morning, no more. These things are new, and I don't pretend to know a lot about them. But that's a safe dose. *(He hands over the bottle of tablets.)*

MARTIN: All right. Two now – eh? *(Beginning to take the tablets.)*

DR. CAVE: That's it. Just take them with a sip of water – they'll soon dissolve inside you. *(He takes a sip of his whisky as MARTIN takes the tablets.)* Don't you worry if you feel a bit queer in about half an hour or so. Keep quiet – and rest – that's all.

MARTIN: *(After swallowing the tablets.)* Doctor – tell me. I suppose you see a good deal of suffering, don't you?

DR. CAVE: Yes. Seen a few pretty bad specimens since I saw you last. Why?

MARTIN: I was talking to an old friend of mine. She was accusing me of being bored – and cynical and bitter. And she wouldn't have it that that was because I saw that life was so hard and damned unpleasant for other people. Said it was because I'd had too much success and had it too easy – nothing to struggle for – and so on –

DR. CAVE: She might be right. But where do I come in?

MARTIN: I was thinking that you're a better argument for her case than for mine. Nothing bored and cynical, and bitter about you.

DR. CAVE: Certainly not. But that's different. When I see people suffer, it's my job to try to pull them out of it. I'm fighting for life. That keeps me going.

MARTIN: Perhaps I ought to be fighting for life.

DR. CAVE: Everybody ought.

MARTIN: If they think it's worth fighting for.

DR. CAVE: Of course it is. Your trouble is – and here you're worse off and I am – that your job as a writer depends on your imagination, which probably magnifies other people's troubles and all the misery in the world. Especially – and this is the point to remember – when your body's had a shock of this sort. So just be careful. Remember what I said. And better give me a ring in the morning. Now – stay there. Make yourself comfortable…and try to relax. *(He takes up his hat and bag, with a nod and smile.)*

OTLEY enters R.. MARTIN is now comfortable in big chair. DR. CAVE sees OTLEY.

Otley, just see that Mr. Cherveril isn't disturbed for an hour or so. He must be quiet for a time. And switch a few of these lights off.

OTLEY: Certainly. Shall I – ?

DR. CAVE: No, I can find my way out. And thanks for the drink. 'Bye!

OTLEY & MARTIN: *(As the DOCTOR goes.)* Good night!

Exit DR. CAVE.

OTLEY: *(Now turns to MARTIN.)* Anything I can do for you, Mr. Cheveril? You said you wanted to see me when the doctor had gone.

MARTIN: Yes. Switch those lights off, if you don't mind, then come and sit down for a minute or two.

OTLEY switches off some light at door, then comes over and sits where the doctor sat, near MARTIN.

OTLEY: They think a lot of Dr. Cave round here, though I've never been to him myself, being one of the healthy ones. Given you something to take, has he?

MARTIN: Yes. These tablets. I take two. *(Mechanically he takes two out and holds them in the palm of his hand while talking.)* By the way, there'll probably be a call from London coming through for me in about half an hour – from Sir George Gavin – and as it's important, you'd better put it through to me here. No other call, please. And if you can manage it, don't let anybody come in. I'm supposed to rest before tonight's rehearsal.

OTLEY: Right you are, Mr. Cheveril. I'll be just along there in my office. Better take those tablets, hadn't you?

MARTIN: *(Rather drowsily.)* Yes, I suppose so.

OTLEY hands him the glass of water, and he takes a sip and swallows the tablets. OTLEY then sees the gauntlet glove on the table.

OTLEY: *(Taking up glove.)* Hello, how did you get here?

MARTIN: Oh – I found it lying on the floor.

OTLEY: They used to tell funny stories about one or two of the things here, including this – you know the sort of stuff – just superstition –

MARTIN: Well, I'm not superstitious.

OTLEY: *(With a rather forced heartiness.)* Neither am I, Mr. Cheveril. Of course, with an old place like this y'know, you do get funny ideas sometimes. I'd better put this back where it belongs.

MARTIN: Who was supposed to wear it?

OTLEY: Nobody really famous. But she made a bit of a stir here about a hundred years ago, and was a great local favourite – and then died quite young. You've probably never heard of her. Jenny Villiers.

MARTIN: *(Sharply interested.)* Jenny Villiers! *(Slowly.)* That's odd. Very odd.

OTLEY: Why, Mr. Cheveril?

MARTIN: I was thinking about her, the other night. I'll tell you how it happened. I'd been looking somebody up in *Who's Who in the Theatre*, and I went on idle turning the pages and came to the section near the end called the *Theatrical and Musical Obituary*.

OTLEY: I know it. Gives the fate of everybody's death and how old they were when they died.

MARTIN: *(Rather dreamily.)* Yes. And that repetition of the word 'died' after every name gives it all a curiously melancholy ring...

OTLEY: *(Almost prompting him.)* And you happened to notice this girl's name?

MARTIN: *(Slowly, dreamily.)* Yes. Jenny Villiers, Actress, died fifteenth of November, 1846, aged twenty-four. I began wondering about her. She must have has some success young as she was, to be included in that list. Yet she was only twenty-four when she died. Everything coming right for her...success at last...and then she's snuffed out like a candle... Jenny Villiers...the name was charming... probably assumed.

OTLEY: I expect so. Bit too good to be true, you might say.

MARTIN: *(As before.)* The Jenny half of it...so young and feminine, bright, almost impudent...the Villiers half, so grand, aristocratic, rather bogus in the old theatrical style... I tried to imagine the girl...in the little time she had... smiling and curtseying in the oil-lamp floats and the gas battens of the queer, remote, stuffy old Theatre of the Forties... I was fascination...queerly moved, too...as if... *(He breaks off.)*

OTLEY: As if – what, Mr. Cheveril?

MARTIN: No, don't let's be fantastic. But I wondered about her…almost began to see her. And then I had to stop. Something happened…yes, somebody rang me up – *(Stops, then stares at OTLEY.)* Why – it was you.

OTLEY: *(Rather startled.)* Well, I did ring you up one night, Mr. Cheveril, about you trying out your new play here. Was that the time?

MARTIN: Yes, that was the time. It was then I agreed to come here.

OTLEY: Bit of a coincidence, when you look at it. You thinking about her and then, without knowing it, agreeing to come to the very theatre she last acted in – eh?

MARTIN: *(With mock solemnity.)* If our lives followed mysterious hidden patterns – design from behind the veil – then here's a good example of one –

OTLEY: *(Uncertainly.)* Well – yes –

MARTIN: *(Drily.)* And our lives don't, you see. But that's why I said it was odd – very odd.

OTLEY: *(Raising with glove.)* I'll put this souvenir back where it came from. *(Going across.)* And if you'd like to know a bit more about Jenny Villiers, there's one or two things here that might interest you. *(He is now by the case.)*

MARTIN: *(Sudden sharpness.)* No, it doesn't matter.

OTLEY: *(Turning, puzzled at the sharp tone.)* Oh – well – of course not. If you want to rest Mr. Cherveril…no reason why you should bother…

MARTIN: No, no, I'm sorry. I don't know why I said that. This stuff I've taken, probably. I'd be glad to have a look at anything you've got there.

OTLEY: *(At case.)* There's a little book about her here – just a sort of tribute some local chap wrote at the time – *(Takes booklet from case.)* And then there's this little water-colour sketch of her as Viola – you might not have noticed it –

(Takes sketch from the wall, then comes across with both booklet and sketch, and hands over both things.)

MARTIN: Thanks. *(Staring at the sketch.)* Um. So this was – poor little Jenny Villiers.

OTLEY: *(Quietly.)* Your hand's shaking Mr. Cheveril. Sure you're all right?

MARTIN: *(Muttering.)* Yes. It's only that stuff. The doctor said I might feel rather queer. Kind of floating feeling… *(Reads title page of booklet.)* Jenny Villiers…a Memoir and a Tribute… By Augustus Ponsonby, esquire – Honorary Secretary of the Barton Spa Shakespeare society... a page of quotations first –

'Be absolute for death; either death or life shall thereby be the sweeter…'

(Then musingly.) Be absolute for death – a strange idea that, Otley… *(Reads again.)*

'When to the session of sweet silent thought
I summon up remembrance of things past.'

An obvious choice. But this isn't. Listen –

'Make me a willow cabin at your gate,
And call upon my soul within the house…'

OTLEY: I seem to remember that. *Twelfth Night* – Viola, isn't it?

MARTIN: Yes.

OTLEY: I think that was the part they liked her best in. But I doubt if you'll find that little book worth reading, Mr. Cheveril – old-fashioned, pompous stuff. Her story was simple enough. They had a stock company here in those days, under an actor-manage called Edmund Ludlow. Jenny Villiers came here from the Norfolk circuit, and got some leading parts. She fell in love with the leading juvenile, Julian Napier, but he suddenly left the company for a London engagement. Then she was taken ill – and died. And Napier didn't last much longer – he went to New

York, started drinking hard, and soon finished himself. That's all there is to it, really.

MARTIN: *(Musingly.)* Nothing in it. Everything in it. 'Be absolute for death; either death or life will thereby be the sweeter…'

OTLEY: *(Preparing to go.)* And I shan't forget what you said, Mr. Cheveril – you'll just take that one call from London…

MARTIN: Yes, please. And switch off the other lights… 'And call upon my soul within the house…'

OTLEY switches off rest of lights and goes out R..

There is nothing now but light near desk. MARTIN, relaxed in his chair, stares idly at the booklet in his hand. After a moment it is hard to decide if he is asleep, half-asleep, or still awake but brooding. There is music.

Then WALTER KETTLE, a youngish but thin, grotesque figure. White-face, dressed in black, enters slowly from upstage R., and moves like a ghost across, pausing to stare across at MARTIN, who sees him. But before MARTIN can move –

KETTLE had glided out upstage L..

Then as MARTIN still stares upstage, a soft golden light comes across upstage R.. Then a man's voice, with other's joining in, is heard singing 'Villikins and his Dinah'. Then, as light spreads, more voices off R..

JOHN STOKES: *(Off R., calling)* What's happening, Sam, me boy?

SAM MOON: *(Off R..)* Mr. Ludlow wants to see everybody in the Green Room.

STOKES: *(Off, but nearer, humorously.)* Ay, ay – so shall it be. Come, ladies, the Green Room!

Two youngish ACTRESSES, dressed in the style of the forties, now enter R., whispering attended by JOHN STOKES, an old actor very like ALFRED LEATHERS. MARTIN's light is still burning, but it is much dimmer now. Slowly he rises, to stare at these people. Two

youngish ACTORS, one smoking an old-fashioned pipe, now enter.
They are followed by MRS. FANNY LUDLOW, a commanding oldish
woman, wife of the manager, who carries a large shopping basket.

1ST ACTRESS: Did you find anything nice Mrs. Ludlow?

FANNY: *(In a deep solemn tone.)* Yes, my dear. Four pork chops
and a fine cauliflower. Mr. Ludlow is extremely fond of
pork chops – fortunately. He will need all his strength to
sustain him through this crisis.

2ND ACTRESS: Oh dear – has something terrible happened?

FANNY: Mr. Ludlow will explain.

There is now from outside an imitation galloping noise, with cries
of 'Gee up!' then 'Steady, my steed!' etc. SAM MOON, the comedian
of the company, enters R., riding a large umbrella. He pulls up
sharply, sweeps off his hat.

MOON: Ladies, your servant.

He goes through the business of dismounting, then hands umbrella,
as horse, to STOKES, who enters into the spirit of the business.

Give me 'orse a rub-down, fellow, an' a mouthful o' hay.

STOKES: *(As groom.)* Ay, ay, sir. Will your honour by staying
here the night?

MOON: S'death! I am on urgent business for the Duke.

FANNY: *(Reproachfully.)* Sam!

MOON: Ma'am?

FANNY: Save your drollery for tonight's performance, when
you will need it. At the moment it is out of place.

MOON: Sorry to 'ear it, ma'am, most sorry to 'ear it. But still
we've 'ad troubles before – and said good bye to 'em.

Here a few other minor members of Ludlow's company can enter,
taking their place on the outside of the circle. Then JULIAN NAPIER,
the juvenile lead, enters. He is very handsome in a romantic forties
style, with long dark hair, etc.

JULIAN: *(Rather haughtily.)* I hope this won't take long. I have an engagement with two gentlemen at the White Hart in half an hour. What's the matter now, Mrs. Ludlow?

FANNY: *(Rather stiffly.)* Mr. Ludlow will explain, Mr. Napier. And you may be sure that Mr. Ludlow would not call the company together at this hour unless it was something serious.

JULIAN: Possibly not. But I must keep my engagement at the White Hart.

MOON: Are they swells, Julian, me boy?

JULIAN: *(With assumed nonchalance.)* One of them's a baronet. He took a box the other night. *(Stares around.)* Miss Vincent not here?

FANNY: *(Grimly.)* I don't see her.

Some exclamations of surprise and exchange of glances.

JULIAN: Look here – what's happened?

FANNY: All in good time.

1ST ACTRESS: I think I saw Miss Vincent with Mr. Ludlow just before we came up here.

FANNY: They you were mistaken.

2ND ACTRESS: Who was it then? I didn't think it was Miss Vincent.

Enter EDMUND LUDLOW, actor-manager, an elderly man with a presence. LUDLOW immediately takes charge of the situation. He faces the company.

LUDLOW: Ladies and gentlemen – Miss Vincent has left us.

Some cries of astonishment and annoyance.

Left us in circumstances of the basest treachery.

FANNY: *(Grimly.)* And still owing much money in the town. Over five pounds to Trimbleby's alone.

LUDLOW: So I believe, my love. I will not speak of ingratitude –

FANNY: *(Grimly.)* I will! The ungrateful creature!

LUDLOW: But as you know, I proposed to revive *The Maniac of the Wreck* chiefly because of Miss Vincent, and although she knew this, and allowed herself to be billed in the leading role, I have evidence now that she has agreed to accept the offer from Mr. Buckstone – for small parts –

FANNY: *Very* small parts.

LUDLOW: At least a week ago. Inexcusable, of course, Black treachery. In the old days she would have found it impossible to live down such an act – but now – when ambition is preferred to honour – when money and false pride reign undisputed –

JULIAN: *(Cutting in, impatiently.)* Well, the point is that she's gone. And we certainly can't do the *Maniac of the Wreck* without her. And what about our *Twelfth Night* – also widely announced? We haven't a Viola now.

LUDLOW: *(Heavy rebuke.)* If you will kindly allow me. Mr. Napier, to discuss my business… Clearly we can't do the *Maniac,* so I'm proposing to put back *The Soldier's Widow* or *The Deserted Mill,* which always takes…

A groan from the company.

STOKES: It depends on your broadsword combat – as I've said before…

LUDLOW: Yes, yes, I agree. We'll have special rehearsals this time of the broadsword combat. And as for our *Twelfth Night,* we can put it off a week or so –

JULIAN: While you try to find a Viola worth seeing? Not much chance.

LUDLOW: *(With solemnity.)* I have a Viola worth seeing. And unless I am much mistaken, a far better one than Miss Vincent's. A Lady Teazle and a Rosalind and a Ophelia too. Mr. Kettle remembered that our friend Mr. Murphy of the Norfolk Circuit recommended us a good juvenile female lead who wanted a change. Mr. Kettle saw her, and has

brought her back with him. She has already given me some excellent readings from classic roles. *(Calls to L..)* Walter, you can do the honours.

KETTLE enters L., smiling.

KETLLE: Ladies and gentlemen – may I present to you our new juvenile female lead – Miss Jenny Villiers!

JENNY now enters L.. She is very pretty, rather fragile type, with auburn, light-brown or golden ringleys, and is charmingly dressed. She smilingly curtsies, while the others applaud smilingly. She then drops a small gaily-coloured purse. KETTLE tries to pick it up, but JULIAN is quicker, and stand offering it to her, smiling, while KETTLE scowls at him. JENNY smiles at JULIAN.

JULIAN: Yours, I think, Miss Villiers.

JENNY: Thank you.

JULIAN: I am your new leading juvenile – Julian Napier.

As the two stand looking at each other, the whole scene is completely silent and frozen and the light on it begins to fade slowly. The effect is rather like an old daguerreotype. MARTIN takes a pace forward, staring at the scene.

MARTIN: *(In slow, rather drugged tone.)* So that's how it began. But of course, that's how it would begin. But is it beginning again now? Has this happened – or is it still happening – or am I dreaming. What am I talking about? I'm dreaming, of course.

He takes a pace of two forwards. The scene, much fainter now, comes to life in quick dumb show, with the music playing softly. JENNY is being introduces to the others, but in a quiet gliding fashion they all move towards left, and soon are all gone with the light gone too now. MARTIN mover upstage, then turns round to look at his desk light, which is now burning as before. In a bewildered, slow fashion he comes back towards desk and his chair, then sits down heavily and buries his face in his hands. After a moment we hear FANNY's voice in darkness upstage R.. MARTIN slowly raises his head.

FANNY: Yes, dear, but you can make more of it than that.
It's a big scene, and properly done, it always takes
famously. Now when I did it, I always got on tip-toe and
stretched my hands out on 'Horror, horror', and then on
'Distraction, come', I crossed my hands in front of my face.
I'll show you what I mean, dear – just watch me.

*Golden light comes up on FANNY and JENNY, who are rehearsing
upstage R.. If possible, JENNY should now be wearing plainer
working dress. As MARTIN stares at them as their light comes up, his
light at desk begins to fade. FANNY now illustrates the movements,
which are as false and stagey as the dialogue. And it is clear that
JENNY cannot take this speech seriously.*

You see, dear? 'Oh, horror, horror!' *(She stands on tip-toe,
with arms outstretched and fingers wide apart.)* Then – so and
so and so and so – slowly coming down, you see, dear, till
you get to 'Distraction, come possess me now, for I will be
thy bride'...like this... *(She bows her head, shuddering, and
crosses her hands before her face.)*

JENNY suddenly giggles.

What's the matter, dear?

JENNY: I'm sorry, Mrs. Ludlow. I do see what you mean,
and you're doing it beautifully. It's just – that – well,
this Moorish princess sounds such an idiot, asking to be
Distraction's bride.

FANNY: *(With dignified rebuke.)* Properly played, Miss Villiers, I
assure you, the part never fails. Ask Mr. Ludlow.

Enter KETTLE, L..

Yes, Walter? Am I wanted on the stage?

KETTLE: Yes, Mrs. Ludlow.

FANNY: Very well. I'm just taking Miss Villiers through his
big scene in the *Moorish Princess* – which she doesn't seem
to quite appreciate. Here's the book – *(Hands him a prompt
book.)* just see what you can do.

She goes off L. in dignified disapproval.

JENNY: Oh dear – I hope I haven't offended her. You see, I couldn't help laughing – not at her – but at the part – it's so silly! You must admit it is. Listen. *(She assumes tragic posture and tone, not too obviously burlesqued, doing the same movements as FANNY.)*

> 'Oh Carlos! Noble youth! How have my fears
> Betray'd thee to thy doom!
> Inhuman father! Noble, injured youth!
> Methinks I see thee stretched upon the rack,
> Naught I can do can save him. Vain, alas!
> Vain are my maiden tears and pray'rs!
> Distraction, come possess me now, for I
> Will be *thy* bride!'

You see, Mr. Kettle? I can't act it because I can't believe in it. No girl ever behaved like that, or talked like that. It isn't true!

KETTLE: Of course it isn't. But then no girl ever talked like Viola or Rosalind.

JENNY: *(Earnestly.)* But that's not the same thing. We'd *like* to talk as Viola and Rosalind do. It's what we *feel*, turned into wonderful words. But this isn't. It's all just silly stuff. Asking for Distraction as if it were some old admirer who lived round the corner. Now – isn't it silly?

KETLLE: *(In humorous whisper.)* Yes. I've thought so for years. Language, situations, gestures – all ridiculous. You're quite right.

JENNY: Ph, bless you for saying that! You see, if she only said something quite simple and direct, like –

> 'Oh Carlos – noble Carlos – because I was
> frightened I betrayed you – perhaps to
> your death!'

Just standing there, quite still, looking down on him –

KETTLE: Do it like that.

JENNY: Oh – do you think I dare?

As they stand there, looking at each other, MARTIN takes a pace or two forward, nearer to them.

MARTIN: *(Quietly, but with a note of excitement.)* Yes, my dear, yes. Dare – break through the routine, smash the old moulds – dare – as we all must do – to give it new life –

JENNY: *(To KETTLE.)* All right. I will.

VOICE: *(Off L..)* Miss Villiers, Mr. Kettle, wanted on stage!

KETTLE: *(Calling.)* Coming!

He leads the way, JENNY following rather reluctantly, the light fading as they go.

MARTIN: *(Calling.)* Jenny!

JENNY hesitates, turns and looks round in rather bewildered fashion. MARTIN calls more anxiously.

Jenny Villiers!

But she has gone off L. now and her light too.

Light up on the desk now. MARTIN turns and looks at it, and then comes slowly down. Door R. opens now, showing strong white light and OTLEY looks in.

OTLEY: Were you calling me, Mr. Cheveril?

MARTIN: *(Confused.)* What? No, I don't think so. I mean, I'm sure I wasn't.

OTLEY: *(Dubiously.)* I thought I heard you calling – that's all.

MARTIN: I must have been dreaming…

OTLEY: You're sure you're alright, Mr. Cheveril? You don't want me to get hold of Dr. Cave?

MARTIN: No, of course not… I'm all right, thanks… I must have dozed off.

OTLEY: Well, I won't disturb you – until your London call comes through.

He closes door.

MARTIN settles down in his chair, and takes up the booklet.

MARTIN: *(Staring at the title page.) Jenny Villiers… A Memoir and a Tribute…by Augustus Ponsonby Esquite… Honorary Secretary of the Barton Spa Shakespearean Society… (He gets up, feeling restless.)*

PONSONBY and STOKES have now entered secretly. PONSONBY is an absurd but rather charming little middle-aged bachelor.

PONSONBY: *(Speaking in darkness.)* Yes, sir. Augustus Ponsonby –

MARTIN: *(Staring, astounded.)* What?

Light now comes up on PONSONBY.

PONSONBY: Augustus Ponsonby… Honorary Secretary of the Barton Spa Shakepearean Society…and inveterate and most enthusiastic playgoer, sir…

MARTIN: *(Who has moved forward.)* No doubt you were. But you're not my idea of a ghost, my friend.

PONSONBY: Well known in the town – and no doubt known to you, I trust, as a staunch supporter of Mr. Ludlow's talented company here.

Light now comes up on STOKES too.

STOKES: Heard of you often, Mr. Ponsonby. I'm John Stokes. You must have seen me often.

PONSONBY: Of course, of course, Mr. Stokes. Delighted to make your acquaintance. I cannot imagine what the company would do without you – such versatility, such strength and experience!

STOKES: An old actor, Mr. Ponsonby. After more than forty-five years, a man learns how to carry himself through five acts – and a farce –

PONSONBY: And carry other people too sometimes, eh, Mr. Stokes! Ha, ha, ha! You've seen some great nights in the theatre, I imagine, sir?

STOKES: I have, sir. And they'll never come again. In my time, Mr. Ponsonby, I've played with Edmund Kean, Charles Kemble, Liston, Mrs. Golver, Fanny Kelly –

MR. PONSONBY: Great names, Mr. Stokes!

STOKES: The Theatre was *the* theatre in those days, Mr. Ponsonby! It was all the public had, and so we all did our best with it. None of your panoramas and dioramas and Apollonicons, and the rest of them then. It was the *Theatre* and the Theatre as it ought to be. Now they'll do to anything, just a rage for silly amusement, Mr. Ponsonby, – and it's all money, money, money. I tell you, sir, the Theatre's dying – and though it may last out my time, thank God – I don't give it very much longer. The old spirit's gone – the plays aren't the same, the audiences aren't the same, the actors aren't the same –

PONSONBY: No doubt you're right Mr. Stokes. As an amateur, I wouldn't venture to quarrel with your experience. Yet I called here specially this morning to tell Mr. Ludlow that many of us amateurs and patrons here wish to congratulate him on his company's new acquisition, Miss Villiers.

STOKES: I'm glad to hear you say so, Mr. Ponsonby. And Mr. Ludlow will be glad too. Miss Villiers has only been with us a few weeks, but we're all very pleased with her. Plenty to learn yet, of course – that's only natural – and I've given her a few pointers myself – she's apt to be restless, and won't keep her head still – but genuine talent there, sir, and a most pleasing personality – ambition of the right kind, too – a young lady with a fine future, sir. At least, if the Theatre had a future, which I doubt.

PONSONBY: Would it be possible for us to see Miss Villiers in some leading Shakespearean roles?

STOKES: Rehearsing 'em now, sir – rehearsing 'em now. In fact – well, here they are –

The light opens out, golden as before, and JENNY, JULIAN and WALTER KETTLE enter, all with some prompt books.

JULIAN: *(Heartily.)* Hallo, Ponsonby! You're not supposed to be in here in this time of day!

PONSONBY: I was looking for Mr. Ludlow –

JULIAN: He'll be round at the Lion.

STOKES: I'll take you there, Mr. Ponsonby.

JULIAN: Jenny, may I introduce Mr. Augustus Ponsonby – one of our most enthusiastic patrons –

PONSONBY: *(Bowing.)* And also one of your greatest admirers, Miss Villiers –

JENNY: *(Modestly.)* I'm afraid I haven't done anything here yet worth admiring, Mr. Ponsonby. But perhaps soon – with any luck –

KETTLE: It's not luck, but hard work. And we ought to be working now. You'll have to excuse us, Mr. Ponsonby.

PONSONBY: *(Perturbed.)* Oh – yes – of course – I'm so sorry –

STOKES: Come along, we'll go round to the Lion. You don't want me for an hour, do you, Walter?

After bowing again, PONSONBY goes out upstage R. with STOKES.

JENNY: Rather a sweet little man.

JULIAN: He's a pompous little ass really – but he runs some sort of Shakespearean Society – and they're good for a hundred seats on a benefit night.

KETTLE: *(Sharply.)* He may be rather pompous, but he's not an ass – and something better than a buyer of seats for benefit nights.

JENNY: *(Smiling at him.)* Mr. Kettle, you're very bad-tempered this morning. What's the matter?

KETTLE: *(With the misery of a man in love.)* I'm sorry, Miss Villiers…too much work, probably… I didn't mean…

JULIAN: *(Carelessly.)* Well, you needn't work here, Walter. You can go down to the stage. I can take Jenny through our scenes. That's why we're here.

KETTLE: *(Miserably.)* I don't know about that –

JULIAN: *(Haughtily.)* What? Are you insinuating that I'm not competent to take Miss Villiers through scene I've plays hundreds of times? You – ?

JENNY: *(With reproach suggesting familiarity.)* Julian – please! *(Smiling at KETTLE)* I knew how busy you are, Mr. Kettle – and I did ask Julian specially –

KETTLE: *(Roughly.)* No, you didn't. I overheard *him* asking you –

JENNY: I was going to ask him.

JULIAN: But I was first, that's all.

JULIAN and JENNY suddenly look at each other, and it is clear that they are in love. KETTLE, seeing this look, turns away. He is now very near MARTIN standing on edge of light. The scene is now frozen.

MARTIN: *(Quietly, to KETTLE.)* So you were in love with her too? And hadn't a chance. Hoped to teach her all you know about acting – and I have an idea you were the man here who did now – and probably did teach her, too but never had a chance. I wish I could talk to you properly Walter Kettle, there's something of *me* in you. I know exactly what you're feeling. And it'll soon be worse for you, much worse, poor devil. Go on, there's nothing you can do.

This re-animates the scene. KETTLE turns and looks from JULIAN to JENNY.

KETTLE: *(Bitterly.)* All right. I'll leave you. You have your prompt books?

JULIAN: Yes, though I doubt if we shall need them.

KETTLE: *(Walking away upstage, then L..)* I doubt it too.

JENNY and JULIAN now use the area upstage R.. They are watched by MARTIN.

JULIAN: Let's go straight to Act Two, Scene Four, after the music. Ready? *(He becomes the Duke, acting in rotund style.)* 'Come hither, boy –'

JENNY: I cross there – um?

JULIAN: Yes. Not too quick. Now then –

> 'Come hither, boy: if ever thou shalt love,
> In the sweet pangs of it remember me.
> For such as I am all true lovers are –
> Unstaid and skittish in all motions else,
> Save in the constant image of the creature
> That is beloved. How dost thou like this tune?'

JENNY: *(As Viola.)*

> 'It give a very echo to the seat
> Where Love is throned.'

JULIAN: *(As the Duke.)*

> 'Thou dost speak masterly:
> My life upon't, young though thou art, thine eye
> Hath stay'd upon some favour that it loves:
> Hath it not, boy?'

JENNY: 'A little, by your favour –'

(Breaking off.) Oh, Julian – please – don't look at me like that.

JULIAN: *(Seizing her hands.)* How can I help it? And what does it matter?

JENNY: Because – oh – we ought to work – we oughtn't to be thinking about ourselves.

JULIAN: *(Triumphantly.)* So that's what you were thinking too!

JENNY: No – I don't mean –

JULIAN: Yes, you do. And you can't help it either! *(Putting his arms around her, whispering.)* My darling Jenny – my sweet, sweet Jenny – I love you – I worship you – I can think only about you!

JENNY: *(Overcome.)* Julian – you hardly know me yet –

JULIAN: I've known you for ever. And don't call me just Julian – dearest!

JENNY: *(Whispering.)* Dearest! I think – I love you too.

He slowly lifts up her face, her arms creep round him, and they are about to kiss.

MARTIN: *(Harshly.)* No, no, no!

The light goes at once, leaving JENNY and JULIAN in darkness and only a tiny sport on MARTIN. The desk light downstage L. went long ago. There is the loud rushing wind sound, with music, both of which go quieter as MARTIN speaks again.

It's cold. I'm not even in that Green Room now, not even in the theatre…outside somewhere…old streets…ghosts… or am I the ghost now?

Sound of horse and carriage comes nearer, then dies away again. Wind and music rise again.

No, stop – stop! Where is she? What's happening to her?

Light begins to come up on next small set in alcove R., which shows corner of a rather drab sitting-room of the period. It is late at night, and the 1ST ACTRESS, wearing curlpapers and yawning is listening to JENNY rehearse her Viola speeches. We hear JENNY's voice, speaking first lines before we see her. MARTIN stays centre downstage.

JENNY: 'I see you what you are – you are too proud;
But if you were the Devil, you are fair.
My lord and master loves you; O, such love
Could be but recompensed, though you were crown'd
The nonpareil of beauty!'

1ST ACTRESS: *(Yawningly.)* 'How does he love me?'

JENNY: 'With adorations, with fertile tears…' No, that's not right, is it?

1ST ACTRESS: *(Indifferent.)* Sounds all right to me, dear.

JENNY: No, it isn't. I remember now –

'With adorations, with fertile tears,
With groans that thunder love, with sighs of fire.'

(Impatiently, as the other does not follow.) Go on!

1ST ACTRESS: D'you know what time it is? Nearly two o'clock.

JENNY: *(Half impatient, half apologetic.)* What does that matter?
No, I'm sorry – Sarah darling – I know you're tired – but I
must go through it again. Now then –

1ST ACTRESS: 'Your Lord does know' – so and so and so 'might
have took his answer long ago.' *(Yawns again.)*

JENNY: 'If I did love you in my master's flame,
With such a suffering, such a deadly love,
In your denial I would find no sense;
I would not understand it.'

1ST ACTRESS: 'Why, what would you?'

JENNY: 'Make me a willow cabin at you gate,
And call upon my soul within the house –'

MARTIN: *(Quietly.)* No, not like that, my dear.

JENNY: No, that isn't right.

> 'Make me a willow cabin at your gate,
> And call upon my soul within the house;
> Write loyal cantons of contemned love,
> And sing them loud even in the dead of night;
> Holla your name to the reverberate hills,
> And make the babbling gossip of the air
> Cry out, Olivia! Oh, you should not rest
> Between the elements of air and earth,
> But you should pity me!'

1ST ACTRESS: Pity me, you mean. Keeping me up until this
time! I don't know why you should want to bother –

JENNY: Because I must – I must – there's so little time –

MARTIN: *(Like a sad echo.)* So little time…

153

1ST ACTRESS: I suppose you and Julian have been spooning instead of rehearsing –

JENNY: *(Gasping.)* Sarah!

1ST ACTRESS: Oh everybody knows about you two. Talk about babbling gossip of the air –

JENNY: No, Sarah, don't – please don't talk. I'll go back...

Lights now begins to fade.

JENNY: 'Oh you should not rest
Between the elements of air and earth,
But you should pity me.'

Music has come in and light have been fading. Sound of wind, not too loud. Now light comes up on L. alcove, where deak, etc., have now gone. In the alcove is a small bar set, with cosy corner of counter, bottle and comic fat landlord behind. LUDLOW and a rather seedy JOURNALIST are having drinks. MARTIN can be off stage during this scene.

JOURNALIST: *(Raising glass.)* Your health, Mr. Ludlow.

LUDLOW: Same here. Now, what you want to say is something like this. Um – let me see. 'Following the phenomenal and unprecedented success of Miss Villiers, and – er –'

JOURNALIST: *(Making easy notes.)* ... 'at the special request of many distinguished patrons'

LUDLOW: Certainly. Put that in. Then – er – 'Mr. Ludlow announces a Grand Benefit Performance for Miss Villiers on Friday the Ninth, when – er – she will play one of her favourite roles, Viola in *Twelfth Night*, with Mr. Ludlow himself as Mavolio and Mr. Napier as the Duke. The evening will conclude with a brand new screaming farcical item, *Catch 'em Alive-O.*

LANDLORD: Ha, ha!

LUDLOW: Same again, George.

LANDLORD: Ha, ha! *(Attends to drinks.)*

LUDLOW: 'By kind permission of Colonel Baffer, etc., the Band of the Fifteenth Dragoons will be in attendance to render selections during the intermissions. Free list entirely suspended...'

JOURNALIST: *(Making notes.)* Got that. Nobility and gentry?

LUDLOW: Certainly. 'Nobility and gentry have already secured a large number of seats – and – er – the public is advised to make application...' Y'know, the usual –

JOURNALIST: Yes, of course. Prices up?

LUDLOW: Certainly. 'Owing to the very large demand – and – er – in order that Barton Spa should have an opportunity of paying a generous tribute to the work of this gifted young actress – y'know – pile it on. *(Drinks handled.)*

JOURNALIST: Pleasure to do it. Your health, Mr. Ludlow.

LUDLOW: Same here. Matter of fact – and no nonsense – she's the best I've had for years – works, too.

A MESSENGER looks in.

What's this?

MESSENGER: For you, Mr. Ludlow.

He hands over a large envelope and goes.

LUDLOW: *(Opens envelope, and gives a whistle.)* Now listen to his. Here's a bit of news for you – first time it's happened. *(Reads.)* 'Mr. Augustus Ponsonby presents his compliments to Mr. Ludlow, and on behalf of the Barton Spa Shakespearean Society invites Miss Villiers, Mr. and Mrs. Ludlow, Mr. Julian Napier, etc., to a late reception and supper at the White Hart Hotel, after the Grand Benefit Performance for Miss Villiers on Friday, the Ninth.' *(Enthusiastically.)* There you are! *(Passes it.)* Read it yourself. Didn't know it was coming. Great compliment.

LANDLORD: Ha, ha!

LUDLOW: *(Drinking up.)* Well – there it is – all ready for a nice half-column in your *Bartonshire Chronicle.* And now – to work – to work – !

As he is saying this, light fades, and music and perhaps the sound of wind is heard. Light comes up on alcove R., which is now JENNY's dressing room, with small lighted mirror. She wears voluminous wrap, which conceals dress she wears in next scene. Flowers on dressing table, etc. MARTIN is now standing centre again, watching her.

NOTE: During this scene, the bar set in alcove L., is replaced by original flat, etc., and desk etc. are restored. As light comes up on this dressing-room set we hear three knocks, which are repeated. These can actually be before set is lit.

JENNY: Come in!

Enter JULIAN, carrying some red roses. He is muffled up in dressing gown and scarf, under which he wears his evening clothes for next scene. He offers her the roses, bending amorously over her.

Julian! Thank you, my darling. I was hoping you would – but thought you'd been too busy to remember – darling!

JULIAN: You're never out of my thoughts a moment, Jenny. I love you!

JENNY: *(Gravely.)* I love you too.

He kisses her, but she gently pushing him away.

No please – darling. Not now. They'll be calling us in a minute. Wish me luck for my great night!

JULIAN: I am doing – all the time. And I feel it'll be my success too. I shan't be jealous.

JENNY: *(Surprised.)* Of course not. I knew that. Darling, there isn't much time.

JULIAN: *(Quick whisper.)* Listen, then. You're staying in the hotel too tonight, aren't you? What's the number of your room?

JENNY: Forty-two. But –

JULIAN: No, my darling – please listen. You must let me come to you after all those fools have finished talking – it's our only chance to be alone together – and I want you so terribly, my love – I can't sleep – I can't think properly – sometimes I feel I'm going mad –

JENNY: Oh – Julian – I'm sorry –

JULIAN: No, I'm not blaming you, of course. But tonight – it can be *our* night – at last. Room Forty-two. I'm along the same landing. Nobody will know.

JENNY: *(Hesitating.)* It's not that, darling. It's – I don't know what to say.

JULIAN: Of course not. I don't want to press you now. But give me a sign – when we're with those fools at the hotel – look – if you give me one of these roses I've brought you, I'll know it's all right. Please, my darling!

JENNY: *(Half-laughing.)* You are a baby! All right, then!

VOICE: *(Off L..)* Overture and beginners, please! Overture and beginners!

JENNY: We're being called. I must hurry.

JULIAN: Don't forget. One red rose, and you'll make me happy.

He goes out of scene.

A knock. 'Miss Villiers – overture and beginners.'

MARTIN takes a pace forward, as if to speak to her, but the light begins to fade as she hastily completes her make-up. Music. Sound of wind, which merges with sound of distant but considerable applause. MARTIN, who now has the booklet in his hand, had moved near the desk, whose light is up again. MARTIN stares at the booklet.

MARTIN: *(Reading slowly.)* 'Never will those of use who were privileged to be present both at the Theatre Royal and later at the White Hart Hotel that evening forget the occasion. An audience which included nearly all the nobility and gentry of the neighbourhood filled the theatre

from pit to ceiling, and every entrance and exit of the brilliant young actress was lustily applauded. A more delightful Viola was never seen, though of that more later. Then afterwards there was the reception by the Shakespearean Society at the White Hart Hotel, where the writer had the honour to make the first speech, in praise of the chief guest of the evening, upon whose radiant charm no shadow of forthcoming early doom was yet cast. 'Miss Villiers', said the writer...'

The soft golden light now comes on PONSONBY, in evening dress, who is standing far upstage, behind a large dining table, covered with a white cloth. The back wall has now gone, and the back of the stage represents a dining room in the White Hart Hotel. As the light spreads, we see others, in evening dress, standing or seated behind the table. There is JENNY, resplendent with her red roses, JULIAN – who is seated several places away – LUDLOW and FANNY, and between them actors representing the members of the Barton Spa Shakespearean Society. There is nothing on the table, as everybodying is holding his or her glass in hand. The light is so contrived that the faces are well lit but the downstage part of the table goes into shadow. There can be lights representing candles on the walls. During speech that follows, MARTIN moves slowly nearer, watching and listening.

PONSONBY: *(In the rather pompous oratorical style.)* Miss Villiers – on behalf of the Barton Spa Shakespearean Society, I wish to offer you – and Mr. and Mrs. Ludlow and all members of Mr. Ludlow's Theatre Royal Company – our most grateful thanks for the pleasure, the delight, the intellectual and spiritual satisfaction you have given us this season, which, illuminated by the lustre of your dazzling performances, has undoubtedly been the most memorable season that Barton Spa has had for many, many years.

Cries of 'Hear, hear!' and some applause. JENNY looks demure, but is clearly aware of his absurdity.

It is hard for us to believe that genius married to such youth and beauty will be content much longer to hide itself from the – er – the gaze of metropolitan audiences –

LUDLOW: Now, now – don't put ideas into her head, Mr. Ponsonby!

PONSONBY: Of course not, Mr. Ludlow! I merely wished to observe – er –

MARTIN: *(In cool, clear tone.)* I wonder how much more we shall have of this long-winded ass.

PONSONBY: That's why we of the Shakespearean Society are aware of our good fortune and that is why we have taken this opportunity of offering Miss Villiers our homage and most grateful thanks. And now I call upon Sir Romford Tiverton to propose the Toast.

Applause. SIR ROMFORD TIVERTON is a fantastic old buck.

SIR ROMFORD: *(Holding up glass.)* Mr. Charman – and fwends – it is with vewy gweat pleashah – that I wise to pwopose the toast of our beautiful and talented guest of honah – Miss Villiers – and coupled with the names of our old fwends – Mistah and Missis Ludlow.

OTHERS: *(Holding up glasses.)* Miss Villiers!

They all drink, except JENNY and the LUDLOWS.

OTHERS: Speech! Speech, Miss Villiers!

JENNY: *(Dismayed.)* Oh – must I?

PONSONBY: Of course you must!

LUDLOW: Go on, me dear – just something short an' sweet.

JENNY: *(Rising.)* Well – ladies and gentlemen – I can't make speeches – at least, not public ones…unless of course somebody writes them for me and I learn them off by heart. I'm very gratefull to all of you for helping to make my benefit such a wonderful success, and for entertaining us here. I've never been happier in the theatre that I have here at Barton Spa.

Apearing on the stage – as I'm sure you know – isn't all fun and glitter and applause. It's hard and sometimes heart-breaking work. And we're never as good as we'd hoped

to be. The theatre is like life – all sort of – packed up in a little gold box – and like life – it's often frightening, often terrible – but *wonderful.* The only thing I can say – except thank you – is that I'm only one of a company – a very good company, too – and that I owe a great deal, more than I can say, both to Mr. and Mrs. Ludlow –

Some applause.

And also to our brilliant leading man, Mr. Julian Napier –

Here, to sound of applause, she tosses a rose across to JULIAN, who catches it and kisses it. The scene is then immediately frozen, every person remaining still, while now JENNY speaks in low, intimate tone, as if to MARTIN without seeing him.

(To MARTIN.) You see, I had to throw him the rose – poor Julian, he kept looking so downcast, so wistful. They were all making such a fuss of me, and hardly noticing him. I wanted him to be happy, too. You undertand, don't you?

MARTIN: Are you talking to me?

JENNY: *(Same tone.)* I'm talking to somebody who's here now, who understands me, but who wasn't there when it all first happened.

MARTIN: When it *first* happened? Then – does it all go on happening?

JENNY: You can get back to it, if you think hard about it, although it's never just the same. This time, *you're* here.

MARTIN: *(Urgently.)* But why should I be here? And why should this supper of ghosts catch my heart?

JENNY: *(With more animation at first.)* I know now! If I hadn't thrown him the rose that night, there would have been no child – and then no link of daughters down the years to you –

MARTIN: *(Urgently.)* What daughters down the years? Jenny! Jenny Villiers!

But the scene is reanimated, and her tone is now as before, when making the speech.

JENNY: So – ladies and gentlemen of the Shakespearean Society – on behalf of us all at The Theatre Royal – I thank you again. Good my lords, you have seen the players well bestowed. *(She curtsies to applause, then sits down.)*

PONSONBY: Mr. Ludlow!

Applause, as LUDLOW rises ponderously.

LUDLOW: *(Grandiloquently.)* My friends – from the bottom of me heart I thank you. You have – to continue the quotation from Hamlet – used us well, not only here, in this rich and festive hour, but also in the playhouse itself – for I see around me tonight many familiar faces, and know that although you are me patrons and I your humble servant, you will allow me to address you as my friends.

Some applause. MRS. LUDLOW is overcome.

I have been among you now for many years, both as an actor and as a manager, and now, as I look back from this year eighteen forty-six…

But now the telephone rings, softly at first, from the desk, where the light begins to come up. At the same time the light on the banquet scene and LUDLOW's voice in the speech that follows begins to fade.

LUDLOW: …a stormy year of much strife at home and troubles abroad, when it might be thought that the Thee-ay-ter would cease to command the attention of a public concerned and worried about the Corn Laws, the Chartists, the Irish Famine, the wars in Mexico and India…

MARTIN, centre, turns to look bewilderedly at telephone and desk. Telephone bell rings louder and desk light comes up, and banquet scene goes fading. For a moment MARTIN is held between past and present, and then slowly moves towards desk, where light is on full and telephone ringing loudly. Banquet scene has now gone, and if possible original back wall should be restored, though so long as back

stage is cleared and dark, this can wait. As MARTIN reaches desk, door R. opens, showing very bright light ouside, and OTLEY looks in.

OTLEY: Your London call, Mr. Cheveril.

MARTIN: *(Confused.)* Yes… I heard the bell…

OTLEY: Right, then. *(Closes door.)*

MARTIN takes up the telephone with an effort.

MARTIN: *(At telephone.)* Yes… this is Mr. Cheveril speaking personally… All right… I'll hang on…

Holding the telephone, he looks around in bewilderment and puts his hand across his eyes, obviously in confusion, as the music starts up again and the curtain slowly falls.

End of Act One.

Act Two

This Act begins exactly where Act I stopped, so everything is the same. MARTIN, obviously confused, is waiting to speak on the telephone.

MARTIN: *(At telephone, after pause.)* Yes? Hello – hello! Yes, it is – I said so before. Oh – Lord! Yes, I'll hang on.

OTLEY opens door R. and looks in.

OTLEY: Coming through, Mr. Cheveril?

MARTIN: Now they've found me, they've just lost the other people.

OTLEY: My girl can wait for it –

MARTIN: No thanks. I'd better hang on myself now.

He puts a hand to his head and then across his eyes again, like an exhausted and bewildered man. OTLEY notices this.

OTLEY: I don't want to bother you, Mr. Cheveril – but are you sure you're all right?

MARTIN: No, I'm not sure.

OTLEY: Nothing I can do, is there?

MARTIN: Don't think there's anything anybody can do – thank you, Mr. Otley.

OTLEY: Easily nip out and get Dr. Cave again, you know.

MARTIN: No, thanks, don't bother. It's not a case for Dr. Cave – not yet, anyhow. *(Hears voice on telephone, and speaks into it.)* Yes, this is Mr. Cheveril, and I think Sir George Gavin wants to speak to me.

Nods dismissal at OTLEY, who goes out, closing door R..

Hello, George... Hell of a lot of fuss, isn't there, when you have to talk on a telephone... Yes, I dare say I do. I had to take some stuff... No, no, go on, George... Yes, I know you were...and I'd made up my mind earlier to refuse

your very generous offer, George... felt I'd finished with the Theatre... Well, I don't know... No, it isn't that I've changed my mind – the fact is, I can't exactly get hold of my mind to change it... I know it does, but I haven't had a drink all day... I took this stuff, and was resting and dozing here in this Green Room, and I supposed I must have been dreaming although I wasn't really asleep... No, day-dreaming – more vivid than that. But dreaming, of course. Must have been...

JENNY is now on the stage, in darkness, and we hear her quiet sobbing. MARTIN hears it and reacts.

I say, is somebody crying at your end of the line?... No, I know, but I thought I heard somebody... Yes, probably I am... But it was all extraordinarily vivid, though entirely imaginary of course... *(Now he hears a louder and more definite sob. He is sure now, without looking round, and speak with quiet firmness.)* I must go George. I'll speak to you later.

He turns and sees JENNY, who is now visible in soft light. He puts down telephone quietly and rises, taking a step or two towards JENNY, who is looking towards him, without seeing him.

Jenny! Jenny Villiers! Can you hear me?

JENNY looks bewildered, as if she hears something, but does not recognise his presence. KETTLE, who looks haggard and unkempt enters L. and stares at JENNY, who now turns to see him. He is about to withdraw, when her voice stops him.

JENNY: *(Timidly.)* Walter! *(KETTLE turns.)* What's the matter?

KETTLE: *(Harshly.)* Nothing's the matter – is it?

JENNY: *(Choking back little sob.)* I see.

KETTLE: *(Harshly.)* Why do you think something's the matter?

JENNY: Because we used to be such good friends – and you were so kind and helpful to me when I first came here – and now you're so bitter and harsh – as if I'd offended you. *(After he does not reply.)* Have I offended you, Walter? If I have – I'm sorry – I never meant to.

KETTLE: Take no notice of me. I shan't be here much longer. And I don't know which has been worse – to see you so happy, so radiant, as you were at first, with that conceited fool Napier – or to see you as you are now – made miserable by him –

JENNY: *(Agitated.)* No – please – don't say that, Walter. It isn't true. If I'm unhappy, he's not making me unhappy –

KETTLE: Something is – and I can't imagine what else it could be –

JENNY: Tell me – I've been wanting to ask this – and you're the only one I can ask. I don't seem unhappy when I'm playing, do I? It doesn't show then, does it?

KETTLE: No – thank God! Haven't you seen me – haven't you *felt* me – watching you from my corner? There you are still – with all your lights blazing, your banners flying – but then, as soon as the curtain's down, you're pining and drooping –

JENNY: *(Smiling.)* Now that's not true, Walter. I don't pine and I don't droop. You've made that up. Walter – dear Walter – be friends. I need friends –

She extends a hand. He crosses swiftly and kisses it fiercely, so that she shrinks a little, then he stares at her a moment, turns and goes. She fights hard to keep her self-control. SAM MOON and JOHN STOKES, both wearing great beaver hats, now enter, and do a comic act for her.

MOON & STOKES: *(Together.)* Your servant, madam!

Dexterously each raises the other's hat and they bow at the same time. JENNY smiles at them.

JENNY: Be covered, gentlemen!

MOON touches her cheek with his forefinger, and then delicately tastes his forefinger.

MOON: Too salty.

STOKES: *(With a glance of real concern.)* Tears, eh?

JENNY: Let's talk about something else – at once.

MOON: Quite right. Yes, John, I used to get a devilish good dinner of stewed beef behind Drury Lane for threepence ha'penny. For sixpence a man could dine like a lord.

STOKES: That's another thing that's wrong now. Everything costs too much, including actors.

JENNY: What about actresses?

STOKES: There aren't any?

JENNY: *(Geniunely indignant.)* What? John Stokes – you have the audacity to stand there –

STOKES: Now, now, my dear – I don't say you haven't the making of an actress, and quite a good one, but it'll take you another fifteen years at least to become what *we* called an actress –

JENNY: *(Dismayed.)* Fifteen years! Why –

MOON: No, it's not long. You'd be surprised – wouldn't she, John?

STOKES: You turn around one morning – and where are they?

Enter R. MRS. LUDLOW and both ACTRESSES, all obviously agitated.

FANNY: *(Dramatically.)* Gone!

JENNY: *(Alarmed.)* What?

STOKES: Who's gone?

FANNY: Didn't I say that that low fellow Varley, who came to see us last week, was probably scouting and touting for Mrs. Brougham, who has the Olympic now? If he's not opening at the Olympic a week from today, as soon as they can get the bills printed and put up, then my name's not Fanny Ludlow. Mr. Ludlow and I walked out of the Olympic when Madam Vestris had it. 'Never again,' I said to Mr. Ludlow –

STOKES: But who's gone?

FANNY: Without saying a word – not even goodbye. He must have been sitting up with that Varley both nights – demanding parts, settling terms and billing –

STOKES: But who – who?

FANNY: Why, Julian Napier, of course. Who else? *(To JENNY.)* Child – you're as white as a sheet.

JENNY: Am I?

She tries to smile, and the others begin to move out L.. Then she falls in a dead faint. The women look after her, as light slowly begins to fade.

FANNY: You men, go and get some water and a drop of brandy – and ask Agnes for my *sal volatile.*

The MEN hurry out and the WOMEN bend over JENNY.

Better loosen everything. There – there – there –

1ST ACTRESS: *(In shocked tone.)* Mrs. Ludlow – I think –

FANNY: *(Quietly.)* You needn't. I know now. And I know now why Julian Napier left in such a hurry –

2ND ACTRESS: Do you think she told him?

FANNY: No, she wouldn't. He guessed – and then ran away – a London engagement – and out of his troubles here. And with both of them out of the cast, I don't know what I'm going to say to Mr. Ludlow…

Light has gone now. Small bar set down L. is now seen, with same LANDLORD behind, and LUDLOW talking to JOURNALIST.

JOURNALIST: You're health, Mr. Ludlow!

LUDLOW: Same here. Though if it wasn't practically doctor's orders now, I doubt if I'd touch it. Haven't the heart for it, you might say. You tell me that some patrons are complaining –

JOURNALIST: I'm afraid they are, Mr. Ludlow. We've had one or two letters in fact, but I thought I'd mention it to you before printing 'em.

LUDLOW: Very friendly of you. The same again, George. I ask you – what can a man do? Suddenly it all comes at once, without warning. Napier – breaking his contract, mind you – sneaks off to London –

JOURNALIST: Where I hear he's having a great success at the Olympic –

LUDLOW: Possibly, possibly. Never a very discriminating audience. When he goes, Miss Villiers, around whom I had built my season, instantly collapses. Her distress at being abandoned in this fashion – for she was a wife to the fellow in all but name – aggravates her condition – and – well, you may have heard –

JOURNALIST: Yes, I did. I thought at the time it was probably better that way –

LUDLOW: So did I. But when that's over, instead of picking up, she gets worse, steadily worse. Doctor's tried everything – but – no use.

JOURNALIST: A sort of decline – eh?

LUDLOW: Yes. Week after week, a slow ebbing away. And everybody in the Company aware of it, talking about it, haunted by it. What's a man to do, sir?

Enter KETTLE, who is wet, and looks haggard and desperate.

KETTLE: They wouldn't let me see her. She's obviously worse. But that old fool of a doctor won't say anything. I waited – to speak to him. But it was useless. He doesn't know what he's doing or where he is. *(Takes drink that LANDLORD passes.)*

JOURNALIST: *Or where poor Miss Villiers is either – eh?*

LUDLOW stops him from saying more.

KETTLE: *(After swallowing his drink.)* I know where she is. She's at death's door. Queer phrase that, when you come to think of it – death's door.

LUDLOW: Walter, my boy, this won't do. You're wet through – and shivering. You'll be going down next.

KETTLE: Not I. I'll burn my time out. This town's like a steaming graveyard tonight. I felt we were all dead and just didn't remember. That doctor's nothing but a fat old corpse falsely resurrected. Another, George?

LANDLORD: Ha, ha!

LUDLOW: And when you've had that one, you'd better run along to your lodgings and get to bed, Walter. You're a sick man yourself.

KETTLE: Of course I am. We're all sick men. You with your painted faces and painted scenes. This fellow here with all the solemn lies he prints. And even George there, who poisons us so that we don't notice too much on our way to the graveyard. That's where we're all going, gentlemen. And a pleasant journey to you.

As he goes out and the other three look at one another in bewilderment and consternation, the light on the bar, which has been fading, now vanishes. There is some music and the sounds of rushing wind. Then a tiny light – it can come from a flashlamp held in his hand – comes on MARTIN, who can be either downstage L., as far downstage as possible, or upstage C. Wind dies down, and music fades away.

MARTIN: *(Quietly but with a touch of urgency.)* Jenny… Jenny.

JENNY's voice can come through a loud-speaker here, if it is quiet and sensitive enough. Otherwise she speaks off.

JENNY: It was very lonely – dying.

MARTIN: Lonely?

JENNY: *(Slowly, simply.)* Yes, very lonely. Everybody seemed a long way off. It was the loneliest thing that had every happened to me.

MARTIN: *(Gently.)* Were you frightened?

169

JENNY: No, I wasn't frightened. I think I was too tired to feel frightened. But I was lonely – and terribly sad – until the very end.

MARTIN: *(Slowly.)* Until the very end? After week and weeks in some dreary little back room, far away from the lights and music and applause, feeling lonely and sad…wasted hands and hollow cheeks…great burning eyes and bright hair…what happened then, my dear? *(He pauses as if waiting for a reply, then urgently.)* Jenny, if it was better, not so terribly sad, at the very end, I must know. Make me see. Let me listen. Jenny, what happened? Do you hear me?

As light fades on MARTIN, it comes on in small bedroom set in R. alcove. JENNY, wasted and very pale, with her hair loose, is half-sitting up in bed. Two tall guttering candles at her side. A stout old nurse of the period, the Sarah Gamp type, sits on small chair at bedside. Her face can just be seen; JENNY's is clearly seen; the room itself is in shadow. The effect is one of romantic desolation. JENNY speaks very simply but is obviously delirious.

JENNY: *(Pointing to candles.)* You know what we used to call them?

NURSE: *(Soothingly.)* Yes, dearie. Candles. They're only candles.

JENNY: No, not just candles – not when the wax has all run down the sides – thick white wax, running and melting away. We used to call them winding sheets. That's true, isn't it? Winding sheets?

NURSE: Now, you've not to talk like that, dearie. Only just 'ave patience, and we'll 'ave you better in no time. You want to act in the thee-aytor again, don't you?

JENNY: *(Alarmed.)* Yes, of course. What time is it? I mustn't be late. I must get dressed. Why am I lying here?

NURSE: *(Bending forward to restrain her.)* Now – now – now – you can't go tonight, dearie. You're too poorly – and any-ow, it's too late.

JENNY: *(Muttering.)* Yes, it's too late...far too late... Goodnight ladies; goodnight, sweet ladies; goodnight...goodnight... *(Her voice dies away, but then she hears something, and is rather startled, sitting up a little.)* Listen – what's that noise?

NURSE: Only the rain, dearie. The west wind's bringing the rain tonight.

JENNY: Heigh-ho – the wind and the rain...that's sad too... I don't know why it should be...but it is. And he meant it to be, y'know... 'But that's all one, our play is gone'...it's pretending not to be sad, not to care at all, but all the time it *is* sad. It makes me cry.

NURSE: Don't let it then, dearie. You needn't bother your 'ead about it.

JENNY: *(Alarmed again now.)* Yes...yes... I must...and there isn't much time. What does it matter how late it is, Sarah... I know you're tired, but I must go through it again. 'Make me a willow cabin at your gate. And call upon my soul within the house...'

As she sinks back, exhausted, elderly DOCTOR enters quietly R. and stands looking down at her, then looks enquiringly at NURSE. BOTH keep near foot of bed.

NURSE: *(Whispering.)* I'm afraid she's weakening fast, doctor. And her poor mind's a-wandering again.

JENNY opens her eyes and smiles at DOCTOR.

DOCTOR: *(Quietly.)* Now, Miss Villiers.

JENNY: *(Very quietly and sadly.)* I'm afraid I've been a great trouble to you, Doctor.

DOCTOR: No, you haven't, Miss Villiers.

JENNY: Yes, a great trouble...where's Nurse...has she gone?

NURSE: No, I'm still 'ere – bless yer!

JENNY: *(Faintly.)* I can't se you...it's dark...why is it so dark? And what's that noise?

NURSE: Only the rain, dearie.

JENNY: *(Half sitting.)* No…listen!

> *There is the sound of distant applause and music far away but then coming nearer, calling 'Overture and Beginners. Overture and Beginners.' JENNY hears it, and with a last effort sits up, smiling.*

My call…my call…

> *As she sinks back exhausted, light begins to fade, but music comes up for a few moments and there is the rushing wind sound. But these die out as the light completely vanishes, and there is a moment or two of complete darkness, during which a very distant sound of a tolling bell can be heard. Then tiny light comes up on MARTIN.*

MARTIN: *(Slowly, sadly.)* So that's how it was. But is this the end? Is there nothing left of Jenny Villiers but a name and a date, a portrait and a glove? And why the link of daughters down the years to me? There's nothing left. *(As if a thought strikes him, calling.)* Kettle! Walter Kettle!

> *Light goes off MARTIN and comes up on R. alcove. This now represents a corner of the Prop. Room. It is a bizarre little scene, with bits of armour, old costumes, and one or two grotesque old pantomime heads hanging up behind. Small table with chair behind. Bottle of gin, a couple of glasses, and two large candles burning. The light should be fairly strong in centre of scene with strong shadows and shadowy edges. KETTLE, looking as before, is sitting, brooding, and drinking. After a moment or two, LUDLOW enters.*

LUDLOW: *(Sympathetically.)* Walter, me boy – we all know how you feel. We all feel the same.

KETTLE: *(In despair.)* No, you don't. Have you ever felt a rusty saw-edged dagger in your heart?

LUDLOW: She's gone, Walter – and wild words and strong liquor won't bring her back.

KETTLE: The words aren't wild – to me. And the liquor might smooth the edge of the dagger – though it hasn't done so far –

LUDLOW: I depend on you Walter. This Theatre depends on you –

KETTLE: Then you and this Theatre must learn to look after yourselves. I've finished here – I hate every stick and stone of it now she's gone. *(Helps himself to another drink, gulping it down.)*

LUDLOW: Times are hard and won't be easier without Jenny –

KETTLE: *(Angrily.)* She isn't in her grave yet – but you can talk of her as if she was only a name on the bill –

LUDLOW: *(Ignoring this outbreak.)* I say, times are hard – but I might consider a substantial increase in salary for you, Walter –

KETTLE: Salary be damned – and you and your Theatre with it! I'm not even staying in this country, man.

LUDLOW: *(Surprised.)* Why – where could you go?

KETTLE: *(Sullenly.)* I've a cousin in Australia – New South Wales – who's written more than once he'd pay my passage out there if I'd join him.

LUDLOW: Australia? But they've no theatre there yet –

KETTLE: So much the better. All the Theatre that I want is lying in a coffin –

There is a voice off, calling 'Mr. Ludlow', and LUDLOW goes off. KETTLE takes another drink shudderingly, then buries his head in his hands. LUDLOW returns.

LUDLOW: *(Quietly.)* Someone wants to see you, Walter.

KETTLE: *(Not raising his head.)* Tell 'em to go away.

LUDLOW: It's the nurse that looked after Jenny –

KETTLE looks up, enquiringly.

She won't talk to anybody but you – and she is very persistent and urgent about it.

KETTLE: If she's come to torture me with any death-bed scenes, I'll wring her fat neck.

LUDLOW: *(Quietly.)* But you'd better find out what she wants, Walter.

He goes out and then the NURSE enters, a fat shapeless figure, who looks curiously at him. Her manner is both unctuous and mysterious.

NURSE: Mr. Kettle, I'm Mrs. Parsons, you remember, the nurse that looked after our poor dear –

KETTLE: *(Cutting in, harshly.)* Yes, yes, I know. What is it?

NURSE: You're takin' it 'ard, aren't you, Mr. Kettle? An' I'm not surprised, 'cos I said all doing 'It's that poor Mr. Kettle that loves 'er an' the one she ought to 'ave 'ad –'

KETTLE: *(Starting up, cutting in.)* For God's sake, woman! Any more of that and I'll – *(Breaks off.)* No, no. Forgive me. But I can't endure that sort of talk now. If there's something you think I ought to know, then tell me what it is – and then leave me alone.

NURSE: Yes, I 'ave. Very special – an' only for your ears as I told 'em out there.

KETTLE: Sit down then. And have a drink – gin.

NURSE: *(Sitting down.)* Just a nip – 'cos o' the kind o' nasty weather we're 'aving, Mr. Kettle.

He sits and pours out two drinks. She takes hers.

Your 'ealth! *(Drinks, and then is more confidential.)* It's all on account o' the baby, – 'er's, y'know, Mr. Kettle –

KETTLE: *(Seriously attending now.)* I though the child died –

NURSE: Looked as if it was going to – proper touch-an'-go – an' she couldn't 'ave it, of course – an' then 'er mind wandered at the last. It's been with my sister these last three days – an' now the doctor says it's perking up fast – a bonny little girl it is – and'll take after 'er mother, I'd say – same colourin', I'll be bound. But now the question is – what's to become of it? Workhouse?

KETTLE: *(Aghast.)* Workhouse! Good God – never!

NURSE: Well, I can't keep it – an' my sister can't afford to – only doin' it now to oblige –

KETTLE: Wait a minute! *(He thinks.)* Suppose you had to take a baby a long way by sea – to Australia, we'll say – what would be the best age for it to go?

NURSE: *(Giving it some thought.)* Well, that's a question, Mr. Kettle. Some 'ud say one thing, an' some another. But I'd say – if there was proper milk arrangements, like I 'ear tell there is sometimes – then I'd say round about six months old –

KETTLE: Where does your sister live?

NURSE: Mrs. Grott, she is – at Number Four, Canal Terrace –

LUDLOW now appears on scene.

KETTLE: *(Rising.)* Tell her I'll see her in the morning –

NURSE: *(Rising.)* Well, Mr. Kettle, if you could –

KETTLE: *(Cutting her off sharply.)* In the morning, Mrs. Parsons. I'm sorry but Mr. Ludlow and I have some business –

NURSE: Yes, of course. Goodnight – all –

Bustles out. KETTLE looks hard at LUDLOW.

KETTLE: I've changed my mind – if you'll accept my terms. And it's take it or leave it. No haggling.

LUDLOW: Name them, Walter.

KETTLE: Give me an extra thirty shillings a week for the next six months – and I'll keep sober and work like a black for you and your Theatre –

LUDLOW: Another thirty shillings? It's a lot of money –

KETTLE: Take it or leave it. I need the money – and you've always underpaid me.

LUDLOW: It's a bargain then. But what happens when the six months are up?

KETTLE: Australia for me – *(Adding softly.)* and perhaps my family.

LUDLOW: Shall we drink to it?

KETTLE: *(Filling a glass for him.)* You can drink to it! But as for me – I said *sober* and I meant *sober*. Look!

He hurls the gin bottle off and we hear it crash as the lights go. Light on MARTIN.

MARTIN: *(Musing.)* Kettle went to Australia – and took Jenny's child with him – as his adopted daughter. And that's all I know. There's no Jenny – nothing left but a portrait and a glove. *(Calling urgently.)* Jenny! Jenny Villiers! Where are you?

We hear her ringing laugh. MARTIN calls gladly.

Jenny!

Soft golden light goes on upstage C. of Green Room. SPRAG, a little middle-aged author, is ending his reading of a farce to LUDLOWS, STOKES and COMPANY, excluding KETTLE. They all wear dark clothes and sit huddled listening gloomily, except JENNY, who is dressed in white, standing near the AUTHOR, and she is gay and excited and enjoying the reading. The OTHERS, of course, are not aware of her presence. The old daguerreotype effect should be very marked in this, the final ghost scene.

SPRAGG: *(With the over-emphasis of despair.)* Mr. Tooley: 'No, ma'am, I have to confess that I never had a brother and if I had had a brother I wouldn't have behaved like that to him.' Mrs. Tooley: 'Aunt Jemima, it was just another of Mr. Tooley's tarradiddles.' Comic business with parasol again – very effective.

JENNY: *(Laughing.)* Yes, I can see her. Go on, Mr. Spragg. What's the curtain?

The COMPANY shows no reaction, so SPRAGG, after a despairing glance around, continues.

SPRAGG: Aunt Jemima: 'Well, me dear, I can only say thank goodness it's you who's married to the man and not me. But I'll not cut you out of me will this time, 'cos I'm truly sorry for you married to such a fool.' Mr. Tooley: 'I deserve no better of you, ma'am, but in future I'll remember to *tarry* before trying to *diddle* again –'

JENNY: Very neat, Mr. Spragg.

SPRAGG: Aunt Jemima: 'Gracious – what's that?'

JENNY: *(Genuinely interested.)* Farmer Giles again, eh?

SPRAGG: Entrance of Farmer Giles down chimney, covered with soot. *(He glances at the COMPANY.)* Very funny effect this, bang on the curtain. Mrs. Tooley: 'Why it's poor Farmer Giles.' Farmer Giles: 'Yes, and black in the face after listening to MR. TOOLEY'S TARRADIDDLES'.

Gives a great sneeze – all strike attitudes – Tableau. Curtain. End of Farce – Mr. Tooley's Tarradiddles.

He mops his brow: and looks in despair at the glum company.

JENNY: *(Amused.)* I loved it, Mr. Spragg.

LUDLOW: *(Gloomily.)* Thank you, Mr. Spragg. Very funny, I'm sure.

SPRAGG: *(Exasperated.)* But – dash my buttons! – You never laughed once – not one of you –

JENNY: Oh – what a shame! Poor little man! Letting him read all that – and nobody laughed at anything but me.

FANNY: *(Gloomily.)* Tell him, Mr. Ludlow.

SPRAGG: Tell me what?

LUDLOW: *(Sadly.)* I have a confession to make, Mr. Spragg. I asked you to come and give us this reading of you new piece a week or two ago, as you know. I forgot to cancel your visit and then hadn't the heart to tell you.

SPRAGG: Tell me what? Not closing, are you?

LUDLOW: No, no.

FANNY: We were closed last night, Mr. Spragg, because all attended the funeral of our leading female juvenile whom we all admired and loved dearly – our poor sweet Jenny Villiers –

SPRAGG: *(Dismayed.)* Oh – I say!

FANNY: And this is the first time we've met since we said goodbye to her for ever –

JENNY: *(Urgently.)* No, no – darling – it isn't like that at all.

FANNY: *(Moved.)* We're feeling it, Mr. Spragg, we're all feeling it most deeply.

A sob or two from the ACTRESSES, nose-blowing from MEN.

JENNY: *(Coming forward.)* No – look – it doesn't matter a bit. Please!

Now the light begins to fade on all but JENNY and MARTIN. The voices of the OTHERS begin to fade too.

SPRAGG: You ought to have told me, y'know. Not fair.

FANNY: *(Tearfully.)* I know we ought. But we thought you might be able to make us forget...

JENNY: There's nothing to forget.

MARTIN: It's no use, Jenny. You're a ghost even to the ghosts now.

JENNY: *(To him.)* No, I'm not.

1ST ACTRESS: *(In fading tone.)* And we can't forget her...

STOKES: *(Fading tone.)* It'll take some time yet, I'm afraid...

MOON: *(Fading tone.)* The heart's right out of us, you might say...

JENNY: *(Protesting to them.)* No, Sam, John, Sarah, all of you. It doesn't matter about me. Nothing's been lost. And all that matters is – to keep the flame burning clear.

MARTIN: *(Mumuring.)* 'The best in this kind are but shadows.'

As PLAYERS fade out, still mumbling.

JENNY: They're going. They're going. *(To MARTIN.)* You tell them it doesn't matter about me – or about anybody – as long as the flame burns clear. *You* know.

MARTIN: *(Bewildered.)* How should I know?

JENNY: You did once. Tell them.

MARTIN: Too late, they're gone. And it was all long ago.

Stage is dark now, except for small light on JENNY upstage L., and bigger light on MARTIN C..

JENNY: *(Whispering.)* Yes, I can see you.

MARTIN: Because we're both ghosts.

JENNY: *(Light and voice fading.)* No, it's not like that. Why are you pretending not to understand?

MARTIN: Why should I understand? And why did you say I knew once?

JENNY: *(A faint whisper.)* Because – we talked – don't you remember?

MARTIN: *(Alarmed.)* Don't go

Actually she has gone, but we hear her voice. MARTIN is looking for her distractedly.

JENNY: Yes. And don't try to find me.

MARTIN: *(Calling, in anguish.)* Jenny! Jenny Villiers!

JENNY: *(Very faint and far away.)* No…not yet…not yet… Remember the link down the years…the last one is waiting…

MARTIN: *(Urgently.)* I don't understand…and I want to see you once more, Jenny…just once more…

Her reflection now appears in the large mirror. He stares at it a moment, much moved.

Jenny! Jenny Villiers!

As she smiles, and her lips seem to pronounce his name, he moves towards the mirror, to take her in his arms, but moves slowly like a man in a trance. There is exultant music. But the image fades as he gets nearer, and he finally stumbles against the dead mirror.

The glass door! Only the glass door!

He falls with a crash in front of the mirror. The music sweeps up, and then a moment or two later door R. opens to admit OTLEY and DR. CAVE, who enter hurriedly. OTLEY switches on lights, showing Green Room exactly as it was before, with standard light on desk, etc.

OTLEY: *(Alarmed.)* He's there – look, doctor. Must have fainted.

DR. CAVE: *(Crossing with bag.)* Durned good job you thought of calling me. He must have been moving around instead of resting – and then had a black-out. Frequently happens with a touch of concussion. Now – let's see…

They are now bending over MARTIN, who lies still.

Hm, shocking pulse. Might have been a near thing. But, he'll be all right. I'll give him an injection of coramine. *(Begins to prepare injection, from his bag.)*

OTLEY: I thought he was looking queer, the last time I looked in.

DR. CAVE: *(On the job.)* This ought to keep him going for a few hours – and then he really will have to rest. I took rather a chance before, but with people of his type, you have to make allowance for the way their minds are working. No good telling 'em to rest if they're not ready to rest. They just fret themselves into a worse state. There – that ought to do the trick.

They watch MARTIN in silence for a moment. Then MARTIN opens his eyes.

OTLEY: It's all right, Mr. Cheveril. Doctor's here.

MARTIN: *(Muttering.)* The Glass Door. The Glass Door.

DR. CAVE: What did he say?

OTLEY: *The Glass Door* – that's the name of his play.

DR. CAVE: Oh yes – of course. Mind running on it, you see – That's what happens with this type. That's why one's got to take risks with 'em. *(In cheerful professional tone.)* Now then, Mr. Cheveril, feeling better?

MARTIN: *(Sitting up slowly.)* Yes, thanks... Sorry about this... But I was all right, y'know...and then when I moved towards her – she vanished...

OTLEY looks in surprises at DR. CAVE who merely shakes his head.

DR. CAVE: Then you did a neat little dive into a complete blackout, Mr. Cheveril. Well now, suppose we get you back into that comfortable chair, eh?

MARTIN rises, with their assistance.

MARTIN: Yes – but I'm all right now, y'know. *(He goes slowly with their assistance, back to his chair.)* I won't try to explain... You wouldn't believe me if I did... But I'm sorry to have been such a nuisance.

DR. CAVE: Don't worry about that. Fortunately, Mr. Otley took a peep at you about half an hour ago and thought you were looking queer, and so very sensibly telephoned me.

MARTIN: *(To OTLEY.)* I'm much obliged.

OTLEY: Not at all, Mr. Cheveril. But I'd better get back to my office. You can give me a buzz from the desk if there's anything I can do for you.

He goes out R.. DR. CAVE now lights a cigarette and looks rather quizzically at MARTIN.

DR. CAVE: I've given you an injection of coramine. I'll keep you going for a few hours – if you've anything you want to attend to urgently – but after that, you'll either rest properly or find yourself another doctor.

MARTIN: Thanks. I'll do whatever you want me to do. But there are certain things I'd like to attend to first. And I couldn't rest until I'd attended to them.

DR. CAVE: So I thought. *(He picks up a bottle of tablets from the desk, and looks at it thoughtfully.)* You took two of these?

MARTIN: Yes. Followed your instructions.

DR. CAVE: Sure you took only two?

MARTIN: Why – yes. I distinctly remember taking two and swallowing them with some water – wait a minute, though. *(Thinks a moment.)* I took four. Not deliberately. I remember now. I took a second two, forgetting that I'd already taken two. I say – I'm sorry.

DR. CAVE: Don't apologise to me. Apologise to yourself. That was asking for trouble. What probably happened was that you gave yourself such a boost that your heart couldn't take it. *(Grins at him.)* What does it feel like to be nearly dead?

MARTIN: *(Remembering, slowly.)* Not yet.

DR. CAVE: What's that?

MARTIN: *(Slowly.)* It's quite different from what you might imagine. Perhaps we go from one kind of time to another.

DR. CAVE: You've been dreaming, Mr. Cheveril.

MARTIN: I wonder.

DR. CAVE: If you'd put just a little more strain on your system my dear sir, you'd have dropped clean out of any kind of time for good and all.

MARTIN: *(Smiling.)* How do you know, doctor?

DR. CAVE: *(Rising.)* Well – I don't. My job is to mend bodies and yours needs looking after. I'll take these, by the way. *(Takes the bottle of tablets.)* So, without unduly exerting yourself, just attend to anything here that you feel you can't leave – and then get to bed, and stay there until I see you again. That'll be sometime in the morning. And don't

worry if you don't sleep too well tonight – and don't take a sedative – just lie quiet. Goodnight.

MARTIN: *(As DR. CAVE goes.)* Goodnight, doctor – and thank you. By the way, you might please tell Otley to look in for a moment if you see him.

DR. CAVE gives an acknowledging wave and departs R. with his bag.

After he has gone, MARTIN looks slowly round the room, obviously remembering what he has seen in it. Soft music. Then OTLEY renters R..

OTLEY: Yes, Mr. Cheveril?

MARTIN: Two things – if you don't mind. First ask your secretary to get through to Sir George Gavin – the number's – er – Regent Six One Five Oh – he may not be there, but leave a message for him to ring me here as soon as he can – it's rather urgent.

OTLEY: *(Making a note.)* Yes – got that. Anything else?

MARTIN: *(Hesitating a little.)* Well – you remember that young actress who wanted to see me – ?

OTLEY: Ah – I'm sorry about that, Mr. Cheveril –

MARTIN: No, that's all right. I refused to see her. I was wrong. If she comes back, I want to see her.

OTLEY: All right, Mr. Cheveril. But it isn't likely she will come back.

MARTIN: *(Slowly remembering.)* Y'know, I think she might. The last thing she said – and I thought it odd at the time – was 'You'll be sorry soon that you said that.' That was after I told her to clear out. And she was quite right. Now I *am* sorry.

OTLEY: Still – that wouldn't bring her back, would it?

MARTIN: I don't know. It might. She also told me to be careful.

OTLEY: *(Surprised.)* Careful about what?

MARTIN: Ghosts, I think.

OTLEY: Oh – well – Mr. Cheveril – it's like I told you – you know how superstitious they all are –

Enter ALFRED LEATHERS L..

LEATHERS: Not interrupting anything, am I?

MARTIN: No, come in, Alfred.

LEATHERS: I'm not wanted on the stage for a spell, so I just came up to see how you're getting on.

MARTIN: We were talking about ghosts. And I was about to remind Mr. Otley that we're ghosts too.

OTLEY: *(Smiling.)* Now, now, Mr. Cheveril – none of that. Well, I'll get your London call put through as soon as I can, and I'll tell 'em down at the stage door to let that young woman come up – if she does come back.

MARTIN: *(As OTLEY goes R..)* Thanks.

Exit OTLEY R..

MARTIN smiles at LEATHERS, who has brought up a chair.

Alfred, do you believe we're ghosts too?

LEATHERS: I know I often feel like one.

MARTIN: That's not what I meant.

LEATHERS: Then I wouldn't know what you mean. But what *I* mean is that I've been acting too long – and – as the youngsters like to say it – I've *had* it. In fact, the Theatre's *had* it. We've had one or two hold-ups down on the stage this last hour, and Pauline and Jimmy Whitefoot and I have been arguing a bit. And I think you're right – and they're wrong. The Theatre's finished and we might as well admit it.

MARTIN: *(Smoothly.)* It was different when you were young, of course, – eh?

LEATHERS: *(Expanding.)* Different? I should think it was.

MARTIN: You've seen some great nights in the Theatre, I
imagine, Alfred.

LEATHERS: I have, Martin. And they'll never come again.
Don't forget that in my time I've played with Irving, Ellen
Terry, Tree, Mrs. Pat –

MARTIN: Great names, Alfred.

LEATHERS: *(Clearly echoing Stokes' speech.)* Ah! – but the
Theatre *was* the Theatre in those days, Martin. It was all
the public had and so we all did our best with it. None of
your films and radio and television and the rest of 'em *then*.
It was the *Theatre* and the Theatre as it ought to be. Now
they'll go to anything –

MARTIN: Just a rage for silly amusement –

LEATHERS: You've taken the words out of my mouth. Yes, silly
amusement – and it's all money, money, money –

MARTIN: The Theatre's dying – though it may last out your
time –

LEATHERS: Yes, thank God! – but I don't give it much longer –

MARTIN: The old spirit's gone –

LEATHERS: Right! The plays aren't the same –

MARTIN: The audiences aren't the same –

LEATHERS: And the actors –

MARTIN finishes this with him.

(With MARTIN.) – aren't the same. *(LEATHERS looks at
MARTIN humorously.)* Here – this is a duet.

MARTIN: Well, you see, Alfred, I know that speech about the
dying Theatre. I've heard it before tonight.

LEATHERS: Not from me you haven't

MARTIN: No, but from somebody rather like you – only he
was talking a hundred years ago, and it was panoramas

then and not films and he'd acted with Kean and Mrs.
Glover in his youth instead of Irving and Ellen Terry –

LEATHERS: Who had?

MARTIN: This old actor I heard –

LEATHERS: Heard? Where?

MARTIN: Here is this Green Room. Just the place to hear it.

LEATHERS: Ah – I see – you've been dreaming.

WHITEFOOT: That's the stuff, Martin!

Both turn away while PAULINE lingers.

MARTIN: Hang on a minute, Pauline. I've a call coming
through that will interest you.

She turns enquiringly and hopefully, while the two actors go out L..

PAULINE: George Gavin?

MARTIN: Yes. He rang me earlier but now I've asked Otley to
get through to him as soon as he can. I think you'd like to
hear what I say to him.

PAULINE: *(With some excitement.)* I will if you're going to accept
his offer. And you are! What's happened? Why have you
changed your mind?

MARTIN: *(Slowly, reflectively.)* I've been thinking about the
Theatre. About its being life in miniature, as the old
writers, especially Shakespeare, were always saying.

PAULINE: *(Rather impatiently.)* I know. All the world's a stage –
and so on. Rather obvious stuff, I've always thought it.

MARTIN: *(As before.)* I wonder if it is – even that. One man – in
his time – plays many parts. The man, you see, is distinct
from the parts, and his time is the stage on which he plays
them. Is it so obvious, Pauline?

PAULINE: Well – perhaps not – if you put it that way. But what
about the Theatre?

MARTIN: I believe now that in our life, as in the Theatre, the scenery and costumes and character make-ups and props are only a shadow show, to be packed up and put away when the performance is over. And what's real and enduring, perhaps indestructible, is all that so many fools imagine to be flimsy and fleeting – the innermost and deepest feelings – the way an honest artist sees his work – the root and heart of a real personal relationship – the flame – the flame burning clear. And Pauline, I believe that for all our vulgar mess of paint and canvas and lights and advertisement, we who work in the Theatre do our share in helping to guard and to show that flame –

The telephone rings. MARTIN answers it.

Yes, that's right – Sir George Gavin… Oh – hello, George… Yes, I am… No, there were some more… Well, call them that if you like, but I'm not so sure… No, that's where you're wrong, George. I've changed my mind. I'm going to say Yes – yes…if your offer's still open, I'm coming in with you – Yes, if you like, with every penny I possess… No, I can't because I'm going to rewrite my third act, but give me a few days and I'll have a scheme for you… All right then, see you on the First Night here… Do I? Well, perhaps I am. Goodbye, George.

He comes away from the telephone. PAULINE looks at him.

PAULINE: He told you that you sounded different, didn't he?

MARTIN: Yes. Good guess.

PAULINE: But what can you do for those characters of yours. You remember what you said? No real understanding. No genuine communication. All making frantic gestures behind glass doors.

MARTIN: I'll try to fling open those doors for them. I'll try to show them that communication may reach further and understanding go deeper than – than many of us ever dreamt. I've got to take that risk.

PAULINE: What risk? What do you mean?

MARTIN: *(Half smiling.)* No, Pauline.

PAULINE: *(Firmly.)* Martin, *what happened?*

MARTIN: I took four tablets instead of two.

PAULINE: No, that's not all. *Something happened.*

MARTIN: No, my dear, don't press me. What I felt was intensely real – and that's why I'm ready to take the risk of opening these doors – but the rest of it – well, if might have been a dream – or delirium – or –

PAULINE: *(As he hesitates.)* Or what? That's not all.

MARTIN: Probably it is.

PAULINE: No. Because you felt it – and it's changed you –

MARTIN: *(Very slowly, hesitantly.)* Or – perhaps – communication and understanding – outside our time – in some unknown dimension of things – oh, I can't say any more.

PAULINE: All right. I won't ask now. But don't go back on whatever it was.

MARTIN: I don't want to. But I can't help remembering the sceptical grin on that doctor's face. He's seen people like me before.

PAULINE: Doctors don't know everything.

MARTIN: No, but they get about a bit. And I've no proof. There can't be any proof now.

PAULINE: Proof – of what?

But MARTIN shakes his head. She looks at him curiously for a moment.

You know – I told you you ought to fall in love – you remember? And you laughed at me. Well, you can laugh at me again – because now I can't help feeling you *have* fallen in love.

MARTIN: You may be right. Perhaps I have.

PAULINE: *(Astonished.)* Yes – but how can you? Who is it?

MARTIN: *(Rather sadly.)* I don't know. I told you – I've no proof now. You'd better go down to the stage now, Pauline.

PAULINE: *(As she goes.)* All right. But don't let go, Martin.

MARTIN: *(As she goes, uncertainly.)* I'll try not to, Pauline. *(But he looks sombre and bewildered as he sits, away from desk, with writing pad on his knee but not writing. Clearly he feels uncertain and rather unhappy as he tries to keep a hold on his experience during the evening. Then he looks up sharply. The crimson gauntlet glove lies on the floor again and he goes forward and as he picks it up and stares at it, the Jenny music plays softly.*

Then OTLEY looks in R..

OTLEY: Miss Seward.

He holds the door open and ANN enters and comes forward. OTLEY going out and closing door. Still holding glove, MARTIN stares at her.

MARTIN: *(Involuntarily.)* Jenny Villiers!

ANN: No, but my grandmother – my mother's mother – was an actress – quite well-known once – Margaret Shirley –

MARTIN: Yes, I remember her.

ANN: And her grandfather – who went out to Australia about a hundred years ago, when my grandmother's mother, my great grandmother was just a tiny baby – well, he'd worked in the Theatre – though he wasn't famous or anything –

MARTIN: And what was *his* name?

ANN: Oh – you wouldn't ever have heard of him. His name was Kettle – Walter Kettle. *(As she notices the effect of this.)* What's the matter? You're trembling.

MARTIN: You're trembling too.

ANN: Yes, but it's different for me – a girl – talking to somebody I've always admired –

MARTIN: I don't think that's it. Is it now?

ANN: That's not fair. And look at you. What's the matter? It couldn't be as quick as this could it?

MARTIN: Quick, slow – here, there – now, then – tomorrow, yesterday – perhaps it's all different from what we think. Aren't you either playing or rehearsing this week?

ANN: No, they gave me a week off. But I must go – because I know you have some work to do.

MARTIN: I have – and it's urgent – worse luck – rewriting the end of my play.

ANN: Then I'm going *(She goes towards door R.. He watches her. Just before she reaches door, she turns and gives him a wonderful smile.)* Am I mad? Or – if I came tomorrow – could we talk?

MARTIN: *(With his heart in it.)* You're not mad – or we both are, so it doesn't matter. And tomorrow we'll start talking – and go on for ever and ever –

As they look up and smile at each other, the music swells up and the curtain slowly descends.

End of Play.